For Holly

Best

Kenneth Jay Lane

Kenneth Jay Lane

FA KING IT

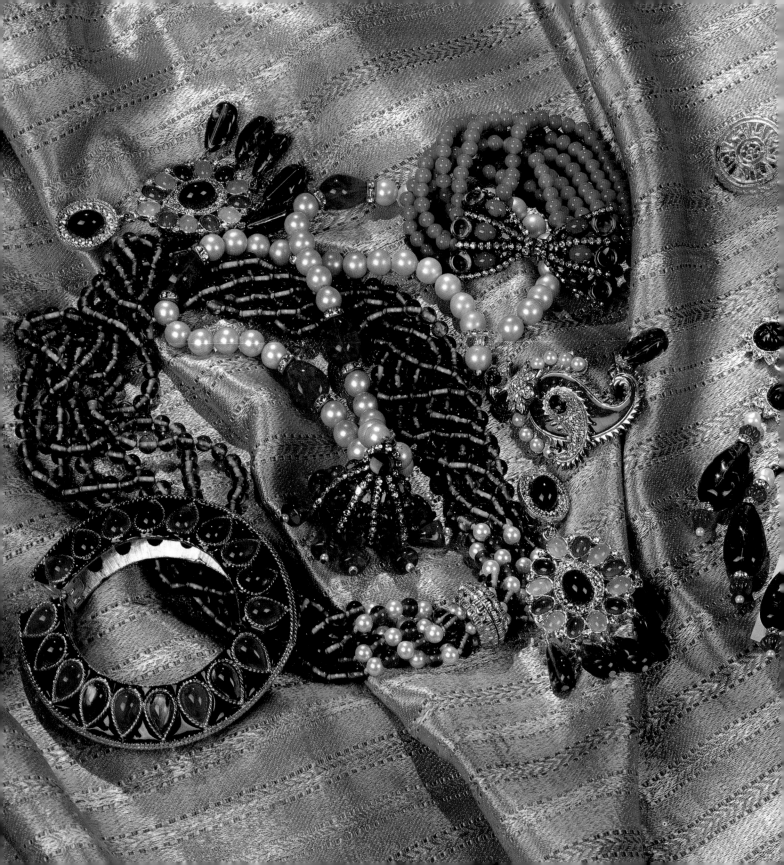

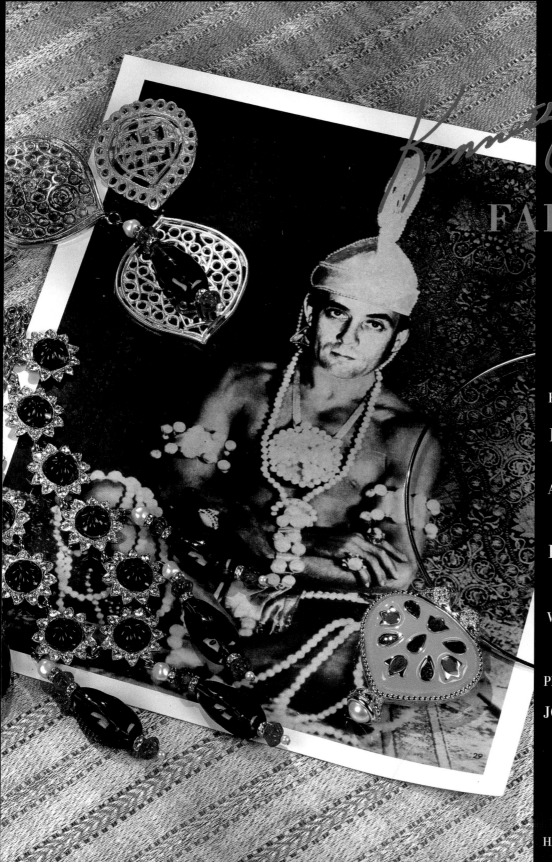

Kenneth Jay Lane

FAKING IT

BY

KENNETH JAY LANE

AND

HARRICE SIMONS MILLER

WITH A FOREWORD BY SUZY

PRINCIPAL PHOTOGRAPHY BY

JOHN BIGELOW TAYLOR

HARRY N. ABRAMS, INC., PUBLISHERS

DEDICATION

To my mother,
who said, when I told her
I was going into the jewelry business,
"Kenneth, please don't tell anyone."
— K.J.L.

Contents

Suzy (Aileen Mehle)
Photo, Skrebneski

Foreword

by Suzy

Is it too much to say that Kenneth Jay Lane, the most famous American fantasy jewelry designer of the twentieth century, is a modern throwback to Benvenuto Cellini, the Renaissance genius whose creations in gold, silver, and precious jewels made him a legend then and now? Or that Kenneth Jay Lane is a follower in the footsteps of Fulco di Verdura, another Italian master of a much later era whose ravishing, imaginative designs made his jewels objects of desire for some of the most fastidious and fashionable women of his time—and today? Or that perhaps he is a little of both—the difference being, of course, that those great jewelers of the past from whom KJL draws inspiration (he says Verdura's ghost still haunts him) worked in the real thing. KJL is a gifted, imaginative craftsman who designs faux masterpieces. And sometimes, many times, his fakes are more beautiful, more opulent, more dazzling than the real thing. Even on a clear night, some people can't tell the difference. Inspired, he may be, but very much his own man—a true original. It follows that KJL's jewels are much less expensive than precious jewelry—except when his vintage creations come up at auction where they fetch very fancy prices indeed. Women who love beauty and fashion covet their KJL necklaces,

earrings, bracelets, rings, and brooches, and through the years they have become collectors' items.

There are those who say he's a sorcerer who turns rhinestones to diamonds and the blue, green, and red crystals and German-made glass he works with into sapphires, emeralds, and rubies that look plucked from an ancient idol's eye or plundered from a pirate's chest. His corals could have been gathered from a reef. His pearls would fool the smartest oyster. Who can forget Barbara Bush and the three-strand KJL choker she wears night and day? Someone—maybe it was Mrs. Bush herself—once said that if she ever removed that pearl necklace her elegant head would drop off, plunk.

It's no secret that KJL has bedecked and bedizened some of the most important and discriminating women in the world: several former First Ladies, including Nancy Reagan and Jacqueline Kennedy Onassis; such movie stars as Audrey Hepburn and Elizabeth Taylor; the iconic Duchess of Windsor (whose real jewels sold at auction for many millions); the British Princesses Margaret and Alexandra; the Spanish Infanta, who is the Duchess of Badajoz; the French Countess Jacqueline de Ribes and the Spanish Countess Aline de Romanones; such fashion immortals as Babe Paley, Gloria Guinness,

and Diana Vreeland; such stylish creatures as Pamela Harriman, Betsy Bloomingdale, and Lee Radziwill; even Princess Diana's step-grandmother, the endlessly prolific romantic novelist Barbara Cartland, glitters nonstop in his gorgeous fakes. There are even some hyper-avid Lane lovers who insist they'd rather appear naked than forsake their KJLs—but you know how people exaggerate.

When the ladies who are stars of international society descend on New York from their stately homes, chateaux, chalets, villas, schlosses, and what have you, one of their first stops is KJL's New York emporium where they paw through the treasures for his latest glamorous designs. And if his own name is synonymous with glamour, it is because he himself is a best-dressed, cosmopolitan figure of great flair, who not only knows his customers personally—many are great friends—but lives a lifestyle as luxurious as their own. His beautiful New York duplex apartment where he entertains the haut monde is one of the most lavish in the city. He is a frequent guest in some of the world's most distinguished houses. To his friends he is simply Kenny: self-confident, sophisticated, charming, witty, amusing to the core, and with the disposition of an angel. When he married a fascinating Englishwoman years ago, his friends all wished him well. When the marriage failed, they welcomed him back to their bosom—Kenny, the perfect extra man.

For those not acquainted with his background, he was born in Detroit, attended the University of Michigan and the Rhode Island School of Design, and worked in *Vogue's* art department before joining Christian Dior and Delman, where he designed shoes. When he began adding rhinestone buckles to those shoes, he also began to think of perhaps designing jewelry, experimenting first in the early 60s with plastic bangles from the dimestore, which he covered in rhinestones, crystal, and anything else he thought clever and colorful enough to catch the eye. As his oeuvre grew and flourished so did his fame. He has won awards from Neiman Marcus, *Harper's Bazaar,* and a special one for his "outstanding contribution to fashion" from the prestigious Coty American Fashion Critics, all accolades to an artist who has held a place of honor for more than thirty years.

Perhaps his most dramatic creation was his replica of the breathtaking Van Cleef & Arpels maharani necklace, bracelets, and earrings that Aristotle Onassis gave Jackie when love was new. Kenny asked Jackie if he could copy the astonishing diamond, emerald, ruby, and sapphire parure, and she said yes. Out from the vault it came along with her diamond earrings with ruby drops, all of which she allowed him to copy for his collection. Later she said to him with that famous Jackie smile going full force, "I saw our necklace on 'Dynasty.'"

I would just like to say that I have Kenny's copy of Jackie's Indian extravaganza and wear it whenever I think a soiree is fabulous enough. Then there are those size four sample beige kid slingback pumps adorned with little rosettes. When I wore them to a dinner a few nights ago, eagle-eyed Kenny said, "My God, I designed those shoes at Delman's thirty-five years ago!" True.

So hang on to your Kennys, ladies. As you can see, I've held on to mine.

Introduction

Like a character in a Somerset Maugham novel, Kenneth Jay Lane was "born under a bluer sky" than generally shines on most of us.

Kenneth Jay Lane is the most elegant of revolutionaries in the world of costume jewelry designers. His work has an undisputed, *enduring*, playful charm in an industry that turns on fashion trends. His jewelry *gains* in popularity every year, regardless of the current clothing fad. His classic designs are coups he masterminds with every collection.

Kenneth has been in the jewelry business for more than thirty years, where he has long been king of the domain. He has another distinction as well. No jewelry designer other than the great Coco Chanel made it acceptable—if not de rigueur—to wear *fakes*. But more than Chanel, Kenneth truly made his costume jewelry a democratic experience. Audrey Hepburn, the Princess of Wales, first ladies Jacqueline Kennedy, Nancy Reagan, and Barbara Bush, and a nurse, bank teller, or airline stewardess could and did buy and wear the identical lion earrings or three-strand pearl choker. It's this versatility and accessibility that make him both an international sensation and the accessible designer displaying his wares on QVC.

What does Kenneth have that makes him unique?

Courage. Invention. A marketing genius that makes the right connections between fine design, gorgeous materials, and the women who appreciate both. When asked what makes him "Kenneth Jay Lane," Kenneth gets a bit nonplussed. He wants you to believe it has all been so easy, so graceful, this success of his, this "eye." You get the idea that he believes in magic. If so, it transformed him from an ambitious artist from Detroit into an institution. And if so, he hopes some of that magic enchants the women for whom he designs.

The best way to describe this phenomenon is to quote Kenneth's own philosophy about his work. "Every woman," Kenneth insists, "wants to be Cinderella when she puts on jewels. Faux jewelry is like wearing glass slippers. A woman can feel like she's going to the ball, even if she's not."

Like Chanel, Kenneth's designs are about *style*, not fashion. Style knows no season. It's an elusive quality that no one can buy—one has it or one doesn't. Style is intense conviction, authenticity—even a bit of gallantry. Kenneth has always had it, even as a boy in Detroit, the town he good-humouredly Frenchifies as "Day-twah."

Encouraged by his "nanny," Kenneth began drawing at

the age of four. Nanny Ann, who, as he tells it, "was also nanny to my mother and father, managed a few thousand things around the house and, herself, had a certain talent for drawing." Although he'd not yet been taken to see a film, all the very earliest Kenneth Jay Lane drawings of women turned out to bear uncanny resemblances to Mae West.

When Kenneth finally *did* see a Mae West film, she was unlike anyone he'd ever seen in life, especially the insouciant manner with which she wore quantities of diamonds—rings on nearly every finger and jeweled bracelets halfway to the elbow.

Kenneth always loved the glamour of jewelry, the razzle-dazzle of high-quality glitter and the effect it has on the women who wear the gems, real or faux. Mae West was about the fun of excess. Kenneth is about the fun of excellence, even if his pavé diamonds are crystal, his rubies and emeralds glass, and his rock crystal lucite.

If those youthful "Mae West" drawings affirm an unwitting *vision* for what was to be, then his destiny was cast. But not yet.

Following a brief flirtation with architecture at the University of Michigan, Kenneth attended the Rhode Island School of Design. He arrived in New York in the 1950s, the years when more American designers in every field were gaining celebrity. There were designers such as Bill Blass, Donald Brooks, James Galanos, and Norman Norell, and shoe designers Roger Vivier, David Evins, and Herbert and Beth Levine, all of whom he came to know. Kenneth calls these years "pre-Oscar," referring to Oscar de la Renta, the multi-talented Dominican designer.

After graduation from RISD in 1954, Kenneth moved to New York to become an art director. Kenneth had met *Vogue's* legendary art director, Alexander Liberman, when he was seventeen years old, and Liberman brought Kenneth in to *Vogue* as a layout assistant in the promotion/advertising art department of the magazine. "I quit because I couldn't sit still at a drawing board all day doing paste-ups," Kenneth recalled. "Rubber cement was my natural enemy."

Through Roger Vivier Kenneth got a job designing shoes for Genesco, which owned Delman and I. Miller shoes and Christian Dior shoes. While at Dior he created his first "collection," which consisted of jeweled accessories made exclusively for a dress designer's runway show.

As Kenneth developed his look, his inspirations shifted easily among Shah Jahan, David Webb, Fulco di Verdura, Jean Schlumberger, the British Crown jewels, the Renaissance, Marie Antoinette, and the Topkapi Museum, among others.

In the 1950s, while materials such as rhinestones and certain metals that had been unavailable during the war years were once again accessible for making costume jewelry, it took the "Youthquake" of the 1960s to change that industry. Fashion was changing. The wrist corsage, the waist cincher, and the circle pin were of another age. Clothing styles became shorter and looser. Rudi Gurnreich shocked the world with his topless swimsuit. Paco Rabanne dared to make dresses out of nonfabric materials, such as plastic or metal paillettes, strung together checkerboard fashion. Hair was short, geometric, and gamine or sophisticated and towering in the novelty hairdo of the day, the beehive.

It was in this "swinging 60s" changing environment that the egg cracked and out came a full grown Kenneth Jay Lane. Both short and upswept hairdos called for

long, dramatic earrings, and Kenneth was there to deliver the glittering prizes to fashionable women. Geraldine Stutz, herself a legendary figure in fashion merchandising, and at the time the president of Henri Bendel's, saw in which direction his jewelry designs were heading and loved it. Soon he was featured on the main floor of the store.

"In the early 1960s, Bendel's customers were hip. They liked the avant-garde, but nothing too obvious," Geraldine told me. "Kenny's stuff had an extraordinary quality—wit and humor. He is a true talent. He made 'frankly fake' very chic."

The 1960s also spawned a rise in popularity of ethnic jewelry—especially big and bold east Indian designs. Kenneth did his own spin on the Indian look. Psychedelia, the products and by-products of the Hippie movement, also influenced Kenneth in its one important theme for him—brilliant color used in unexpected combinations, such as fuschia and coral, topaz and turquoise, sapphire and amethyst. Kenneth's metier is incredible color! Since plastics manufacturers could make fabulously saturated color "stones" at his request, Kenneth designed entire collections known for their color as much as for their design concept.

Everything, including costume jewelry, became bigger, brighter, and more noticeable during these years. Kenneth fit right in; he did costume jewelry better, he had or found the right connections, and everything he did was publicized in all the magazines. Kenneth says he "fell into it" without any technical know-how, but he had the style and the intuitive fashion sense to do it all—and it was done right!

I first saw Kenneth in person in the early 1970s while vacationing in Puerta Vallarta, a Mexican resort town that was popular with jet-setters, artists, West Coast movie bigwigs, and vacationers from everywhere. Kenneth stood out among them all, generating excitement. He was then, as he remains now, the best-known name in costume jewelry—and a man with a presence.

I recognized his almost Hollywood-handsome face—the very dark eyes, the cleft chin—because I'd seen it often in the papers. I'd always had a strong interest in fashion, having been weaned on my retailer parents' copies of *Women's Wear Daily*. I began buying Kenneth's innovative bold jewelry in the late 1960s, when I moved to New York. Paraphernalia, the "Mod" shop next to Vidal Sassoon on Madison Avenue, Abracadabra, with it's one-of-a-kind creations, and Henri Bendel embodied the 1960s fashion explosion that existed only in New York and London.

Twenty years later, when I was researching my first book on costume jewelry, Kenneth was the designer I wanted most to interview. By then, he was a legendary personage who'd transcended his business, his trademark wares, and his art, becoming in the process as familiar in palaces as in shopping malls. We spoke at length, and he regaled me with many stories of jewels, jewelers, and the bejeweled. I was further charmed by *how* he talks about his art, his business and his life—he's waggish, *soigne*, and totally at ease with the world, like a British squire entertaining friends for the weekend.

By the late 1960s, Kenneth's pieces were collected and worn by jewelry fanciers all over the world. He is still creating new collections and revitalizing favorite themes, such as animal patterned jewelry and the traditional strand of society pearls.

Over the past ten years, I've been immersed in the world of costume jewelry—researching, writing, buying

and selling, consulting, curating, appraising, and wearing it. Whether I'm wearing one of Kenneth's dazzling "K.J.L." vintage crystal bib necklaces or discovering one of his 1960s jeweled animal bracelets or magnificent Renaissance figural pins at an antique sale, the thrill is always there for me.

Talking about his work and the source of his inspirations, Kenneth once said to me, "I myself am a fabulous fake." This is not so facile an admission nor simple an explanation. Kenneth is, of course, referring to the fact that existing objects of every sort—from one dollar kitschy knick-knacks to the interior of Jodhpur palace—may influence his next piece of jewelry.

If he's done some culling and gleaning, then Kenneth's influences have been the best in design over the last few thousand years of art, artistry, and artifacts. His eye is almost unfailingly right. He can spot something spectacular, whether from a tomb in ancient Egypt or from the window of Cartier, and know how to adapt all or part of the design to make a piece indelibly his. He doesn't take a picture of what's influenced him, but holds an impression of it, then goes back to his studio and plays around with stones and setting ideas until he gets something that's close to what he saw, yet *different*.

The result will be a piece of jewelry that women will want to own and wear now, as well as for years to come.

In this book, Kenneth talks to me about his work and reveals the fascinating stories about the women who buy and wear it, his far-flung travels, his inspirations, and some amusing anecdotes along the way, such as when the moving sidewalk that takes tourists past the British Crown jewels in the Tower of London was stopped for him at closing time by his friend Princess Margaret, so he could press his nose to the glass cases.

Kenneth's jewelry represents the many facets of his personality—intelligence, humor, irreverence, a sense of history, respect for other designers, and a marvelous way of creating jewelry that makes a woman look and feel wonderful.

Most of all, he says, "It's about dressing up and having a good time."

HARRICE SIMONS MILLER
Fall 1995, New York City

My Introduction

Drawing by Antonio. Collection Kenneth Jay Lane

When I had my first ideas about making costume jewelry I wasn't at all sure that it would be my life's career. As it turned out, I was fortunate to become successful quickly and my things were, rather immediately, worn by many of the world's most fashionable women. Voilà, I was a jeweler.

Fortunately, I never dread going to my office. I really enjoy what I do and get an enormous thrill when a sample that I've been working on, sometimes for as long as a year, finally emerges in a state of perfection. I can't imagine what it would be like to be a dentist or an accountant. The satisfaction I get out of creating things and seeing them worn by women is as great as the gratification I get from any other aspect of my life.

Like so many thoughts and ideas that disappear if they're not written down, I thought it would be interesting to make a record of some of the results of my creative efforts, hence, this book. It's been very difficult to make a selection from all the thousands and thousands of different things I've created over the years since I began in 1962. Perhaps this will be only volume one of an encyclopedic series, since I have no plans to stop creating or to stop working. I expect another several thousand earrings, brooches, bracelets, et cetera, will be born in the not-too-distant future.

KENNETH JAY LANE
Fall 1995

Kenneth Jay Lane in his showroom, 1966. Photo, *Women's Wear Daily,* March 29, 1966

Posing for publicity and obviously proud of my photo credits. I wore that hounds-tooth jacket for about twenty-five years, but eventually had to have it copied— exactly. Classics never go out of style!

Rhode Island School of Design yearbook, 1954

Typical graduation picture!

14

THE EGG CRACKS

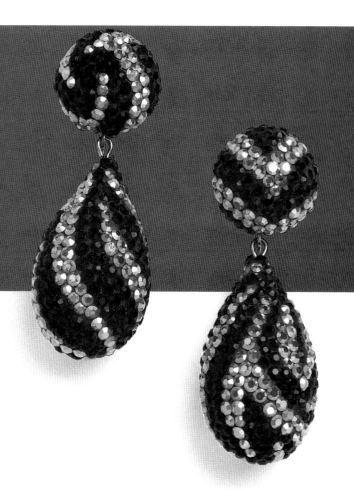

W hen I began designing jewelry, I was the fool that rushed in. I made my own rules. I didn't know what was commercial or what had already been done. I just did what I liked, and I really didn't know much, if anything, about manufacturing costume jewelry.

I fell into jewelry—I didn't head for it. Diana Vreeland, whom I knew well, was the fashion editor of *Harper's Bazaar*. She told me that the Hattie Carnegie company was looking for a jewelry designer and that I must go see them, at her recommendation. Her office made the appointment and I did some sketches. I must say I didn't stay up nights working on a brilliant portfolio. They were not at *all* impressed.

About two or three years later, I began designing my own collection—it was 1962, to be exact. My tiny new company was soon bought by Hattie Carnegie and I was made their design director—but I'll get to that story shortly.

Before this, in the early 1960s, I was design director for Christian Dior shoes and worked in association with Roger Vivier, who was based in Paris. I kept Roger's designs close to the original—very European in idea—and filled in with designs of my own, particularly ideas

ZEBRA-PATTERNED EARRINGS. 1962–63. Pavé silver and jet flat-back stones over compressed cotton. Collection Chessy Rayner

I hate to think of what these earrings would cost to make today. I simply couldn't afford to use such tiny stones. Gloria Bragiotti Etting, who is a very young eighty-six years, has been wearing the gold-and-jet version for 30 years. The first time I saw her wearing them was at her beach house in Loveladies Harbor, New Jersey, when she was wearing a leopard-patterned bathing suit while opening clams.

This pair occasionally come out of Chessy Rayner's closet, and considering that Chessy is in the International Best Dressed Hall of Fame, it's more than a little satisfying to me.

Diana Vreeland and Dick Avedon were sitting a few tables away on the opposite side of banquettes at the entrance of La Caravelle—the chic place to sit in the chicest place to lunch in town. I couldn't understand why they were staring at me until later that day D.V. called and asked me if I'd pose with Halston, who was then making hats at Bergdorf's, for the cover of *Bazaar*. Of course I said yes, but asked her why she had chosen me. Halston had a name, but although I was quite proud of the shoes I designed, they were under the Dior label. Her answer was simple, "Ken, you've got the straightest part in New York City."

In Paris, c. 1959

My small room at the Hotel St. Regis around the corner from Dior, with a terrace and a great view, cost something like $10 a day in 1959. It was really a maid's room with a sink for shaving and bath down the hall. But delicious coffee, juice, and croissants were served to me in bed and the hotel maid ran my bath. I was the only guest on the top floor. When one is young and on the way up, a little "roughing it" is OK.

With David Evins, early 1960s

David Evins was the King of Shoe Biz in the United States. He was so grand that he even smoked in stores when he was doing a personal appearance. *That* inspired me.

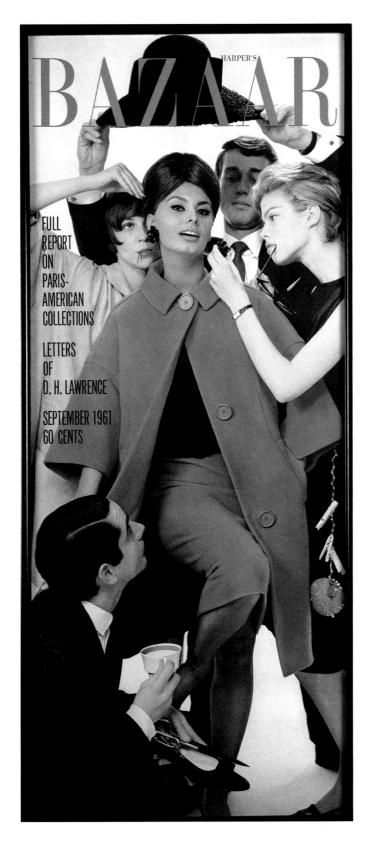

HARPER'S BAZAAR

FULL REPORT ON PARIS-AMERICAN COLLECTIONS

LETTERS OF D. H. LAWRENCE

SEPTEMBER 1961 60 CENTS

that were uniquely American. My leopard silk shoes on a stacked leather low heel were featured in *The New York Times Sunday Fashion Supplement.*

I was offered a job at Dior in Paris by Roger to study with him, and of course I accepted. I never considered how I'd be paid or how I'd live—I just thought how marvelous it would be in Paris. When I announced to Maxey Jarman, the chairman of Genesco, that I'd be going to Paris to live, he suggested I stay on their payroll and work six months there, six months in New York. I did that for a year. The next year, the schedule changed to four months in Paris, then the next, I was there for only two and a half months.

Those *were* marvelous years! Not only was I a young kid, I had a corporate American Express card and was able to pay my own way and even take rich, fancy new friends out to dinner. I lived at the top of the Hotel St. Regis with a view of the Eiffel Tower. I was very, very fortunate.

By 1961, I had more responsibility in the New York office. I also began designing shoes for various designer friends, to be worn by runway models at their fashion shows. Bill Blass and I started a collection of Bill Blass shoes, made at the I. Miller factory. I also designed shoes for Norman Norell, who had brilliant ideas. The backs of American-made shoes were much too high, he thought, and he lowered them to fit more like European and custom-made shoes.

Arnold Scaasi had become an important designer at about this time. Scaasi Couture was located in a townhouse in the West 50s. Arnold designed jazzy showstoppers and I did showstopper shoes for his collection, with "diamond" toes and heels or shoes that were completely jeweled. I suggested making jeweled buttons to match the shoes, and even matching earrings and bangle bracelets, which Arnold thought was a good idea! We used simple shapes for earrings—drops, balls, buttons— and bangle bracelets in solid colors—all crystal, jet, sapphire, ruby, et cetera. I went to Lamston's five-and-

ten and bought plastic bracelets and had them jeweled by the same people who adorned the shoes. I used hard cotton forms—the cores of artificial fruits—which were very light, and I covered them entirely with flat-backed rhinestones and made earrings out of them. They were shown with the collection and looked very snappy.

I gave Arnold the opportunity to add these designs to his own jewelry collection, which was licensed to a firm called Accessocraft, but the owners didn't think they were commercial enough. A good idea is the hardest thing to give away.

However, *The New York Times* thought my stuff for Scaasi was interesting and wanted to do a story on it. I had lunch with a wonderful editor named Patricia Peterson, who wrote about my jewelry. She needed to tell her readers where they could buy it, so since I was working for Genesco, which owned Dior shoes and Bonwit Teller, I called Gloria Fiori, their jewelry buyer. She had the best jewelry department in New York, due to her wonderful eye. She thought my earrings were amusing and different and bought six pairs. They sold out in three minutes, so she placed a larger order and they sold like mad. Years later, Gloria went to work for Avon, and for about ten years I did a collection for them.

Other **inspirations** came out of the **shoe biz**. I went to the factory one day and the thought hit me, "Why not skins?" Inspired by the way shoe heels are covered with leather, I saw how the process could work for covering plastic bracelets. By then, I had ordered enough bracelets from Lamston's that they had given me the carton, which had the name of the manufacturer from Providence, Rhode Island, stamped on it. After that, I was able to buy my bracelets directly from the factory in quantity and much less expensively.

By 1962, I started having my bracelets covered in cobra, lizard, and even alligator skin in marvelous colors. I'd buy scraps of baby alligator from David Evins's factory and have them covered by the same people who

INDO-PERSIAN-MOGUL-INSPIRED EARRINGS. 1962–63. DROP EARRINGS. Glass turquoise and ruby flat-back cabochons, pearls, jonquils, diamonds; BUTTON EARRING. Glass faceted turquoise and ruby flat-back stones, plastic moonstone cabochon center, both with compressed cotton bases.

This sort of Persian-patterned pavé was the style that Helena Rubinstein most liked of my rings.

VARIOUS EARRINGS. 1962–63. (Clockwise, from top right) Sapphire flat-back stones, plastic hoops; Pavé diamonds over compressed cotton button, hollow glass white pearl with flat-back diamonds; Pavé bronze flat-back stones over compressed cotton button, hollow glass white pearl with graduated bronze stones; Mosaic-patterned pavé emeralds, diamonds, light topaz, and topaz flat-back stones over compressed cotton

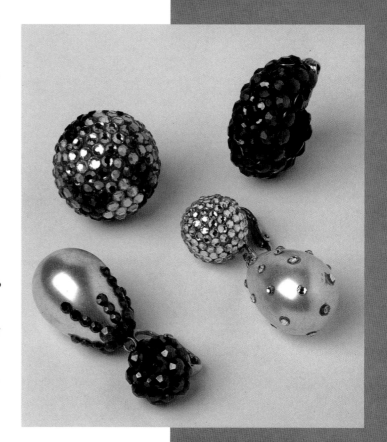

These earrings, with flat-back stones cascading down the pear-shaped pearl, were a great success and I made them in a great variety of colors. Sister Parish, the doyenne of American interior decorators and a great friend, owned them with jets flowing onto white pearls. She wore them *very* often, which was great. However, I think she wore them swimming in the cold salty waters of the state of Maine, where she summered, and the earrings became worse for wear. I had a new pair made for her as a gift— and also to save my reputation—but she would appear wearing the originals, minus many jet stones. I presented her with another pair, thinking perhaps that the new earrings had been baptized as well. To no avail, the practically bald originals appeared again and again and again. I gave up.

I was able to get a bit of my own back when one day, years later, Sister appeared at my house for lunch wearing a straw white hunter's hat with a wide fake leopard band. "Hello, white mischief darling!" I exclaimed.

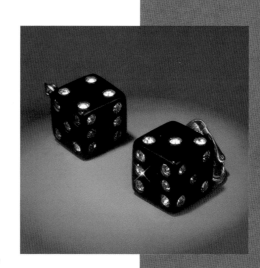

DICE EARRINGS. 1963–64. Plastic dice drilled and studded with diamonds, gold-plated brass ear clips

Not knowing how to make jewelry professionally, I used any ideas that came into my head. This wasn't one of the worst.

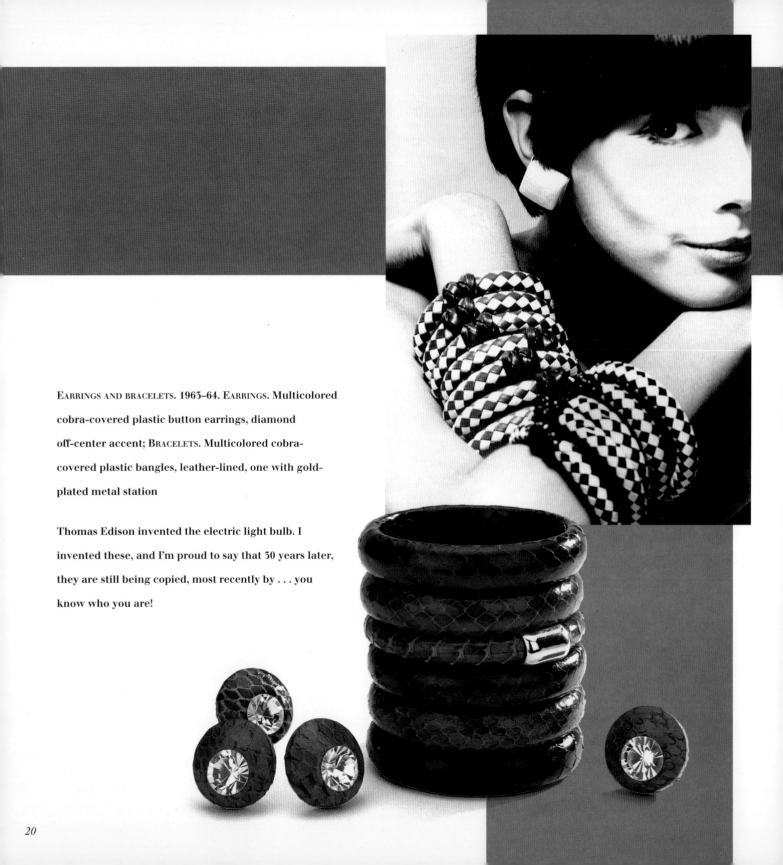

EARRINGS AND BRACELETS. 1963–64. EARRINGS. Multicolored cobra-covered plastic button earrings, diamond off-center accent; BRACELETS. Multicolored cobra-covered plastic bangles, leather-lined, one with gold-plated metal station

Thomas Edison invented the electric light bulb. I invented these, and I'm proud to say that 30 years later, they are still being copied, most recently by . . . you know who you are!

covered heels for the industry. Bill Blass showed these skin bracelets with his collection and sold them out of his showroom! They were worn piled on, mixed in all those wonderful colors, which picked up the various shades of the yarn in the tweed suits he was showing.

At the time I knew so little about merchandising that I went to Geraldine Stutz, who was then the president of Henri Bendel. The store was already selling my earrings, and Gerry loved the bangles. I let Bendel's have an exclusive on the bracelets. That was April. By the June market, everyone had copied them. But that was all right—I was having fun!

I made other pieces using cobra stripping, woven in and out of rhinestone chains, like the Chanel handbag chains. My first things were non-jewelry jewelry. They weren't cast or soldered. I didn't know anything about working with metals. I was just doing gimmicky things that caught on wildly.

I went with my bag of tricks to see all the jewelry buyers, even though I knew most of the store presidents through working with Genesco. Within a month, I was in almost every store on Fifth Avenue in New York, as well as Neiman Marcus, I. Magnin, and Bullock's Wilshire in

California. Saks Fifth Avenue was the only store I didn't sell. I could never reach the buyer on the phone.

Laura Johnson, who was married to Ray Johnson (he was vice president of Saks at the time), ordered some shoes I had done for Christian Dior. They were my interpretations of Roger Vivier's designs. Of course, Laura wasn't allowed to shop at Bonwit's, where the Dior shoe collection was sold, so we had a big secret together. When she called to see if the shoes were ready—and they were—she invited me for dinner that night. I broke whatever engagement I had and dined with her and her husband at the Colony.

As we chatted, I mentioned that I was designing jewelry, and when Ray asked me where it was sold, I told him—Bonwit Teller, Henri Bendel, Bergdorf Goodman, Tailored Woman, B. Altman, Macy's Little Shop, DePinna, and Best & Company. When he asked why not Saks, I told him his buyer must be very busy because I could never get him on the phone. Their buyer called me the next day. Ultimately, Saks became my biggest account.

I had my job designing shoes, and I wasn't really sure if I was going into jewelry designing as a serious profession. I was still working for Genesco at Dior, with an office at the Crown Building on Fifty-seventh Street and

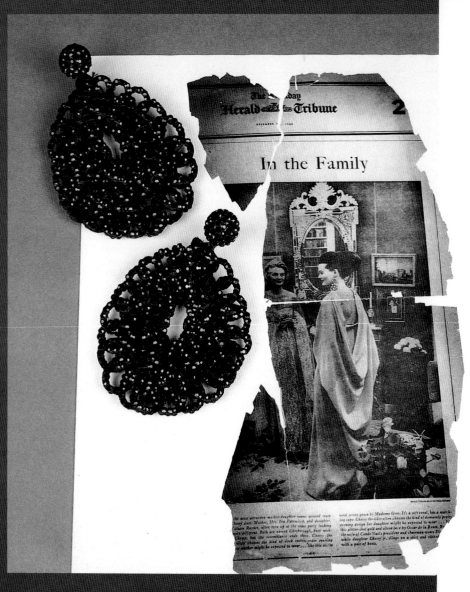

In the Family

Chessy Rayner wearing black shoulder-length earrings,
Herald Tribune, December 1963
FLAMENCO-INSPIRED EARRINGS. 1962–63. Jet flat-back
stones over compressed cotton button, hand-crocheted
double-sided pendant. Collection Chessy Rayner

One cannot make earrings like this any more, nor do
they make girls like Chessy. Where did I find someone
to crochet them? My grandmother crocheted hanger
covers (which I still use), but she was dead.

Kenneth Jay Lane at
Rockefeller Center

Even my mother might have
been proud of me. How many
young men from the Middle West
have the opportunity to make a
spectacle of themselves in the
middle of Manhattan?

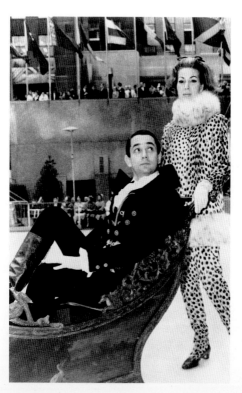

Fifth Avenue. My jewelry office was in the Elizabeth Arden Building at Fifty-fourth Street and Fifth Avenue. If the person who worked for me there as an assistant (and who also pasted stones onto plastic or cotton) called and said a buyer had arrived, I'd excuse myself even if I were in a meeting, hint that I was going to the loo, run down the street, and arrive in a sweat at my other office. That was the summer of 1962.

Oscar de la Renta had begun working for Elizabeth Arden and occasionally we'd be in the elevator at the same time. We'd check out each other's tailoring, but we didn't know who the other was. We met shortly after that and became lifelong friends.

Soon I was working eighteen hours a day. Eventually, when I was receiving larger checks from Genesco by selling my jewelry to the stores they owned—Henri Bendel, Bonwit Teller, Gidding-Jenny in Cincinnati—Genesco and I decided to part company. Jewelry was becoming a commercial venture for me. I started the whole thing very casually, and it mushroomed. I was very fortunate.

A good friend of mine, Patrick O'Higgins, was Helena Rubinstein's right-hand man at the time. He wrote a best-selling book about her called *Madame* after she died. Patrick thought she'd be amused with my faux jewelry since she was known for her real stuff, especially rings. I brought up my plastic-based pavé rhinestone rings, which were five dollars a piece wholesale. "Madame" looked them over and said, "So much? So *much*?" I said, "Okay, for you, four bucks." She bought dozens of them and gave them as gifts to all the right people in Europe. I had made a good investment!

Months after I began designing jewelry, it was getting written up in the fashion columns of the newspapers. There were so many more papers in New York then; besides *The New York Times*, *The Post*, and *The Daily News*, there were *The Journal American* and *The Herald Tribune*. A few years later, Eugenia Sheppard, the *Tribune's* great fashion editor, printed a photograph of socialite Chessy Rayner wearing my new diamanté shoulder-duster earrings, which she had actually suggested I make. Chessy had been a *Vogue* editor, and had and still has a great sense of style. She thought that earrings draped against bare shoulders would be wonderful to wear with strapless dresses, rather than necklaces. It worked. The next day they were in the window of Saks Fifth Avenue. Things don't happen that quickly today.

Saks Fifth Avenue has been my greatest supporter since the beginning. After Eugenia wrote an article about the Duchess of Windsor wearing my jewelry, Adam Gimbel, then president of Saks, called and asked me to lunch. I was rather amused that Saks was more impressed by what the Duchess was wearing than by the quantity of jewelry I was selling up and down Fifth Avenue.

Saks asked me if they could use my name exclusively. I called my stuff "K.J.L." for other stores and "Kenneth Jay Lane" for Saks. For years, Saks advertised me as "Our Own Kenneth Lane." It got more than a little complicated because one can't control stores' advertising. So that changed over time.

I've always been quite practical, and I found a good way to kill two birds with one stone—saving a bit of money and having a good time. The designer Mary McFadden was having a "Come as Your Favorite Dream Party" at her mother's house on Sixty-fourth Street. The same day, Saks Fifth Avenue wanted me to wear something amusing in their promotional tableau that was taking place in the skating rink at Rockefeller Center—they wanted me to come in on a sleigh, looking like a prince from a fairy tale.

I made a deal with Saks to pay for the rental of my costume and got myself up as Ludwig of Bavaria, in black

velvet and gold braid. It was quite fun to be led out on a beautifully decorated sleigh by several lovely models wearing ice skates in the middle of Rockefeller Center where crowds of hundreds, if not thousands, were applauding.

At that point—since my exposure was not quite what it is today—the onlookers were probably all saying, "Who the hell is that?" Saks was very pleased with the promotion and the costume was also a great success at Mary's party. Many of the costumes at that party were quite extraordinary, particularly Doris Stein's, the wife of Jules Stein, the founder of the Music Corporation of America. Doris, who wasn't young at the time, had on the longest false eyelashes in the world and a blond wig, dressed as a kind of "Irma La Douce." The only mishap that evening was when I got home I couldn't pull my boots off. I'd been dancing all evening in a room that was fairly warm, and the boots wouldn't budge off my feet. I had to sleep in them until morning.

About the same time, the Hattie Carnegie organization, which had been one of the great names in fashion when Miss Carnegie was alive, called and wanted me to do a jewelry collection for them. By this time, the company had been sold and it was a whole different ball game.

Years before, under Hattie Carnegie's supervision, their costume jewelry had been quite good. After talking *at* them for about two hours, I ended up telling them that what they *really* needed was Miss Carnegie back on this earth, since they still had a couture division, a fragrance, accessories, and a shop at Forty-ninth Street and Madison Avenue. They asked me if I would be "Miss Carnegie"! So I took the position of design director of the entire Hattie Carnegie Company. Ironically, I became very involved with their jewelry division and met all the people who had factories in Providence and New York.

Larry Joseph, who headed Hattie Carnegie costume jewelry, was a very difficult, tough guy who taught me a great deal. He was the first person to take me to Providence to see the factories and teach me about jewelry-making—from casting to enameling and everything in between. Larry and I fought like mad, but I think we respected each other. Working with Hattie Carnegie was really my education for producing jewelry and learning all the aspects of manufacturing.

Part of my arrangement with Hattie Carnegie was that I was allowed to run KJL as a separate division, still producing my unique pavé earrings and bracelets and the cobra-covered bangles. My marriage to Hattie Carnegie lasted for only eight months. I was doing all I could to get "the ladies" in the front door of the store, including having Billy Baldwin, the chicest decorator in New York at that point, do a "few little things" to the Carnegie shop. I knew Billy's work would produce quite a bit of publicity, since he had never done a shop before. Then I found out that the building had been sold by the accounting firm that owned it, along with the name Hattie Carnegie. They were bringing in racks of "whatever" for a huge going-out-of-business sale they were planning. It was merchandise that had never *seen* Hattie Carnegie before, and the sort of clothing that Miss Carnegie, when she was alive, had never dreamt of, even in her worst nightmare.

When I divorced Hattie Carnegie—it's hard to imagine now—but poor little me had to bail myself out financially. I rented two small rooms in the back of the soon-to-be-defunct shop and worked there for a few months before moving into my own space at 26 East Thirty-eighth Street, which was my first independent showroom. It was a small one-room studio apartment with a kitchen and bathroom.

And that's how jazz was born!

Coro, one of the largest and most established manufacturers of costume jewelry, asked me to design for them on a freelance basis, while I was doing my own col-

lections. Of course, they never used a single idea I gave them! We had an arrangement that I would visit them one hour each week. Usually the people I was supposed to see were in a meeting, so I spent many enjoyable hours having coffee with the chairman's son-in-law, who was on the staff.

I worked for Coro twice, both before and after my stint with Hattie Carnegie. The second time around I changed the rules. I was much better known by then and didn't want to risk being seen at the Coro offices, so we agreed that when we had a meeting, they'd come to see me.

One day, Mike Tancer, Coro's president, who later worked for me after Coro was bought by the Richton conglomerate (which also bought Oscar de la Renta), and their chairman, Mr. Rosenberg, met with me at my very small showroom on East Thirty-eighth Street. Soon after they'd arrived, I happened to glance out and saw, through the large window that looked out onto the street, the Bloomingdale's buyer arriving at the building, unexpected and unannounced. I quickly hid the Coro executives behind a screen in the kitchen area. It was a bit like a French farce! They had to wait there until the buyer turned her back so they could sneak out.

When I started making large earrings in the 1960s, I decided to buy a small factory from a very sweet old guy who was retiring. The factory, which was in Providence, consisted of a few benches, six soldering torches, and six greatly skilled workers. The foreman, Mel, was adorable and knew everything about making jewelry. I offered her fifty percent of the business, which she bought into slowly. The deal also enabled her to buy a company car. I was amazed when I arrived in Providence and saw she'd bought a white Cadillac with "K.J.L." on the Rhode Island license plates. At the time I had a Rolls Royce in New York City bearing the same initials.

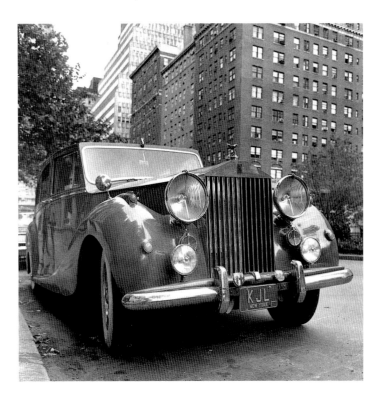

Rolls Royce with KJL license plate. Photo, Pierre Venant, *Women's Wear Daily*, October 31, 1969. Hooper magnesium body, c. 1954

The first day this car arrived in front of my house with Freddie at the wheel, I got in—and out—because it would move only in reverse. Soon afterward the right rear door wouldn't shut and it had to be secured with red cotton workmen's handkerchiefs. So for a while I could accept dinners only on Fifth Avenue. On Park Avenue and side streets, one must exit through the right side door; on Fifth Avenue, one leaves the car from the left.

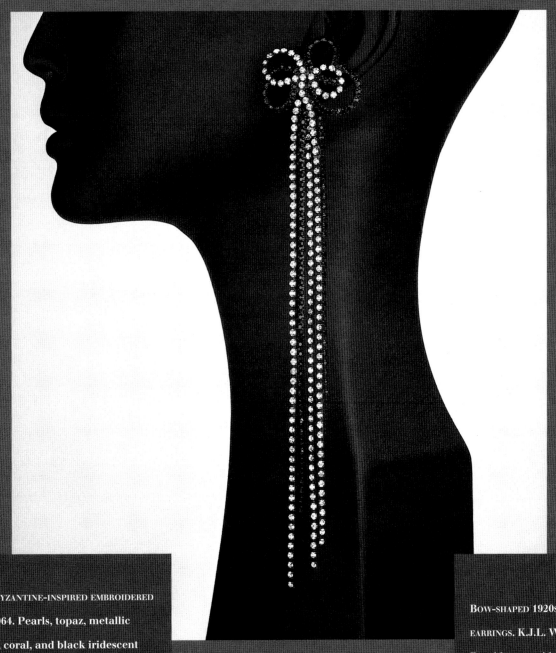

Opposite: BYZANTINE-INSPIRED EMBROIDERED EARRINGS. 1964. Pearls, topaz, metallic gold, white, coral, and black iridescent beads, faceted glass topaz, amethysts, sapphires, rubies, gold bead and pearl fringe, 5" long. Stamped K.J.L. Collection Harrice Simons Miller

BOW-SHAPED 1920S-INSPIRED EARRINGS. K.J.L. Workshop, Providence, mid-1960s. Hand-soldered, black-plated jet and diamond brass chain. Stamped K.J.L.

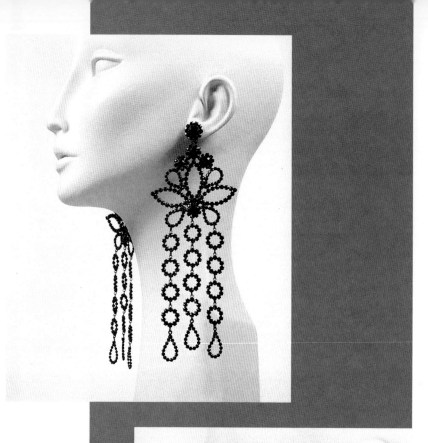

SPANISH 17TH-CENTURY-INSPIRED EAR-
RINGS. Jacques Workshop, NYC, for
K.J.L., mid-1960s. Jet stones, flexible
hand-soldered black-plated brass
mountings. Collection Constance
Emmerich

These same earrings, in rhodium,
were worn by Edie Sedgwick in a
1965 photograph in *Life* magazine.
Edie was a 1960s phenomenon out
of the Social Register, Stockbridge,
Mass., and Andy Warhol's "factory."
The photo appeared in *Edie*, by
Jean Stein and George Plimpton.

SPANISH 17TH-CENTURY-INSPIRED EARRING.
Jacques Workshop, NYC, for K.J.L.,
mid-1960s. Jet stones, faceted jet bead
fringe, hand-soldered, black-plated
brass mountings. Stamped K.J.L.

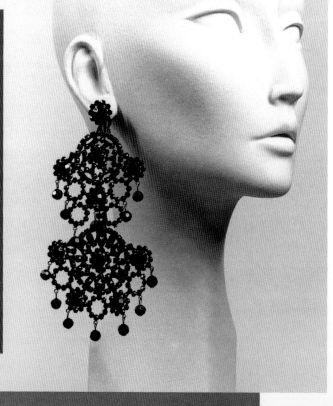

There were marvelous plastic manufacturers operating in those years, which aren't in business today. One of them stopped making stones and went into making plastic bottle tops; another turned exclusively to billiard balls. But when I dealt with these factories, I bought "stones" in wonderful shapes and colors—perhaps sixty different hues—in not-huge quantities at not-huge prices.

I combined extraordinary colors, and since the stones were made of plastic, they weren't heavy and I could make very large earrings. They caught on like a house afire. Women even wore them to the supermarket. I also made earrings using peacock feathers and iridescent beetle bodies I'd buy in the trimming market. I made wonderful embroidered earrings and had to hire embroiderers to do them. These can't be done today because the price would be unbelievable.

I've always thought that great **jewelry is art** that becomes reality when worn by people. On any given day at East Thirty-eighth Street could be seen perhaps Audrey Hepburn, Babe Paley, three fashion editors, a relative of mine, four women friends and their mothers, five messengers running in and out at high speed, Andy Warhol and some of his entourage from the Velvet Underground, and a number of husbands buying gifts for their girlfriends.

Even though the volume of my business was very modest, to say the least, the society columns gave me tons of publicity and reported on who was wearing my jewelry. D. D. Ryan was one of the first, along with Chessy Rayner, Mica Ertegun, Baby Jane Holzer, Babe Paley, Mary Sargent Ladd d'Anglejan, and all the chic ladies and young fashionables of New York.

A cover of *Vogue* magazine in 1965 featured a pair of my gold hand-crocheted earrings that were completely covered in stones, so tiny they looked like diamond lace. My philosophy was that jewelry should be fun! Earrings aren't meant to keep a woman's ears warm, they should sparkle and light up her face. These did. Some of my first "lacy crystal" earrings are still worn today by Beatrice Santo Domingo, who is in the Hall of Fame of the Best Dressed List, when she isn't wearing her wonderful precious jewelry by JAR. (Joel Rosenthal, who *is* JAR, is one of the most innovative and talented designers of precious jewelry in the world today.)

I must tell you that my huge earrings were not marvelous on everyone. There was one quite fashionable woman in New York, Evie Backer, who Truman Capote nicknamed "Tiny Malice," after the Albee play *Tiny Alice*. Evie was extremely petite and was always dying to wear my long earrings. She looked ghastly in them and I told her so very candidly. She was always furious with me but she'd invariably turn up in another pair.

Wonderful Elsie Woodward, Mrs. William Woodward, a great doyenne of New York society, once complained to me that she couldn't wear my earrings because they were too heavy. I told her that she *shouldn't* wear my earrings because she was too old. When I saw her a week later at a party, she was wearing an *enormous* pair. She told me she had found the solution to keeping them on: spirit gum!

One of my **first attempts** at making jewelry not based on plastic from Lamston's was using real shells. Of course Verdura used natural shells before me, mounting them with diamonds, turquoise, and other jewels. I was fortunate enough to see these pieces on the many women who prized and wore them—much before color photographs of these pieces were featured in magazines.

My supply of pretty shells came from a shell shop on Third Avenue, very convenient to my townhouse. I bought lion's paw and exotic purple and orange shells, scallop shells, and wonderful Cuban tree snails. In order to keep the price down, I not only bought shells, I started to collect scallop shells on the beaches of Cape Cod.

Shell forms cast in resin look quite like Verdura's originals. Ward Landrigan, who bought the Verdura name

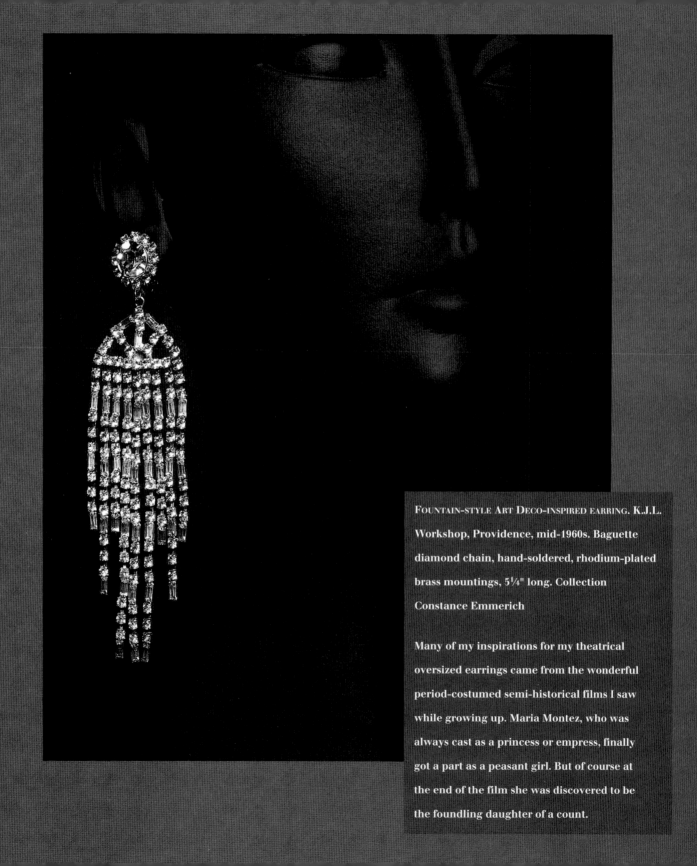

FOUNTAIN-STYLE ART DECO-INSPIRED EARRING. K.J.L. Workshop, Providence, mid-1960s. Baguette diamond chain, hand-soldered, rhodium-plated brass mountings, 5¼" long. Collection Constance Emmerich

Many of my inspirations for my theatrical oversized earrings came from the wonderful period-costumed semi-historical films I saw while growing up. Maria Montez, who was always cast as a princess or empress, finally got a part as a peasant girl. But of course at the end of the film she was discovered to be the foundling daughter of a count.

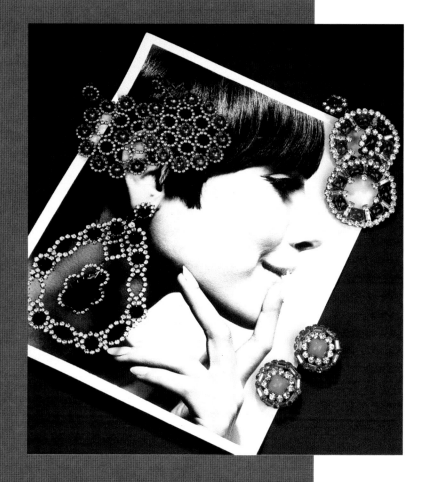

VARIOUS EARRINGS. K.J.L. Workshop, Providence, mid-1960s. Each: hand-soldered, antique gold-plated brass mountings. The Grace Collection. (Clockwise, from top right) DOUGHNUT EARRING. Plastic ruby, amethyst, and emerald cabochons, round and baguette diamonds. Stamped K.J.L.; Plastic turquoise sugar-loaf cabochons, foiled baguette pink sapphires, diamonds. Stamped K.J.L.; Plastic pink sapphire and peridot cabochons, diamond-set brass findings. Stamped K.J.L.

In the 1960s the late great songwriter Sammy Kahn dubbed me "Charlie Earrings," although he never used me in his lyrics.

EARRINGS. Each: gold-plated brass mountings.(Right) 1980s, after a mid-1960s Kenneth Jay Lane original. Unfoiled German glass rubies, turquoise-set chain, diamonds, pearls. Stamped Kenneth Lane; (center) K.J.L. Workshop, Providence, mid-1960s. Foiled glass peridots and diamonds, plastic amethyst cabochons. Stamped K.J.L.; (left) K.J.L. Workshop, Providence, mid-1960s. Unfoiled German glass rubies and sapphires, hand-soldered mounted diamonds. Stamped K.J.L.

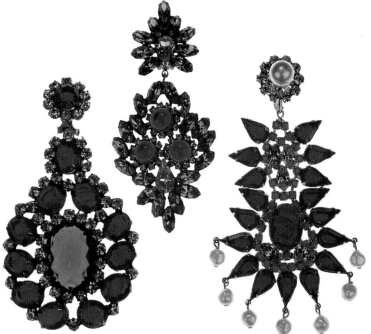

Mica Ertegun, 1966. Photo, Horst

Mica, here looking a bit like the Empress Theodora, is the product of a long line of noble Byzantine Greeks who migrated to, and eventually ruled, Romania. These earrings of mine that she is wearing could very well have been available in 8th-century Constantinople, long before I designed them in 1965. This photograph was sent Federal Express from Bucharest by Mica's mother, and arrived just in time to appear in this book.

Veruschka, *Vogue* cover, May 1965. Photo, Irving Penn

These hand-crocheted earrings, the "Rose White" of the jet ones still worn by Chessy Rayner, were made of gold metallic yarn and encrusted with tiny diamonds.

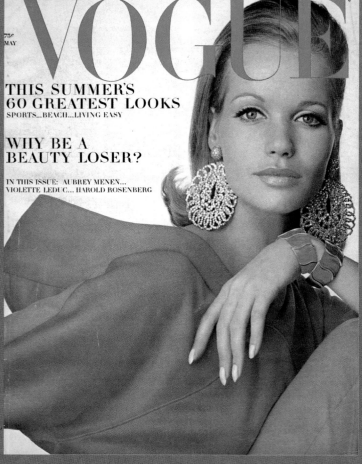

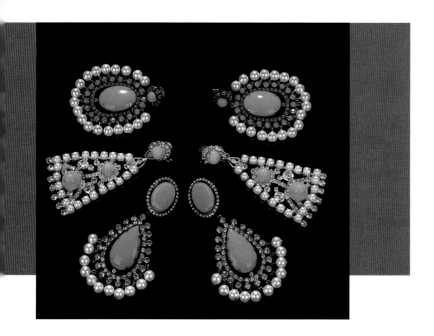

TURQUOISE EARRINGS. Each: hand-soldered, brass mountings. (Top) K.J.L. Workshop, Providence, mid-1960s. Plastic turquoise cabochons, chrysoprase chain, faceted coral, hand-soldered, antique gold plating. Stamped K.J.L. Collection Terry Rodgers; (middle) Mid-1960s. Plastic turquoise high-domed cabochons, hand-set pearls, diamond chain, hand-soldered, gold plating, 4¼" long. Stamped K.J.L. The Grace Collection; (bottom) K.J.L. Workshop, Providence, mid-1960s. Plastic turquoise, jonquils, diamond chain, plastic pearl fringe, antique silver plating. Stamped K.J.L. The Grace Collection

SPANISH FLAMENCO-INSPIRED EARRINGS. K.J.L. Workshop, Providence, mid-1960s. Hand-soldered diamond chain, antique silver-plated brass mountings. Stamped K.J.L. Collection Constance Emmerich

This earring became so popular in the early 1960s that in order to insure production I bought a small "factory" in Providence. The first sample I made myself, arranging the rhinestone chain in clay—the kind young children use for arts and crafts—stone side down, and soldering the back to stiffen it. To my delight, Beatrice Santo Domingo, another friend in the International Best Dressed Hall of Fame, wears them today with great panache.

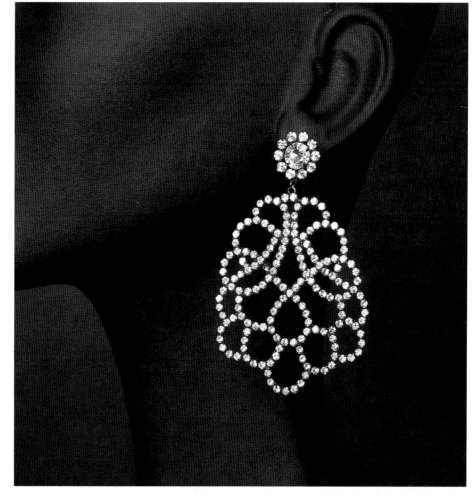

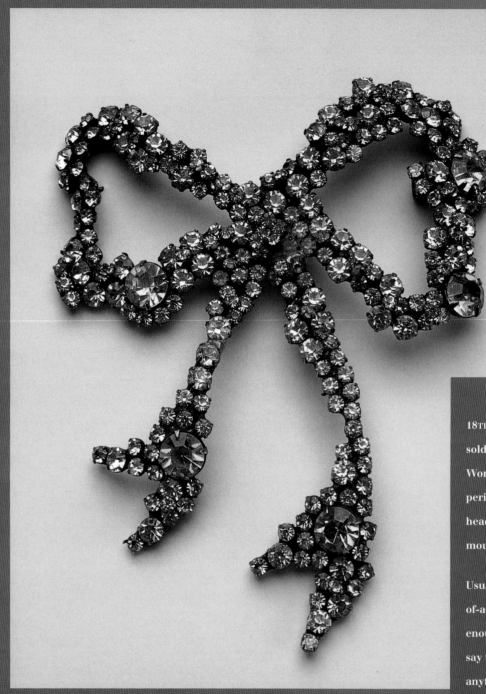

18TH-CENTURY-INSPIRED BROOCH. Hand-soldered by Kenneth Jay Lane at Jacques Workshop, NYC, mid-1960s. Foiled jonquils, peridots, diamonds, diamond-mounted head pins, antique gold-plated brass mountings, 4¼" high. Stamped K.J.L.

Usually one-of-a-kind pieces remain one-of-a-kind because I didn't like them well enough to produce, otherwise one might say they were disasters. Every designer of anything is capable of designing dogs.

In this case, this very 18th-century bow, which I soldered myself using diamond-tipped head pins between the mounted stones to create a double-layered effect, was simply impossible to reproduce.

and creates Verdura jewelry from the original sketches, doesn't seem to mind my paying tribute to the great master. He even gave me credit in a recent article for keeping the Verdura name alive until he began reproducing his original designs.

The cowrie shells that I used in my turtle pin were individually chosen, and fit into each metal casting, one by one. I would go to the shell shop, hold the casting, and find the shell that was right. I did the fitting myself to be sure the shells fit properly and precisely.

Alas, certain shells have since become practically extinct, so I've had to discontinue the piece it would have been set in. One such shell was the body of the wonderful green snail that appeared in *Look* magazine in the 60s, in an layout originated by Susanne Kirtland, the fashion editor. Eventually, I cast shells in metal and set them with multicolored stones, pearls, and diamonds or cast them in plastic and pearlized them.

Among the denizens of the undersea world, branch coral has always been a favorite motif along with shells and pearls. In the sixteenth, seventeenth, and eighteenth centuries, coral was frequently used in decorative or votive objects. One such piece was a figure of St. Sebastian carved in ivory and strapped to a tree of coral.

The image of branch coral was painted on the mirrored ceiling of the Villa Palagonia near Palermo, Sicily. I've seen seventeenth-century allegorical Neapolitan paintings of the elements where coral is always included in a water scene.

With coral's vivid symbolism and flattering color to inspire me, I designed a number of branch coral earrings. I love the look of coral as it curves up against a lady's ear, perhaps with a diamond or pearl drop. I've also used branch coral in Maltese crosses, clasps, and necklaces.

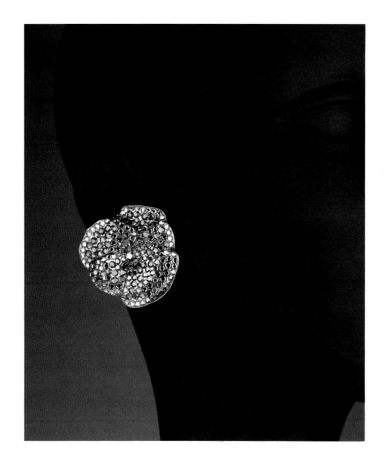

JAR-INSPIRED EARRINGS. c.1990. Pavé diamond, sapphire, and amethyst flat-back stones, antique silver-plated metal

I couldn't resist trying to emulate the great Joel Rosenthal (JAR), pansies being one of his recurring motifs. I had seen a number of lady friends wearing his often one-of-a-kind originals. My factory bluntly refused to follow my carefully detailed diagram as to which color stone to set where, so I made the first sample myself—going back to my original technique of pasting flat-back stones, this time onto a metal casting of a pansy.

SEASHELL AND TURTLE-CLASPED BRACELETS.
Vogue, March 15, 1965. Photo, Irving Penn

One of the best photographs of my jewelry ever. No wonder women drooled over the pages of *Vogue* in those days.

BROOCH. Late 1960s. Natural cowrie shell, emeralds, pavé diamonds, gold-plated metal. Stamped K.J.L.

Fortunately the shell shop where I went to select each and every cowrie to fit into the setting was not far away, although I'm not sure I'd have the patience or time to do it today.

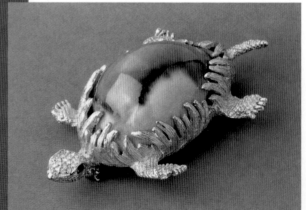

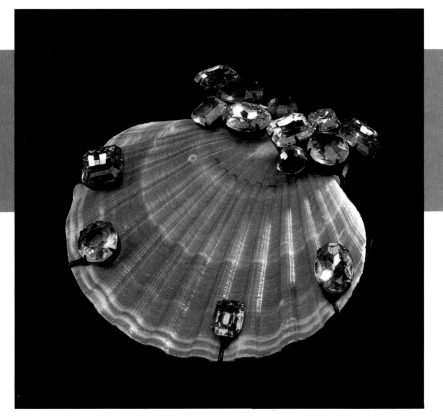

PENDANT BROOCH. Jacques Workshop, NYC, for K.J.L., late 1960s. Natural scallop shell, faceted glass multicolored pastel stones, hand-soldered, black-plated brass wire and mountings, 4¼" wide

Upstaging the Duke di Verdura!

PENDANT BROOCHES AND PENDANT NECKLACE. Jacques Workshop, NYC, for K.J.L., late 1960s. Each: hand-soldered, black-plated brass wire and mountings. (Left) PENDANT BROOCH. Natural lion's paw shell, faceted glass multicolored pastel stones, 4¼" long; (center) PENDANT BROOCH. Polished shell, faceted glass multicolored pastel stones; (right) PENDANT NECKLACE. Natural miter shell (mitridae), faceted glass multicolored pastel stones, black braided silk cord

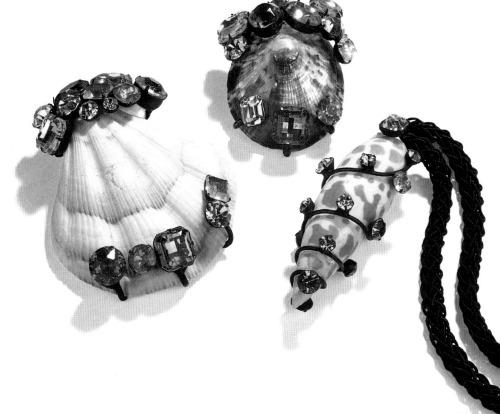

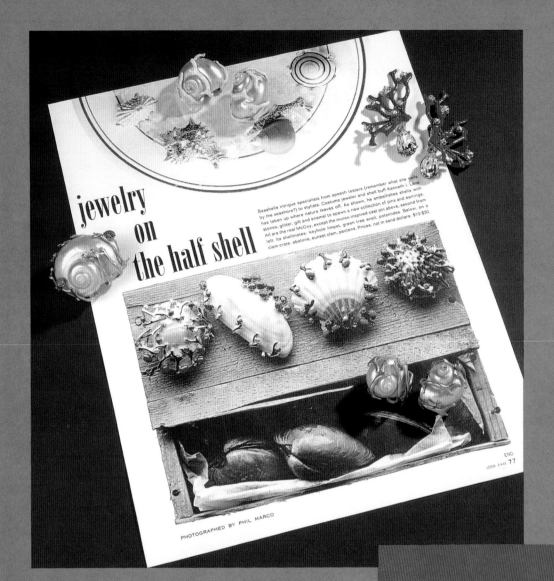

SHELLS AND CORAL JEWELRY. *Look* magazine, May 4, 1965. Photo, Phillip Marco. (Left) GOLD-PLATED METAL SIMULATING BRANCH CORAL BROOCH. Mid-1960s. Natural polished shell, glass coral cabochons. Stamped K.J.L.; (top and bottom) EARRINGS. Mid-1960s. Natural polished shell, one enameled white. Stamped K.J.L.; (right) BRANCH CORAL EARRINGS. c. 1970. Diamonds, coral enamel, 3" long, including pear-shaped diamond drop

When this photograph appeared in *Look* magazine, Lord & Taylor displayed my entire collection of shell jewelry in their Fifth Avenue windows. Susanne Kirtland, the fashion editor of *Look,* which, with *Life,* was one of the most-read magazines in the United States until it shut down in the 1970s, loved what she was doing. This is obvious from the great imagination of this layout. Nothing ordinary or slapdash here!

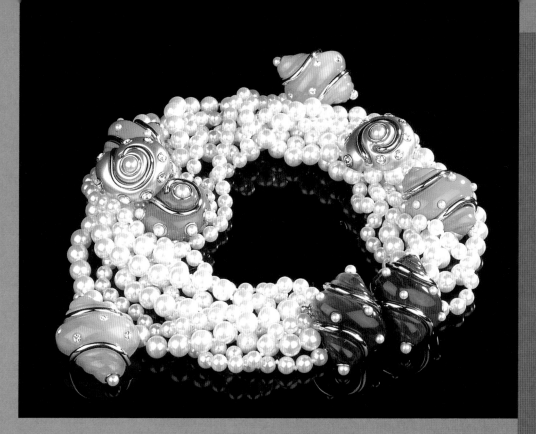

VERDURA-INSPIRED SHELL JEWELRY.
1994. Each: Stamped Kenneth
Lane. EARRINGS. Plastic rose
quartz, turquoise, and coral,
gray pearlized plastic, diamonds,
pearls, gold-plated metal;
NECKLACE. Plastic lapis lazuli,
pearls, hand-knotted glass
pearls, gold-plated metal

These earrings and necklaces,
again inspired by Verdura, are a
great current success, and will
become a classic.

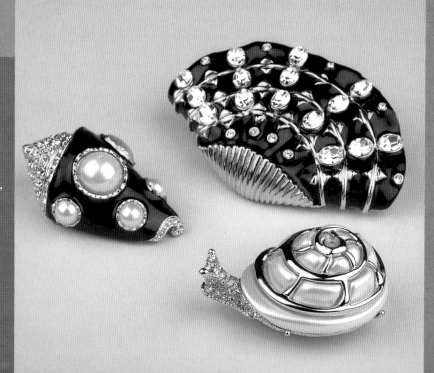

BROOCHES. Each: Stamped Kenneth Lane. (From
top right) VERDURA-INSPIRED SHELL BROOCH. Mid-
1980s. Black enamel, diamonds, gold-plated metal,
4" wide; SNAIL BROOCH. 1992, updated version of
Kenneth Jay Lane late-1960s original. Pearlized
cast plastic, pavé diamonds, rhodium and gold-
plated two-toned metal; SHELL BROOCH. Black
enamel, diamonds, pearls, gold-plated metal

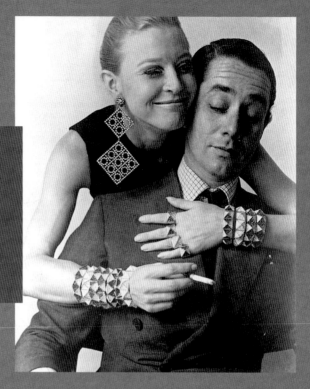

GEOMETRIC BANGLES AND EARRINGS

What could be better?—Embraced by a beautiful girl practically up to her elbows in my jewelry!

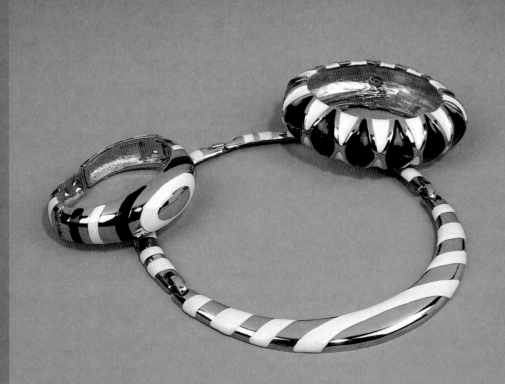

DOUBLE-HINGED BRACELETS AND COLLAR. Early 1970s. Each: gold-plated metal. (Left) STRIPED BRACELET. Black and white enamel. Stamped Kenneth Lane; (right) DIAMOND-MOTIF BRACELET. Black and white enamel, ⅞" wide. Stamped Kenneth Lane; STRIPED COLLAR. White enamel. Stamped Kenneth Jay Lane

I particularly like bracelets that have two hinges, one on either side. They fit the wrist so snugly.

I've had shells set in metal that had been enameled to look like coral. The effect was magical—the shells actually looked like they were held up by real coral branches. Sometimes I used cabochon turquoise, peridots, and other colored stones, combined with the branches. I even fit a large lion's paw shell into an elaborate multi-jeweled necklace which could be worn with a ball gown. I gave one to the ravishing Naty Abascal—both made quite an entrance.

I do use mother-of-pearl in my costume jewelry, but oddly enough, it's more popular in precious jewelry. Once it's mixed with diamonds and gold, it takes on a different aspect.

Besides purely decorative jewelry, I've also designed "functional jewels," such as sunglasses, watches, belts, and handbags. My newest design for sunglasses is like a piece of jewelry—the frame is completely metallized gold, not just a typical, thin wire frame, but really a gold statement.

When I began designing pavé jewelry in the 1960s, I made some handbags using the first technique I knew, setting pavé flat-back rhinestones on both ends of a tubular bag. I had the handbag itself made by a gentleman named Ben King, who was the best belt maker in New York. His business was shrinking, because his quality was so extraordinary—only Norman Norell could afford to use him for his collections. So Mr. King was all too happy to try something new.

I designed a handbag with the snake heads I used in my first beaded bracelets, to hold the handles on either side of the handbag—and a few other ornaments as clasps. Wasn't I surprised, not soon afterward, when I walked up Fifth Avenue and saw my bags in a Saks window, with the label "Ben King." That ended a lovely relationship.

Bags of mine advertised by Saks were made by Lewis Purses, a company which is no longer in existence. I used fabrics handwoven on an eighteen-inch loom, which was

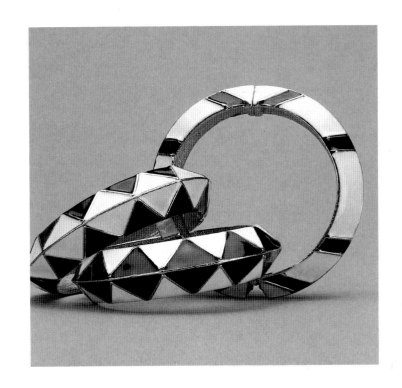

OP ART HINGED BANGLE BRACELETS. Late 1960s. Each: gold-plated metal. POSITIVE/NEGATIVE BRACELET. Black and white enamel. Stamped Kenneth Lane; CHEVRON-MOTIF BRACELET. Black and white enamel. Stamped K.J.L.

Très moderne! A bit of Op-Pop with a dash of Deco!

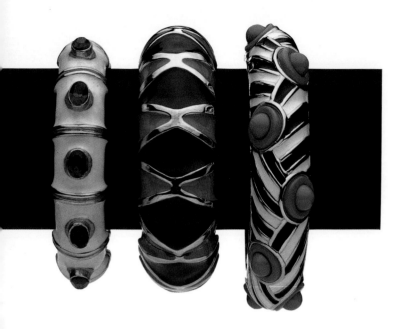

BRACELETS. Early 1970s. Each: gold-plated metal. (Left to right) White enamel, foiled glass sapphires; Turquoise and navy enamel. Stamped Kenneth Lane; Black and white enamel, plastic turquoise cabochons, plastic coral rings

I might have been the first costume jeweler to make enameled bangles. I was influenced, naturally, by Jean Schlumberger. He was the only famous designer of precious jewels who didn't like me—in fact, not at all. David Webb and Fulco were friends who constantly teased me. When I bought a pair of shell cufflinks from Verdura, he remarked they were paid for by his inspirations. David Webb once remarked in public that "I had his life insured."

located in the living room of Alice Stransky, in Far Hills, New Jersey. Alice, a Polish refugee and a charming lady, had worked exclusively for Henri Beatrix, a shop on Madison Avenue, where bags were completely made by hand and were as luxurious as possible. Even then, her fabrics were very expensive.

I had actually met Alice when I was making shoes, because we tried to adapt her fabric for shoes, but it wasn't practical. The handbags were terrific, even though the manufacturing standards were not up to the quality of the jeweled ornamentation. However, some ladies I know who had bought them at Saks and Bergdorf Goodman still have them, wrapped in black tissue paper, to be taken out on special occasions.

My inspirations were those marvelous handbags Cartier made in the 1920s and 30s. Ladies who had those Cartier frames would very often have the bags themselves changed to match certain costumes—often made of the same fabric as the dress or made to match the shoes. A completely matching costume was very stylish in those days—not chic but elegant.

Hordes of ladies came to ogle the relics of another age when all the personal belongings of socialite Mrs. Gilbert Miller—including her lingerie and sable coat—were auctioned at Christie's East. Kitty Miller, who was extraordinarily well dressed and traveled with two maids, died heavily in debt to her trust fund, her father having been Jules Bache, the banker.

At the auction preview, all her handbags were piled into a very large cardboard container. As I walked by with a friend, I said jokingly, in a very loud voice, "Of course, you know that all of Kitty's handbag frames were made of real gold!" After the sale, I realized they probably *were*, and I should have bought them all.

I've since made handbags with various manufacturers, but unfortunately, the manufacture of handbags has departed our shores, so it's much more difficult to find the right makers today.

A Design is Born

Between the idea and the sketch and the finished sample, there are 23,000 telephone calls, three barrels of tears, and a couple of clumps of hair pulled out of one's head. Once you've changed a sample model sixteen times, it doesn't matter with whom you're working even if you're paying them by the hour. They start screaming and yelling and refuse to make one more tiny little change. They're bored. They're tired. They say the piece is fine—no one will notice if it's too heavy, or looks cockeyed, or doesn't have a nice smile.

No, no! I say it all matters terribly. It's the difference between life and no life.

I'm part pugilist, part genius, part magician, part wizard, and part snake charmer. The end result is due to something between flirtation and murder.

As a costume jewelry center, Providence had a lot to show me by what *was* and was *not* there. Jewelry was produced mostly by a small group of people who lived in a relatively circumscribed environment in Rhode Island, the smallest state of the union. Many of the manufacturers had fairly small ideas—people who probably never went into Cartier or Tiffany's and didn't even stop to win-

dow shop and certainly did not know that the Schlumberger department was on the mezzanine at Tiffany's.

I think most of the people in the industry have never really seen a *marvelous* pearl necklace. They haven't seen 20mm South Sea pearls, or natural pearls, or wonderful baroque pearls. Rhode Island industry people don't go to the jewelry exhibitions at Sotheby's and Christie's, which can knock your socks off. They simply have no idea that truth is better than fiction in the world of jewels. I have paid many visits to Schlumberger, to Verdura, and to Bulgari. You can't be a successful costume jewelry designer unless you know the goods—the real stuff!

I love precious and *grand* jewels. When I was working for Genesco and studying with Roger Vivier in Paris, I began to encounter extraordinary jewelry. I went to balls, fancy dress parties, and dinners with newly made acquaintances. This fortunate exposure to dazzling gems marked the early years of my European high life. It was the late 1950s and women were wearing marvelous "stuff."

In a way, the 1950s was a reincarnation of the 1930s, I've always been told, where prewar values still some-

how existed. People like Arturo Lopez and the Baron de Cuevas were continuing to give extraordinary parties, not unlike those given twenty years before.

Eventually, I was fortunate enough to know many ladies who had wonderful collections of jewels. Before I ever thought of becoming a jeweler, I went to a Red Cross Ball in Monte Carlo—you can't imagine the jewelry! There was Sita, Maharani of Baroda, who had absconded from India with a huge hunk of the Baroda state treasury. She wore a parure of pink sapphires surrounded by diamonds to match the embroidery of her sari.

I saw her another time wearing emerald earrings designed as grapes so luscious looking you felt like nibbling on them—you were sure they'd dissolve in your mouth and taste like crème de menthe. And her pearls! They were the size of quail's eggs. I remember Marella Agnelli at a Spoleto Ball in a dark cinnabar-colored ostrich feather tube dress by Balenciaga or Givenchy. She had a blue diamond hanging from one ear, a pink diamond from the other, and a white diamond at her neck.

From looking at all those marvelous women, I knew

what the *goods* really looked like. So I changed the color of faux emeralds, amethysts, and sapphires to look more like the real thing. In many cases, I wasn't satisfied with what was available in the market. Now I have my emeralds, rubies, and sapphires specially made for me in Germany because I find the commercial ones made elsewhere off color. The more commercial faux emeralds are too blue, the rubies too red, and the sapphires, which they insist on calling "Montana sapphires" after a poor grade of American sapphire, I find dull. Some jewelry buyers actually think my amethysts are too purple, not ever having seen precious Bohemian ones.

Many jewelry manufacturers in Providence use only the traditional "gemstone" colors available to them. I've always wanted truer, richer colors for my costume jewelry, something finer. I found the factories that make imitations of the best! The rubies I have made look like pigeon's blood Burma rubies, and my sapphires are somewhere between Kashmir and Ceylon—certainly not Montana.

Why not imitate the best?

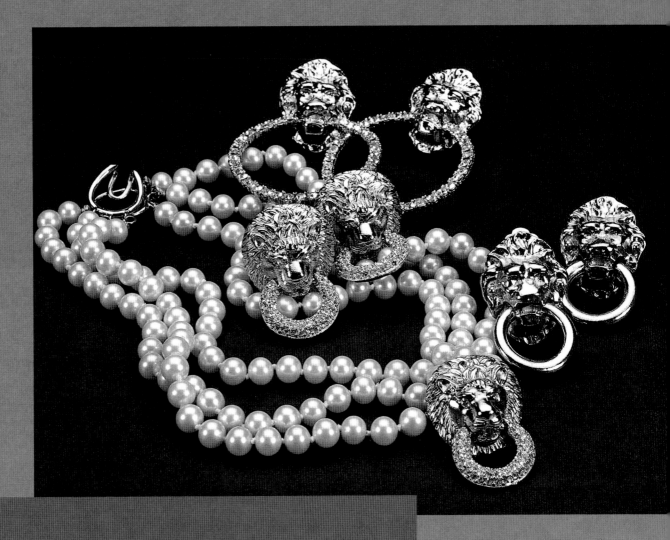

LION'S MASK DOORKNOCKER GROUP. (Top) DOORKNOCKER EARRINGS. c.1985. Gold-plated metal, loose ring set with diamonds, rhodium-plated, 2" diameter. Stamped Kenneth Lane; (right) DOORKNOCKER EARRINGS. c. 1968. Gold-plated metal. Stamped K.J.L.; (center) LION'S MASK DOORKNOCKER NECKLACE AND MATCHING EARRINGS. 1980. Glass pearls, diamonds, rhodium and gold-plated two-toned metal. Stamped Kenneth Lane

One of my great commercial successes. These were inspired by English Georgian drawer pulls and I have never been allowed to retire them. One version or another is constantly in demand. I used this motif for my first collection for Avon, as earrings and as a clasp for pearls.

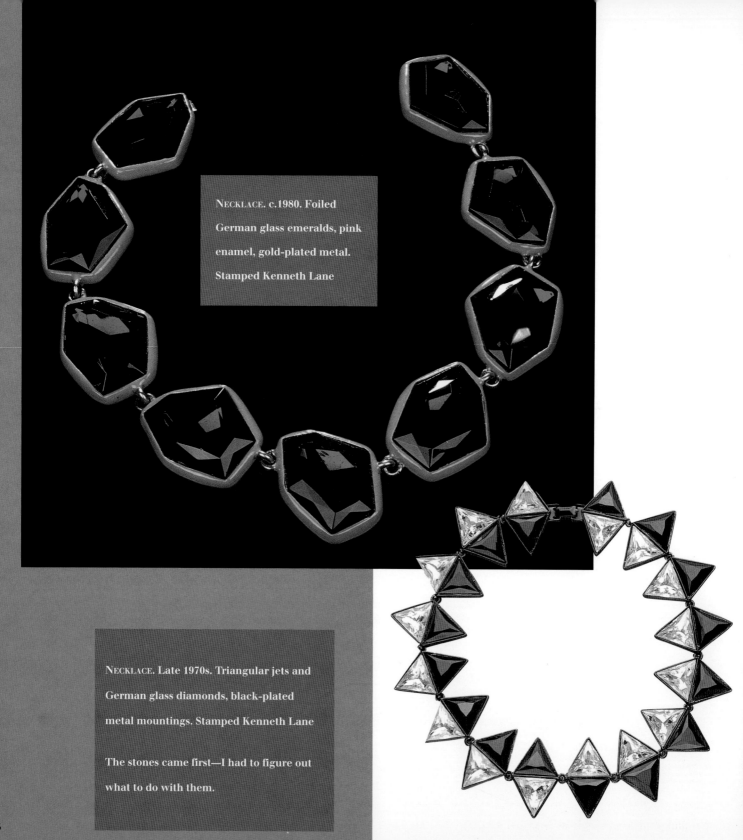

NECKLACE. c.1980. Foiled German glass emeralds, pink enamel, gold-plated metal. Stamped Kenneth Lane

NECKLACE. Late 1970s. Triangular jets and German glass diamonds, black-plated metal mountings. Stamped Kenneth Lane

The stones came first—I had to figure out what to do with them.

Providence, not New York City, became America's jewelry manufacturing center because of an influx of great Huguenot silversmiths who emigrated there in the late seventeenth and eighteenth centuries. They'd fled France because of the revocation of the Edict of Nantes and religious persecution; some went to Germany, many escaped to England—such as Paul de Lamerie—and many others sailed to the colonies, including Paul Revere, almost as well known for his midnight ride as for his great silver craftsmanship. Southern Massachusetts, an area bordering on Rhode Island, became the center for silversmithing.

Eventually, silversmithing turned into an important industry. In the late nineteenth century, silver companies, such as Gorham, were producing work that was as innovative and stylish as anything made in Europe. When costume jewelry became a commercially viable industry because of a new and growing middle class, the silver companies began experimenting with it. Some of the first costume jewelry produced used crystal rhinestones set in sterling silver—the settings were pronged the same way that diamonds were set in gold and platinum.

With the advent of the Second World War, costume jewelry manufacturing centers in Czechoslovakia, Germany, and Austria stopped making jewelry. The factories still in business switched to production of highly technical war material. The craftsmen who left these war-torn countries went to the United States, knowing that there was a climate for opportunity within the industry in Providence. Once here, they soon added their unique expertise.

I adore traveling and have visited museums all over the world—Topkapi in Istanbul; the Pitti Palace in Florence; the Schatzkammer der Residenz in Munich, which has one of the greatest collections of jewels in the world, that of the Wittelbach, the Bavarian royal family; and the Grünes Gewölbe in the Staatliche Kunstsammlungen in Dresden, where treasures of the Wettin, the Kings of Saxony, are displayed.

I've brought back wonderful ideas for jewelry from everywhere I've traveled. In the late 60s, I went to the British Museum for the first time, with the buyer from Neiman Marcus, which was doing a "British Fortnight"

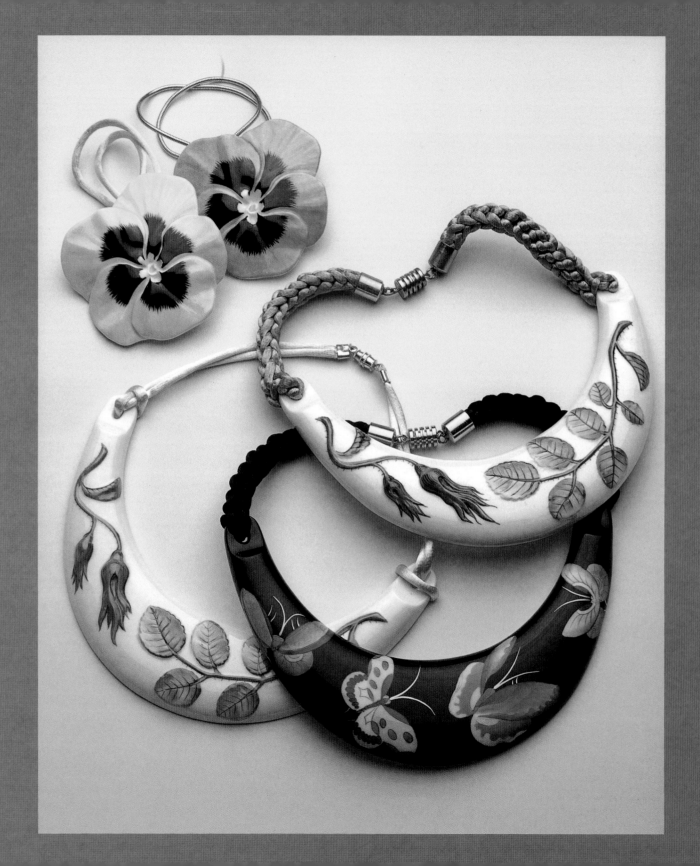

I had the best time doing this collection for Royal Worcester. Shocking the very correct executives, I would run around the factory jacketless, samples in all my pockets, walking them from process to process. I was told that it was impossible to glaze a black background. Not true, it worked—and it worked wonders as a ground for Chinese butterflies from a late 18th-century copper plate. During the Second World War, the artisans at Royal Worcester buried these unique precious engraved copper plates to save them from the "war effort." I found them in their archives and rejuvenated them. Alas, today they are no longer used, though I hope at the very least they have been relegated to a dusty storeroom. Nor is the Blind Earl design, developed in the 18th century for the blind Earl of Coventry, which I adapted for collars and bracelets, still produced as a table and tea service pattern.

A few years later, I spent a week at the Orrefors factory in the snowbound middle of Sweden, making crystal jewelry. The results were great—but so were the prices.

promotion. I had imagined they would have had a good museum shop, like the Metropolitan Museum in New York, with reproductions of pieces from their jewelry collection. There was nothing! I did buy some reproductions of wax seals, which I later copied for my collection.

Then we went to the Tower of London, and I was absolutely bowled over by the incredible table-cut stones that Mary of Modena had brought to England when she married James II. The gems were big hunks of white fire. So I decided to do a "Crown Jewels Collection" for the British Fortnight. I had molds made in Germany for the stones and cast them in glass, much the way glass was cast in ancient Egypt and Rome.

For models, I used the *most* spectacular of the world's most famous diamonds—the Kohinoor, the Hope, the Piggott, and the Cullinan II. I had them all made in about the same 50–60 karat size. I set them in black-plated metal, which gave them the look of old paste. In 1975, Enid Nemy of *The New York Times* did an article called "Fashion Classics," and included a sketch of my "Headlights" necklace, which is what I called it.

The necklace was first made for two women: Diana Vreeland and Lily Auchincloss, who was one of my earliest customers and enthusiasts. I also made a smaller version of the necklace, which was meant to be worn with the larger one. The effect of the two necklaces together was terribly dramatic.

Although the venerable Enid Nemy wrote that the Headlights necklace was a fashion classic of 1975, it didn't really take off until 1983—when I couldn't make enough of them. In that year, I could go to a restaurant or a party and would almost always see five or six ladies wearing it. It was a very noticeable necklace—smashing.

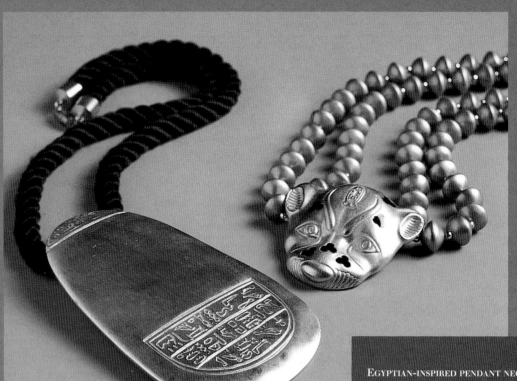

EGYPTIAN-INSPIRED PENDANT NECKLACES. 1973. Stamped Kenneth Lane. PECTORAL. Satin gold-plated metal, twisted black cord; PANTHER HEAD. Black enamel, satin gold-plated brass beads and metal

There are several marvels one must see. The Taj Mahal, the Palazzo Te in Mantua, the Bellottos in Warsaw, and . . . Egypt. If you haven't been, go! If necessary, cash in your life insurance, sell your silver, and disown your heirs. The grandeur of pharaonic Egypt is beyond imagination. Cecil B. De Mille did not exaggerate. The elegance of design, even for everday objects is unique—the sophistication!

Of course, upon returning from my first trip to Egypt I created my own updated version of their jewelry from 2500 B.C. (2000 years before the Golden Age of Greece) to 1 A.D. I still believe each and every scarab and every single eye of Horus that I had cast in metal or ceramic, had enameled and plated in 22k gold—has magic and even occasionally, a curse.

EGYPTIAN-INSPIRED PENDANTS. 1973. Each: gold-plated metal, on natural braided cord. Stamped Kenneth Lane. (Left to right) EYE OF HORUS. Gold-plated metal; SCARAB. Blue enamel; EYE OF HORUS. Blue crackle emamel

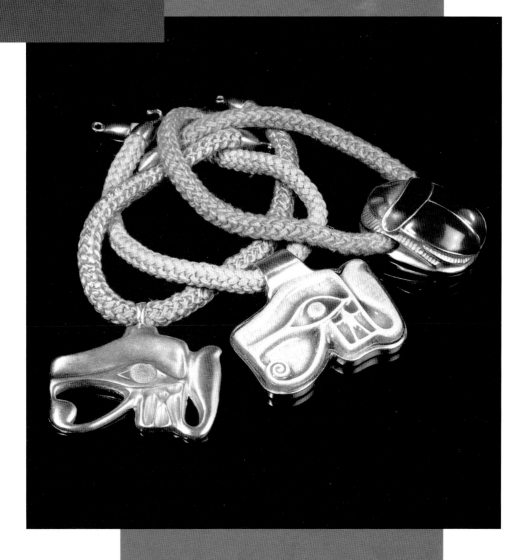

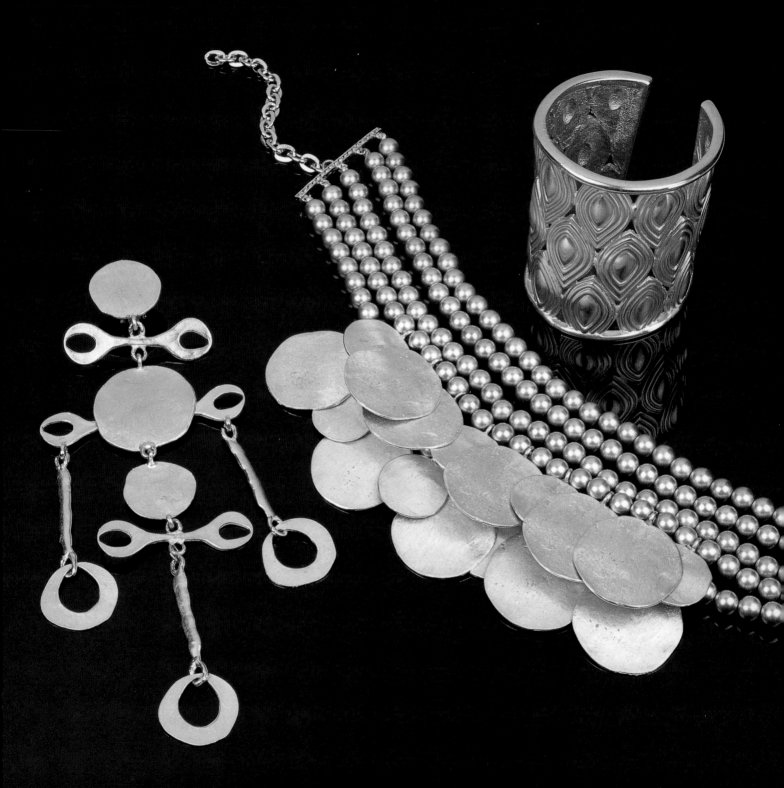

Opposite: MIDDLE EASTERN NOMADIC-INSPIRED JEWELRY. Mid-1980s. Each: Satin gold-plated metal and brass. Stamped Kenneth Lane. WIND CHIME EARRING. 7½" long; ADJUSTABLE DOG COLLAR. Ten large and seven smaller disks; PEACOCK-EYE CUFF BRACELET. 3" wide

The earrings and cuff bracelet are strictly Lane—from somewhere between the lost tribes and Zenobia, Queen of Palmyra—all ancestors.

The five-row dog collar made of golden beads was inspired by probably assembled necklaces sold by "the bald Armenian" to Chessy and Mica. Authentic or not, they are very stylish and can be worn with a caftan in Bodrum or to a ball in New York City, as can my version—with enough cash left over to pay for the gown.

One cannot imagine the full splendor of Egypt unless one has been there. The scale of the temples and the extraordinary treasures of Tutankhamen cossetted in the Egyptian Museum in Cairo is breathtaking. Egyptian jewelry is wonderful stuff, unique and unlike any other ancient gold jewelry made by the Greeks, Romans, or Scythians.

Egyptian motifs have a way of being rediscovered, especially over the last few hundred years. There was a mania for everything Egyptian in the late eighteenth century—soon after Napoleon's Egyptian campaign— and during the first quarter of the nineteenth century. Napoleon's entourage included artists who returned to Europe with detailed drawings and records of the art and architecture of the pharaohs.

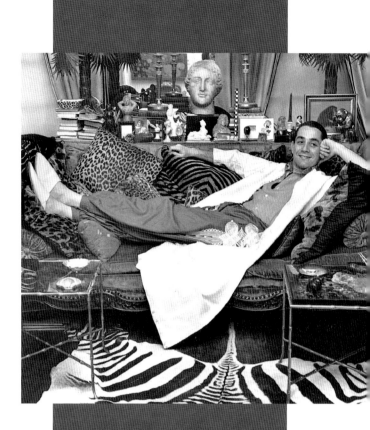

Kenneth Jay Lane at home on East 94th Street. Photo, Tony Palmieri, *Women's Wear Daily*, March 6, 1964

Bill Blass, who had traveled with me in Morocco, was thrilled when he returned to New York a few days after I did to pick up *WWD* and to see a double page of photographs of me, stretched out like a demented pasha, having the last word on Moroccan style.

The image of the sphinx, the gold work, the dramatic Egyptian design sense was alluring and exotic to Europeans. Egyptian motifs were used for jewelry during the French Empire. Micro-mosaics depicting Egyptian designs and monuments were incorporated into gold settings for necklaces and bracelets. The jewelry can even be seen in the paintings of Ingres.

The Egyptians used symbols such as the ankh and the scarab, which gave a spiritual quality to their adornments. The pharaohs, queens and important dignitaries were buried with their earthly treasures, for use in the afterlife. The motifs all have some relationship to the gods and goddesses of their "Olympus."

Then in the 1920s, archeologist Howard Carter literally struck gold when he unearthed the door to the tomb of Tutankhamen. The discovery so excited the world that it heralded another revival of Egyptian style, which was used extensively with Art Deco designs by Cartier—sometimes even using Egyptian antiquities such as shawabtis, which were funerary figurines made of faience or *pâte de verre*.

When I returned from my first trip to Egypt, I began designing my version of Egyptian jewelry. I took many liberties, but kept it all within the framework of design for the pharaohs. The cat and the panther were considered sacred beasts, and I adapted the panther from one I saw on the bed of Tutankhamen for a bracelet. I also did an eye of Horus, which is a very popular Egyptian symbol.

I revived Egyptian jewelry several times, especially when the "King Tut" exhibit was traveling around the world in the late 1970s.

Morocco and Egypt may both be on the north coast of Africa, but each country's use of design, materials, and color is distinct and unique. Traditional jewelry in Morocco is Berber in origin—coral, turquoise, and enameled silver beads are usually worked into multiple strands—an exceptional use of color. This style is different from the jewelry of Yemen and greater Syria. When I discovered the use of resins and the ability to cast resin

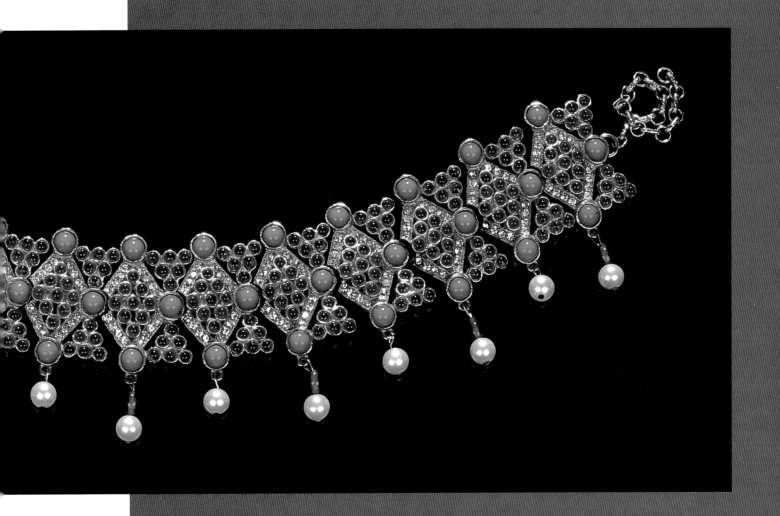

INDIAN-INSPIRED DOG COLLAR. 1968. Emerald cabochons, rubies, turquoise, diamonds, pearl and emerald bead fringe, gold-plated metal. Stamped K.J.L. The Grace Collection

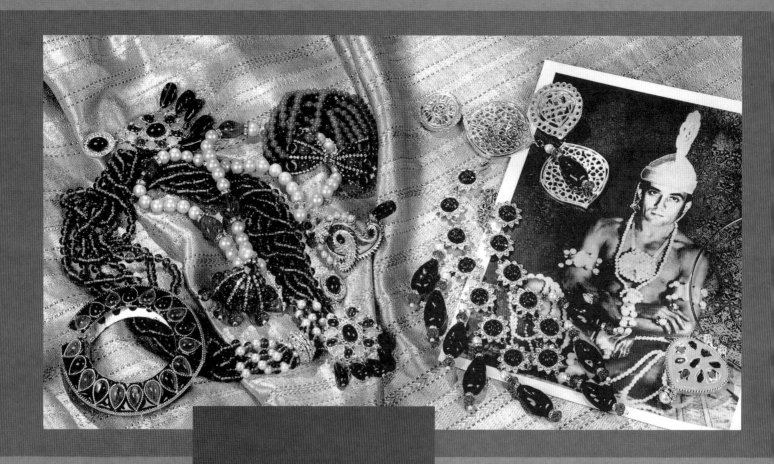

I am proud to say that Diana Vreeland had this photograph of me as a young rajah pinned up on her bulletin board at the Met while we were doing the Royal Indian exhibition. I did deserve this place of honor, however, since I had made the most extraordinary pearl-tasseled ankle bracelets for the elephant that reigned over the show.

into any form, one of the first things I did was to make oversized amber beads, which looked exactly like the ones found in the souks of Fez and Marrakech.

Today, the *lallas* (princesses), who are the sisters of the king, wear wonderful wide gold belts, the clasps set with rather roughly cut emeralds, over their embroidered and brocade caftans which trail on the palace floors as they walk.

I've been to Morocco many times, originally in the 1960s, when La Mamounia in Marrakech was exactly as it was in the 1920s. The *medina* is totally fascinating, probably the most exotic place between New York and Calcutta, with fire-eaters, snake charmers, and magicians. The last time I was there I was invited to the celebration for the twentieth anniversary of Hassan II's reign as king. The sight of him appearing on a white horse, under his red umbrella, was exactly like the nineteenth-century Delacroix painting of the Sultan of Morocco at Meknes.

The first time I went to India was 1968, on the way home from Bali and Angkor Wat. Since Angkor Wat had been closed to tourists until 1967, I couldn't wait to see it. Jackie Onassis had been there a year earlier and had raved about it to me.

I fell madly in love with India and have been there twenty or twenty-five times since—I've stopped counting. Diana Vreeland was supposed to come with me on that

Nan Kempner and Kenneth Jay Lane. Photo, Duane Michals, *New York* magazine, August 29, 1994

Nan Kempner and I played together several times at the request of magazines. The first time we shopped in New York's Soho for a wardrobe of jewelry under $100 for the *Forbes*-owned *Egg* magazine. The Kempner-Lane feature was such a smash the magazine folded after "our" issue.

More recently, we did about the same thing for *New York* magazine, but had to purchase gear from head to toe for under $200. Remembering that one can do so in Delhi or Bombay for the price of a beer at the Paris Ritz, we headed for "Little India" on Lexington Avenue around 28th Street. The salesgirls at the shop we found above an Indian food market were wide-eyed as Nan took off her Saint Laurent couture whatever to try on the $40 kurta and pajamas ensemble that saved the day. She cheated a bit by draping her K.J.L. Marella necklace around her neck for the photograph.

Chessy Rayner in wrapped multistrand torsade necklace. Photo © Tobi Seftel, *Avenue*, February 1991

The famous "Marella" necklace worn as a choker by Chessy and long by Nan.

first trip, but her plans changed at the last minute. Of course her *most* famous remark was, "Shocking pink is the navy blue of India." As soon as I arrived there I sent her a wire that said, "Can't bear all this navy blue." I was absolutely bowled over by the colors of the turbans and the saris, the smells of the spice bazaars, the exotic vegetation, the unique landscape, the beauty of the people, and the mogul architecture of the north and the extraordinary Hindu temples of the south.

My inspiration came not only from Indian jewelry, but from what I saw at every turn, which was uniquely Indian. One sees marvelous examples of mogul jewels and jade objects. Anyone who has visited India or has seen *The Rains Came*, with Maria Ouspenskaya playing a wonderful old maharani, or has ever known Merle Oberon—who was part Indian and had a gorgeous Indian-style emerald necklace—will be intrigued by and appreciate Indian jewelry.

I can't imagine how any designer can create anything without having seen the Taj Mahal at least twice. India fills one so full of inspiration that one doesn't know where to begin.

I've seen the collections of all the dealers there. The maharanis themselves wear very little jewelry these days, basically because of the high wealth tax. My great friend Ayesha, the Rajmata of Jaipur, one of the most glamorous ladies in the world, if not *the* most glamorous lady in India, wears nothing but a chain incorporating a few ruby and emerald beads.

Indian jewelry does knock your socks off. The colors are always the same—diamonds or white sapphires, emeralds and rubies. Sapphires are not considered lucky in India, so you rarely see them in jewelry, even though the best sapphires come from Kashmir.

Of course, the maharajahs and the ladies of the court were once *covered* in jewels—strings and strings and strings of pearls, and diamonds the size of plover's eggs. Some of the jewels are still in Indian royal collections. I've done melon-cut emerald beads for several very

grand maharanis. Even "21 gunners" have worn my beads in New York because they're not allowed to bring their jewels out of India. When they wear their "K. J. L." *esmeraldas*, people's eyes pop.

Speaking of emeralds, once I made a five-strand necklace of melon-cut emeralds with diamond and onyx rondelles for the wondrous Pat Buckley. It was even written up in Suzy's column. I hope Pat doesn't mind that I'm telling everyone her famous emerald necklace isn't genuine, but *she* certainly is the real thing.

Some of the courtly Indian emeralds are actually Colombian emeralds that the maharajahs bought in the 1920s at Cartier in Paris. Some of Catherine the Great's emeralds wound up in India after the Russian Revolution.

Most Indian motifs are quite simple. They're often mango shaped, called *botehs*, or to us, "paisleys," which has various roots. Some say it was the impression of the fist put into ink, which was the seal of the Sultan of Turkey, or perhaps Akbar the Great. The name comes from the town of Paisley in Scotland, in which weavers of the nineteenth century loomed copies of Indian and Kashmiri embroideries and motifs.

I once went to a shop that was inside the gate of the great fort of Jodhpur, one of the marvelous, intact palace forts of India. The royal family of the state actually lived there until almost the middle of this century when they built an enormous Art Deco palace. Today they live in part of the palace, while the other part is a luxury hotel.

In this shop, which was basically filled with uninteresting things, I came across some very curious nineteenth-century Muslim seals, which had the most fascinating calligraphy patterns. I thought that to invent these calligraphic forms, rather than duplicate them, would be almost inconceivable—the seals had a charm and authenticity innate to the original design. I bought a bag full of them, all different, and had them cast when I came back to New York. And thus my Jodhpur collection.

There's a wonderful opulence and amusement in Indian jewelry, which works very well with the fashions of

Runway model at Oscar de la Renta collection. Fall 1990.

today. I've always been influenced by it and do variations constantly. Sometimes I anglicize it, sometimes I keep it quite native and make a mixture of tribal and courtly, which you would never see in India, where it's either one or the other. There's a process for setting stones or enameled gold into jade that's uniquely Indian, and I have done it quite successfully using resins instead of jade.

In the middle 1960s, in India, there were wonderful rubies that are almost impossible to find today. About thirty years ago, Marella Agnelli was fortunate enough to purchase a marvelous Indian necklace, yards long, of ruby beads with a sprinkling of emeralds. She wears the necklace constantly, and in the 70s she asked me to do a version of it for her. I've done that style of necklace in many materials, mixing rubies and emeralds and any other gems that come to mind.

I had ruby and emerald beads made of a very special glass in the town of Surat on the Arabian Sea. Eventually, when they'd arrive (sometimes after more than a year of letter writing) I'd make necklaces which, for all the world and particularly in the right light, looked like Marella's. The first one was worn by Tatiana Liberman, the wonderful Russian wife of Alexander Liberman, the creative director of Condé Nast and Renaissance man— artist, sculptor, writer, and photographer, who as I mentioned before, gave me my first job at *Vogue* when I came out of school.

Years later, I gave a similar necklace—with slight improvements—to Annette de la Renta, when I was staying with her and Oscar in the Dominican Republic. I had since learned how to make a certain clasp whereby necklaces of various lengths could be attached to each other to create one great, long sautoir. After that, Oscar used these necklaces in his collection, wound around the neck several times, or draped down the front of the gown, even to below the waist. Every woman in town wanted one.

At a gala at the Metropolitan Museum for Gianni Agnelli's seventieth birthday, I arrived just behind

DOUBLE-HEADED DRAGON HINGED CROSSOVER BRACELET. c.1968. Black, white, and red enamel, glass chrysoprase and turquoise, diamonds, gold-plated metal. Stamped K.J.L. The Grace Collection

This bracelet is really more Chinatown than Peking, but with no apologies. Notice the white enameled tiny teeth and red tongues.

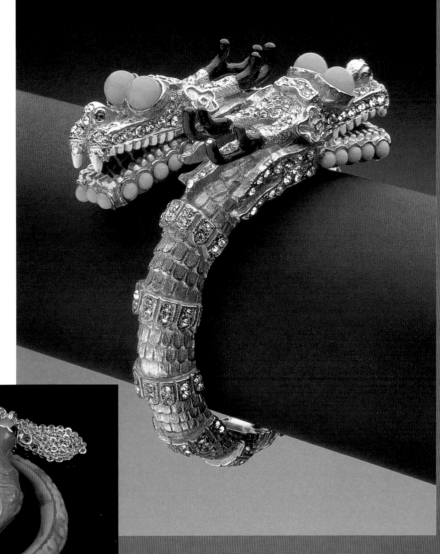

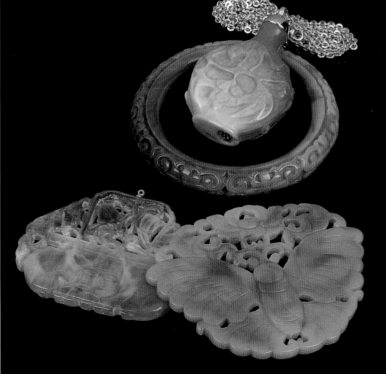

CHINESE-INSPIRED PENDANTS AND BRACELET. Late 1960s. SCENT BOTTLE PENDANT NECKLACE. Cast plastic coral, gold-plated metal. Stamped Kenneth Lane; BRACELET. Cast plastic jade; BUTTERFLY PENDANT. Cast plastic jade, 3½" wide; VASE PENDANT. Cast plastic amber, gold-plated brass ring

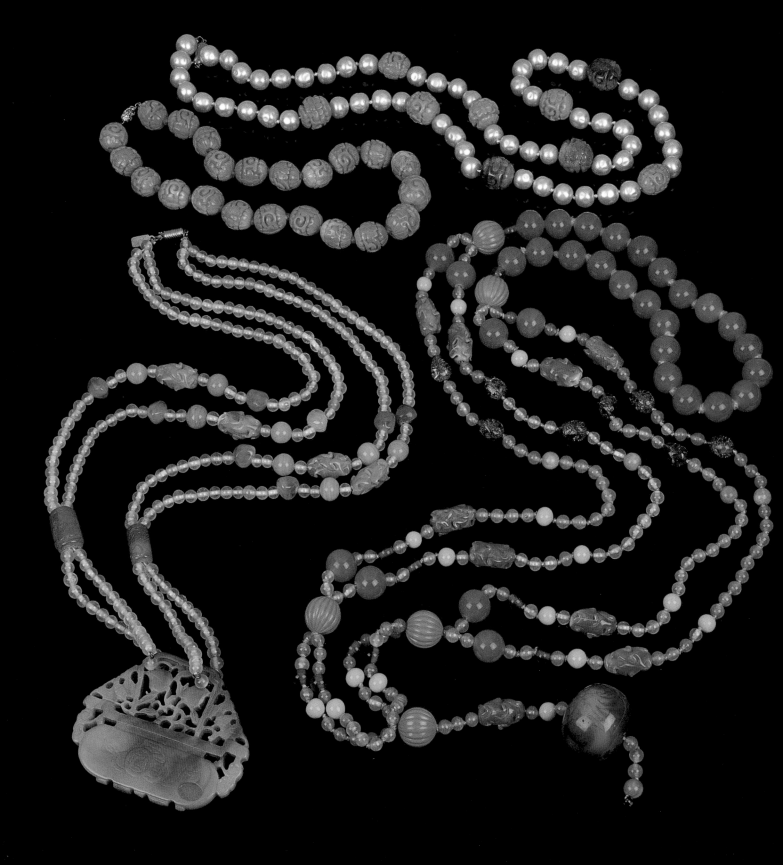

CHINESE-INSPIRED NECKLACES. Early 1970s.
(Clockwise, from top right) NECKLACE. Hand-knotted
baroque glass pearls, cast plastic coral and jade
beads, gold-plated metal clasp; MANDARIN-STYLE
NECKLACE. Glass rose quartz, ruby, green beryl,
crackled amethyst and turquoise, plastic round
and fluted coral and jade beads, 58" long. The
Grace Collection; PENDANT NECKLACE. Glass rose
quartz, tubular glass and genuine polished carnelian
nuggets, round glass jade and elongated cast plastic
jade beads and pendant, gold-plated metal clasp,
36" long. Stamped Kenneth Lane; NECKLACE. Cast
plastic hand-knotted coral beads, diamonds,
rhodium-plated metal clasp

The limited color palette actually used in old
China for jewelry was similar to the Art Deco one,
but with the addition of rose quartz and cinnabar.
I assiduously avoided such "Chinese-y" motifs as
pagodas, buddhas, or fans, and tried to keep the
designs fairly authentic. But of course, from time
to time, I couldn't resist cheating a bit.

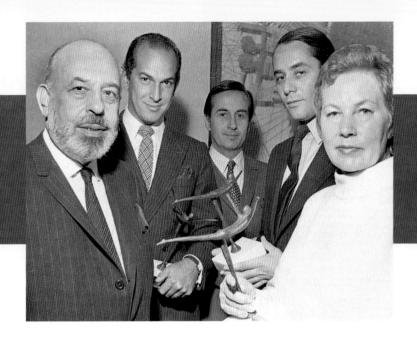

Kenneth Jay Lane receiving the Neiman Marcus Award, 1968, with Stanley Marcus (front left) and Oscar de la Renta (rear left). Photo, Fred Coston

When I visited Neiman Marcus again in 1969, I arrived wearing a beard not unlike Stanley's, except that it was dark. I had grown it that winter in Bali where I had no hot water to shave. Mrs. Marcus senior, Stanley's mother, didn't approve of it at all, but she wasn't fond of her son's either. I shaved it off soon after because it itched like hell.

Wendy Luers, the wife of the president of the museum. She was wearing her necklace of my rubies wound double around her neck. There were about three other women at the party wearing it, as well. In the receiving line, Marella *also* had on her precious ruby necklace. She shook her finger at me and said, "Kenny . . . naughty, naughty, naughty!"

She was amused, I hope!

Of course, but alas, I've never been there. The closest I've ever been is China-town in San Francisco, where I bought some wonderful carved jade beads, which I later copied in resin and used in Mandarin necklaces, which hang down almost to the knees. The colors of Chinese beads are those of coral, jade, rose quartz, black onyx, lapis lazuli, and turquoise. The Chinese also made great use of pearls and many of these necklaces were worn by men. I've seen paintings of Chinese women who wear most of their jewelry in their hair. Very often the jewels were made of kingfisher

feathers—a remarkable iridescent, peacock blue. I've never found a way of simulating that.

Long before the exhibition in 1980 of Chinese costumes at the Metropolitan Museum, I experimented with Chinese motifs. I designed a Chinese watch face for Neiman Marcus, which practically caused a revolution because unknowingly in place of the hours I used Chinese characters that had possible political significance.

When I was making a personal appearance at Saks in San Francisco and showing my faux carved jades, beautifully dressed Chinese women came in, and held my pendants to the light, incredulous that they were not genuine. I made reproductions of precious carved stone Chinese scent bottles and hung them from chains as pendant necklaces. I sometimes designed carved "jade" surrounded by faux diamonds in grand necklaces. I used actual Chinese cinnabar beads and also copied carved cinnabar bracelets in colors that were never used in China.

Chinese ladies were very modest about the amount of jewelry they displayed. In the late 60s, I was a guest columnist for *The New York Herald Tribune* for the vacationing Eugenia Sheppard. I told the story about a lady called Orchid Yen, the sister of Madame Chiang Kai-shek. The story went that someone admired her pearl necklace, which could be seen only at the nape of her neck, the rest of it being concealed by the high mandarin collar of her long *cheongsam*. Traditional politeness demanded that she offer the admirer the pearls, so she responded by asking if he'd like to see the rest of them. When he said yes, she lifted the hem of her ankle-length skirt, showing that the pearls went well below her knees. Later I found out there was no such person as Orchid Yen.

While I'm sailing on the China Seas, I'll head for Japan. Although there really is no such thing as Japanese jewelry, I designed my own version of Japanese-inspired jewelry for a "Japanese Fortnight" at Neiman Marcus. Since Neiman Marcus was one of my first customers—I had won the Neiman Marcus award in 1968 and I had great respect for Stanley Marcus, who is one of the great

PRE-COLUMBIAN-INSPIRED FROG NECKLACES AND MASK BROOCH. Stamped Kenneth Lane. PENDANT NECKLACE. 1977. Satin gold-plated brass beads and metal pendant; BROOCH. c.1970. Plastic jade, ruby cabochons, diamonds, gold-plated metal; NECKLACE. c.1990. Glass baroque pearls, satin gold-plated metal; NECKLACE. c. 1990. Satin gold-plated brass beads and metal

Inca, Aztec, Mayan, take your pick. But the Verdura-inspired jade mask is definitely Olmec. The plaque incorporates a frog motif, which could be from the west coast of Africa. The plaque itself came from an original design of Millicent Rogers, which I copied for the "American Women of Style" exhibition at the Met for Diana Vreeland.

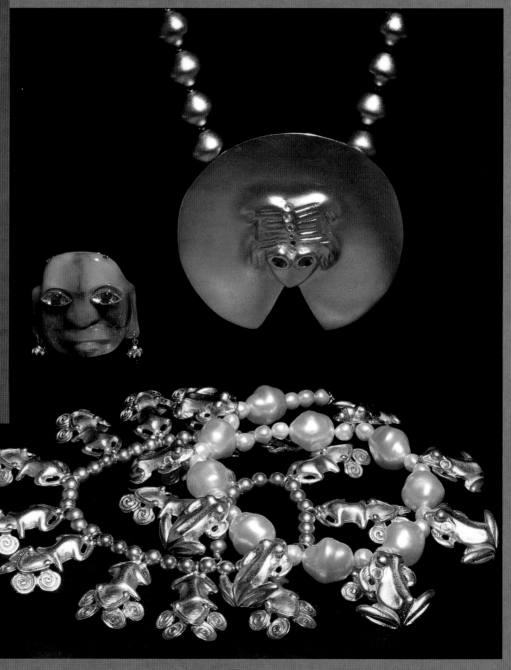

merchants of our time—I made a special effort to do the impossible for them.

I had been in Tokyo showing my jewelry to the Japanese press, which had been arranged by my then-licensee Best International, which had a shop in the Imperial Hotel. They did these exhibitions beautifully, combined with a fashion show of Bill Blass dresses. The buffet changed three times; one at breakfast, another at lunch, and the third at the evening cocktail show, for which there was no shortage of superior Iranian caviar. I found a shop selling ceramic beads with calligraphy painted on them under the glaze. I bought as many as I could find and had them made into necklaces for the Neiman show. The president of Best International, Yuki Masuda, presented me with calling cards, printed on bamboo paper, with my name in English on one side and in Japanese calligraphy on the other. When I arrived at Neiman's with my Japanese collection, I handed out these cards. Stanley Marcus was terribly impressed—he thought I had gone to enormous effort to have these cards created especially for my appearance at his store.

The only Japanese designs I've used in my collections are from netsukes, which I had copied in cast resin simulating ivory, amber, or jade, and worn as pendant necklaces, similar to the Chinese scent bottles.

Spain has style—who is more stylish than a matador in the bullring, or flamenco dancers who wear huge earrings? In fact, it was this jewelry that had a tremendous influence on my early earring designs. In my version, the graceful arabesque shapes were made of cut-out plastic,

light enough so as not to fall off. I'd adapt these shapes and have jet beads glued onto both sides, with jet beaded fringe.

I also designed flamenco-inspired earrings that I had made by embroiderers. One pair appeared on the cover of British *Vogue* in the 1960s. Besides jet, I had them done in multicolored beads as well. I had them embroidered front and back and glued together. They were made the way embroidery is on a couture dress, which today is only done in few places, like the Orient, or Lesage in Paris. In California, there are Mexican workers who do fine embroidered pieces for films, or for Las Vegas show girls' costumes.

The **Pre-Columbian** civilizations of Central and South America created wonderful images in the purest of gold. Unfortunately much of it was melted down by the Spanish conquistadores. I have seen extraordinary museums filled with gold in Lima, Peru, and Bogotá, Columbia. There is also wonderful Pre-Columbian gold in the archaeological museum in Mexico City, the Museum of Natural History in New York, and the Dumbarton Oaks Museum in Georgetown, Washington, D.C.

Archaeologists are constantly finding new treasures. One of the most recent ones is in the treasury of Sipan in Peru, which I saw exhibited at The Metropolitan Museum of New York. The images of Pre-Columbian jewelry go from naturalistic forms such as the simple peanut, to human faces, to ferocious likenesses of animal or birdlike gods.

At either the Kunsthistorisches Museum in Vienna, or

ISLAMIC-INSPIRED JEWELRY. Stamped
Kenneth Lane. (Left) NECKLACE AND
MATCHING EARRINGS. 1985. Pearlized cotton
and plastic pearls, gold-plated metal discs,
caps, and earrings; (top right) NECKLACE.
1985. Gold-plated metal discs and brass
beads; DOUBLE-HINGED CUFF BRACELET. 1972.
Gold-plated metal

Borrowed from North Africa and Near
Eastern nomads to adorn the international
ones of the "jet" set. This bracelet was
one of D.V.'s personal favorites and was
sold at her Sotheby jewelry auction.
The earrings never leave the ears of
Drede Mele, one of the best-dressed
women of Paris. She wears them with ball
gowns and with Armani suits at lunch.

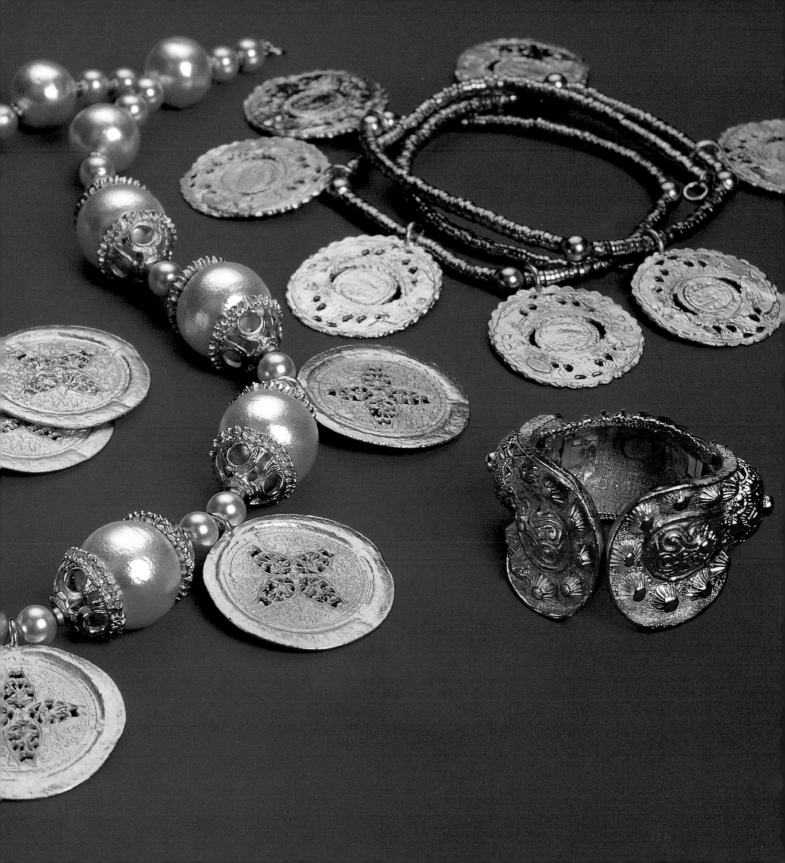

at the Schatzkammer der Residenz in Munich, there is a jade Olmec mask that is one of the most marvelous objects I've ever seen. It's mounted as the face of a Buddha-like god, done in gold, enamel, and precious stones.

Once I saw my friend Marilyn Evins, who is the widow of the great shoe designer David Evins, wearing an absolutely wonderful brooch set with a jade Olmec mask with diamond and ruby eyes—made by Verdura. I admired it enormously.

Then I got my chance to do my version of it. I was in the *plaza de mercado* in Acapulco and I found several new nonprecious jade carvings of masks that looked exactly like the old and very valuable ones. This was at a time when such things were still being hand made by the Indians. I bought the carvings and couldn't wait to get back to New York and have them cast in plastic. They looked, for all the world, like jade.

I have taken great liberties with these motifs and used them in or out of their original context, to create fanciful earrings, pendants, bracelets, and even rings. I hope that the gods of the Mayas, Aztecs, and Incas do not become angry with me for creating my own deities.

Some tribal or ethnic jewelry is hard to pinpoint as to place of origin. One may find many different cultures in various parts of the world, using an identical or similar motif. It's hard to see the difference between a design from Yemen and the same motif from Tunisia. My solution is that sometimes I invent my own tribes.

There's a fantastically clever jewelry dealer in the covered bazaar in Istanbul whom Turkish friends call "the bald Armenian" because he has two strands of hair which are probably three miles long and are wrapped around and around his head, like a turban. He's an absolute charmer and charges the most outrageous prices for the "tribal" assemblages he puts together using old gold beads and coins.

I've always loved tribal jewelry, particularly when it's made of very pure gold. Most people think tribal jewelry is made of silver, but that's only because they haven't seen the best of the real stuff.

Chanel was famous for combining exotic faux primitive jewelry with precious pearls, rubies, and emeralds and wearing it with great style. Diana Vreeland always said you needed something barbaric to take the curse off a *robe de style*, meaning a black velvet ball gown.

Sometimes I was able to improve on centuries-old designs. I once designed a bracelet I was rather proud of, based on a traditional middle Eastern style, which can be found in many markets and souks in Turkey and Greece. The original is very difficult to wear, because there it has a very small opening and fits only tiny wrists. Mine has two springs in it so that it opens wide and clamps onto any size arm. I've been doing that bracelet for twenty years at least—Madame Vreeland wore it often.

Not all my influences or inclinations can be traced to foreign cultures. Once, when I was doing an appearance at Saks Fifth Avenue in Palm Springs, I bought a piece that had been made by American Indians, an old Navajo silver squash blossom necklace. I was having dinner that night at Trader Vic's with the now-deceased super-agent Irving "Swifty" Lazar, Frank Sinatra, and a group of other people, and I had the necklace on. We all wore such crazy combinations of clothes then—in the early 60s and late 70s. I probably looked like a fool, but that was all right.

When I returned to New York, I took the necklace apart, copied the parts, put them back together, and eventually sold the original at Sotheby's for almost three times what I paid for it. I made my copy of it in gold rather than silver, using turquoise enamel instead of stones to get the irregularities of shape, but it didn't work. Nobody wanted an American Indian necklace in gold!

A Design Is Born, Deux

I remember once in Rome in the early 1970s I went to see Gianni Bulgari, who was then head of Bulgari. After chatting for a while, I thanked him for advertising a certain necklace that had inspired me to do a version of it. He immediately asked if I'd like to see the real one. He called an assistant to have it brought out and unfortunately was told that it was being shown in Milan that day. However, I *did* get to see it on the lady who eventually bought it.

A few years later, I was at a small dinner at Oscar de la Renta's house. There were three ladies there, besides his late wife, Françoise. Three of them were wearing my "Bulgari" necklace—Françoise, Diana Vreeland, and Babe Paley. One male guest had not yet arrived. I didn't ask who it was, but lo and behold, who should it be but Gianni Bulgari. Rather than being annoyed at my copies, he instantly asked me the price of the necklace and ordered a dozen of them to give to girlfriends.

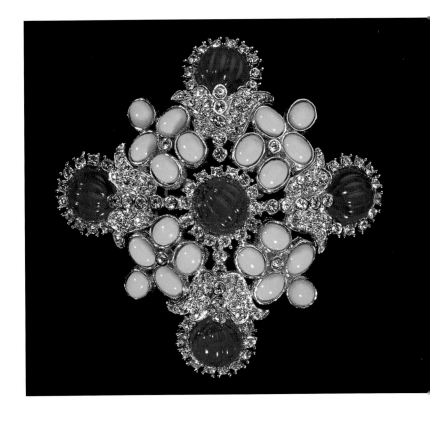

MODIFIED BYZANTINE-STYLE CROSS PENDANT BROOCH.
1970. Plastic turquoise, fluted glass rubies,
diamonds, gold-plated metal. Stamped
Kenneth Lane

The **Maltese Cross** is a wonderful shape. Perhaps if it hadn't been the symbol of the Knights of St. John of Jerusalem, who became the Knights of Malta, it would not have been so prestigious to become a member of that society, and wear the cross.

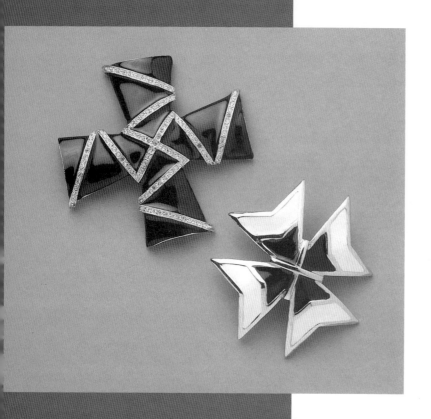

To be a Knight of Malta, one had to prove "sixteen noble quarterings," that is, to have had sixteen ancestors who were able to bear arms. Even the Russian Orthodox czar was so enamored of the Maltese cross that he became the head of the Knights of Malta in Russia, and his portrait, which now hangs in the Russian Museum in St. Petersburg, shows him proudly displaying his diamond Maltese cross.

Crosses and orders were probably first made fashionable in this century by Chanel. D. D. Ryan often wore two Chanel-designed pins, a variation on the Maltese cross, high on the shoulder of her jacket. Gloria Vanderbilt not only wore a striking antique diamond Maltese cross, but incorporated a paste one of mine in one of her romantic collage paintings, which was reminiscent of the Mexican images of the Virgin of Guadeloupe.

Fulco di Verdura, David Webb, and Jean Schlumberger all made superb variations of the Maltese cross. But not until the 1960s did it become very popular. The brilliant Geraldine Stutz, who put the once-forlorn Henri Bendel back on the map with her marvelous new ideas of merchandising, owns a number of my early Maltese crosses and she still wears them in twos and threes.

In the 1960s, women wore symmetrical crosses smack center on their fashionable Courrèges dresses, which were super-modern and futuristic designs straight out of a Flash Gordon comic strip or film. These dresses were probably made to be worn without any jewelry, but ladies *will* adorn themselves. Many women decided that clothes by Courrèges, or similarly designed minimalist looks at the time, were the perfect background to show off their grand orders.

I don't consider myself, literally, an iconoclast—I don't go around to churches bashing icons or statues of saints. However, I have been known to remove the faces of saints from byzantine crosses and replace them with emeralds, rubies, sapphires, and pearls.

CROSS BROOCHES. Stamped Kenneth Lane. (Top to bottom) MALTESE CROSS-STYLE BROOCH. 1992. Glass sapphires, square-cut and pavé diamonds, rhodium and gold-plated two-toned metal; MODIFIED MALTESE CROSS-STYLE BROOCH. 1970. Clear plastic pears, pavé diamonds, rhodium and gold-plated two-toned metal; BROOCH. 1973. Foiled faceted glass stones, hand-soldered gold-plated filigree brass, 3½" across; BROOCH. 1980. Pearls, diamonds, gold-plated metal

This Maltese cross on a golden sunburst motif was much inspired by one made by Verdura for Clare Booth Luce, and sold at auction from her estate. A very good friend of mine bought the original diamond one and, wearing it for the first time at dinner at La Grenouille restaurant, noticed a lady staring at her and eventually pointing to her shoulder—there it was—my near-duplicate.

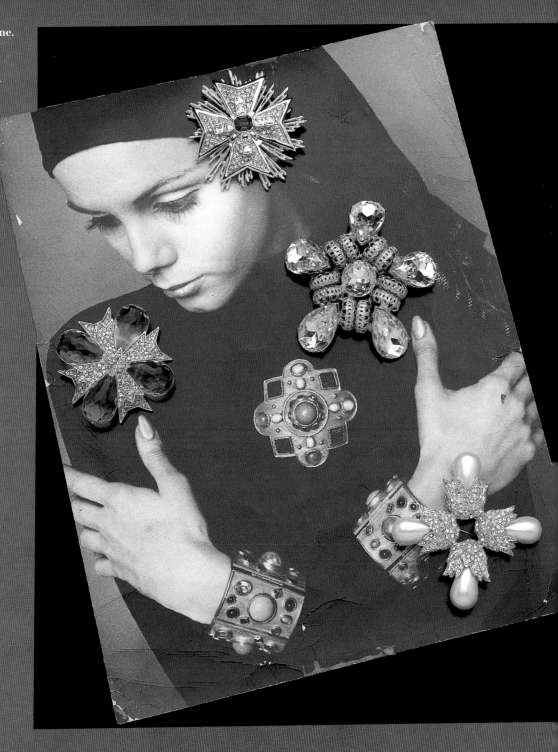

The Maltese cross may have become all the rage, but there was a version that *I'd* made that I had doubts about. It was over this dubious cross that I made a grand faux pas: I was at a Sunday lunch in Paris given by a very fashionable lady, Countess Christiana Brandolini, the sister of Gianni Agnelli of Fiat. She has a very personal style and combines things marvelously, in a kind of rich, wild gypsy way that really suits her. We were sitting around a large table and I noticed her wearing a huge sweater with an enormous brooch in the middle of it. I thought it seemed familiar—it looked like something of mine. She kept shifting about with a certain purpose and finally asked me if I noticed anything. I said, "Of course! You've got on that *hideous* Maltese cross of mine."

She said, "Perhaps not. Take a better look."

My God, she'd had it copied in precious stones by Boivin! I told her that the next time she had one of my pieces copied, she should use one of my better designs.

On another occasion, I was quite flattered when I saw Chessy Rayner's mother, the beautiful Mrs. I. V. Patcevitch, whose husband was the publisher of *Vogue*, wearing one of my favorite crosses which she'd had made by David Webb, in precious stones.

There are so many kinds of crosses, besides the Maltese, that are utterly smashing. The primary jewelry worn during the Renaissance was the cross. Look at portraits of nobles and royals that hang in museums from the Prado to the National Portrait Gallery in London. It is very rare that the lady in question—the noble sitter—was not wearing a jeweled cross, often with pearls dripping from it. In the paintings by Bronzino, which hang in the Uffizi Gallery in Florence, to the portraits of Elizabeth I, the imposing jeweled cross is always present. In the portraits of German nobles by Lucas Cranach, the Elder, there is usually a cross hanging from an oversized golden chain, sometimes long and wrapped around the neck. The chains look like they must weigh a ton.

Many of the great jewels of the Renaissance, besides the cross, were inspired by mythology or a combination of mythology and religion, as in the story of St. George and the dragon. The most impressive image of St. George and the dragon, which is not a piece of jewelry, but a great piece of sculpture, is in Munich. Miniatures of it were fashioned as jewelry to be worn by both men and women. The highly prized and most important order in Great Britain is called "The Great George"—a jeweled St. George and the dragon.

Much of Renaissance jewelry was inspired by the materials themselves, particularly baroque pearls. These were sometimes found in certain rivers that fed into the sea and were called river pearls. They were rather strange and irregular in shape, and would suggest to the jeweler a portion of a person's or animal's anatomy. The pearls were designed to look like the breastplates of warriors, the torsos of mermaids, the bodies of birds or animals—practically any creature one could imagine, real or fictional. Probably the best examples were from the workshops of the remarkable Dresden goldsmith, Dinglinger, made for the Elector Augustus of Saxony, King of Poland, and can be seen in the Grünes Gewölbe.

I first saw these pieces in 1968 before Dresden was as rebuilt as it is now. Today, the Grünes Gewölbe in the

BYZANTINE-INSPIRED CROSS BROOCH. 1990. Glass rubies, flawed emeralds and center sapphire, satin gold-plated metal, 4⅞" across. Stamped Kenneth Lane

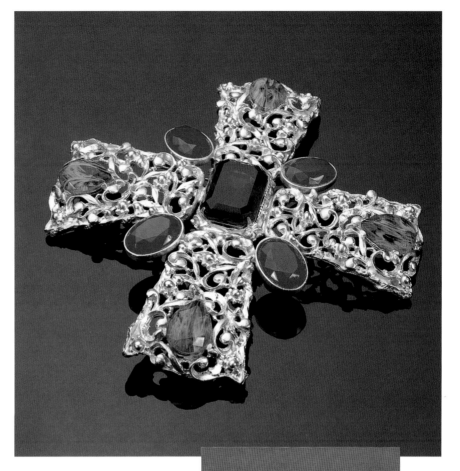

MODIFIED MALTESE-STYLE CROSS BROOCH. 1967. Plastic emerald, turquoise, and hematite sugar-loaf cabochons and turquoise high-domed cabochons, baguette diamonds, antique gold-plated metal, 3⅝" across. Stamped K.J.L. Collection Harrice Simons Miller and Robin Feldman

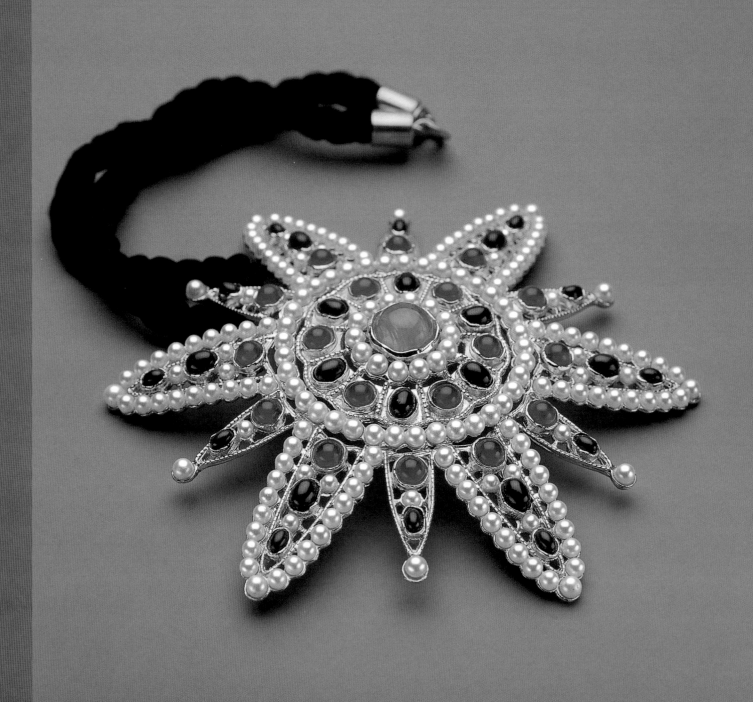

Opposite: BYZANTINE-INSPIRED
PECTORAL. 1970. Glass ruby, jade
and rose quartz cabochons,
pearls, twisted black silk cord,
gold-plated metal, 6" across.
Stamped Kenneth Lane

The inspiration for this very
imperial jewel sits behind heavily
guarded glass in the treasury at
the Hofburg in Vienna, I think.
If it isn't there it should be.

BYZANTINE-INSPIRED NECKLACE.
K.J.L. Workshop, Providence,
1967. Plastic amethyst, ruby,
sapphire and emerald cabo-
chons, mounted round and
baguette diamonds, baguette
diamond chain, hand-soldered,
gold-plated brass mountings,
4¼" diameter. Stamped K.J.L.
The Grace Collection

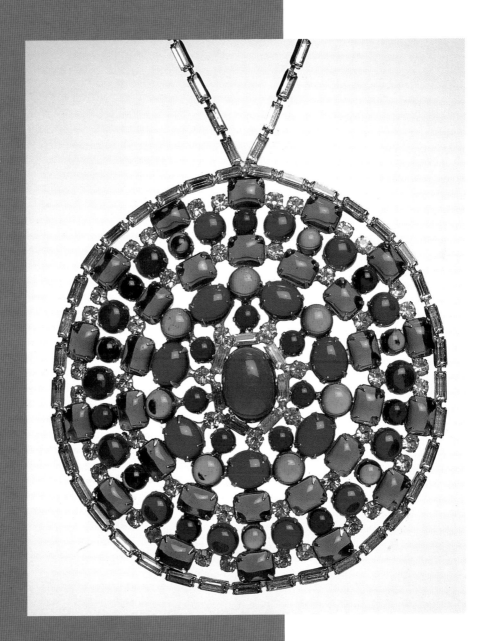

BULGANTINE NECKLACE. 1971.
White enamel, diamonds,
glass sapphire and ruby
cabochons, gold-plated metal.
Stamped Kenneth Lane

It's only fitting that the Bulgaris,
who are of Greek origin, should be
influenced by the Byzantine Empire
which kept Greek culture going for
centuries after the fall of Rome.

RENAISSANCE-INSPIRED BROOCHES. (Left to right) HORSE AND HOUND BROOCH. Late 1960s. Glass lapis lazuli, coral, and jade cabochons, faceted topaz and amethysts, emeralds, diamonds, turquoise beads, baroque pearl drop, antique silver and gold-plated two-toned metal. Stamped K.J.L.; UNICORN BROOCH. Late 1960s. Lapis lazuli, turquoise, topaz, and emerald cabochons, pearl bead fringe, diamond collar, antique gold-plated metal. Stamped K.J.L. Laguna. Collection Prudence Huang

My fantasy running amok. The Renaissance meets James Thurber. You'll never see this unicorn in *your* garden.

The quite touching freak animal had a dog for a father and a horsey mum. This must have been inspired by a fantastical Hindu miniature of a mythical beast.

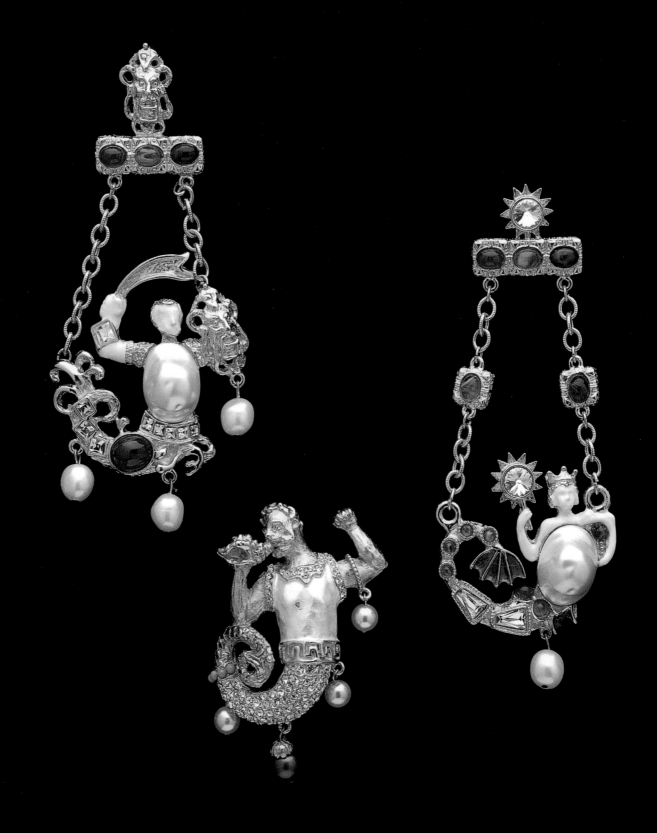

Opposite: RENAISSANCE-INSPIRED BROOCHES.
Each: gold-plated metal. (Left to right)
WARRIOR BROOCH WITH ENHANCER. 1993.
White enamel, ruby, emerald, and sap-
phire cabochons, pearlized cast plastic,
square diamonds, baroque pearls, 5⅝"
high. Stamped Kenneth Lane; NEPTUNE
BROOCH. Late 1960s. Diamonds, gray and
white pearls, turquoise, pearlized nail
polish. Stamped K.J.L. Laguna. The Grace
Collection; MERMAID BROOCH WITH
ENHANCER. 1993. Transparent green
enamel, ruby, emerald, and sapphire
cabochons, pearlized cast plastic, key-
stone and brilliant-cut diamonds.
Stamped Kenneth Lane

Perhaps lingering far too long in the
museums of royal treasures. Trying to
be Cellini?

EUROPA AND THE BULL PENDANT BROOCH.
1968. Glass lapis lazuli, emerald, coral,
and turquoise cabochons, foiled square-
cut sapphires, baroque pearls, rhodium
and gold-plated two-toned metal.
Stamped K.J.L.

Europa's revenge!

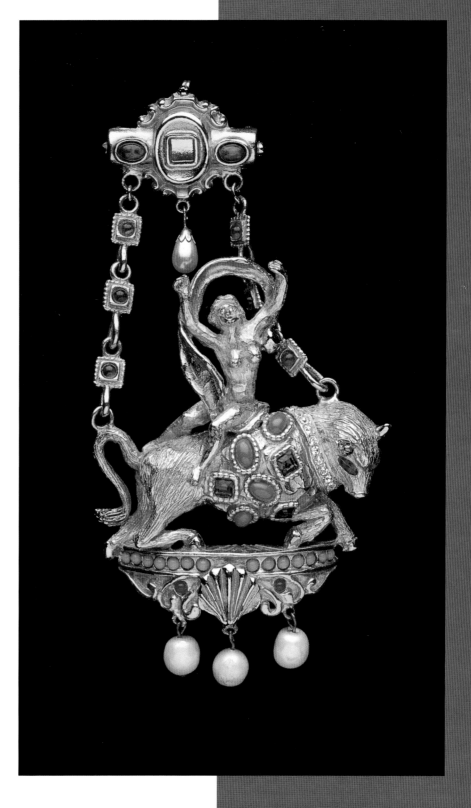

PEAR BROOCH. c. 1966. Gray pearlized hollow blown glass pearl, diamonds, antique gold-plated metal. Stamped K.J.L. Collection Virginia M. Fuentes

This adaptation of the Baroque pearl suggesting an anatomical part really worked for this pear. *The* most successful design of all my Renaissance endeavors. It was resurrected in the mid-1980s in cast plastic and in every possible flavor, although the pearl remained the most popular.

Staatliche Kunstsammlungen has been restored, and the collection is displayed in a manner reminiscent of the eighteenth century. It's a treat for the eyes and inspiration for the jeweler.

Before I was able to cast faux baroque pearls in resin as I do now, I had to improvise. To do this, I painted over metal with a few coats of white pearlized nail enamel to get the right effect. Later, we used the baroque pearls I had made in pearlized resin for other neo-Renaissance inspired jewelry and in more whimsical and contemporary designs, for the bodies of elephants, turtles, frogs, and other beasts. I designed a half man/half fantasy creature and a pear pin, using a large baroque Renaissance-style pearl.

The Metropolitan Museum of Art has a superb collection of Renaissance jewels; some are in the Linsky Collection, next to the Wrightsman Gallery. Displayed there are fanciful beasts—ones more imaginative than those that have appeared in any children's fairy tales.

Once I saw an adorable pig, one of a huge family of pigs in a Venice window. Mine was lying on its back just waiting to be made into a brooch. After I made my version of it, substituting a large pearl in its belly à la Renaissance, this little piggy went to market that day!

When I was **still designing shoes** for Genesco, I'd very often stop by the shop À La Vieille Russie, which was a few blocks up Fifth Avenue from my office on Fifty-seventh Street. Mrs. Schaeffer, the *propriétaire*, was very sweet to me. I was very young and she'd show me all sorts of treasures. Although I never bought very much, I spent a lot of time there browsing. There was a wonderful gold cigarette case there, possibly by Fabergé, with a very subtle *repoussé* octopus on it. It was satiny gold, which would eventually inspire me to design satin-finish gold bracelets.

Years later, I was doing cuff bracelets and I made one with a *repoussé* octopus. It was *not* a big seller! I have a

FRUIT SALAD JEWELRY. 1992. Each: Stamped
Kenneth Lane. APPLE PENDANT NECKLACE.
Pearlized cast plastic apple, pavé diamond
leaf, rhodium and gold-plated two-toned
metal, gold-plated brass chain; STRAWBERRIES.
Cast plastic brooch, earring, and pendant,
gold-plated metal and brass chain

Steuben glass began marketing a crystal
and 18k gold strawberry pendant in the late
1960s or early 1970s which I always admired.
I designed the brooch first in a red to
simulate purpurine and went on to make
the earrings and pendant in many colors.

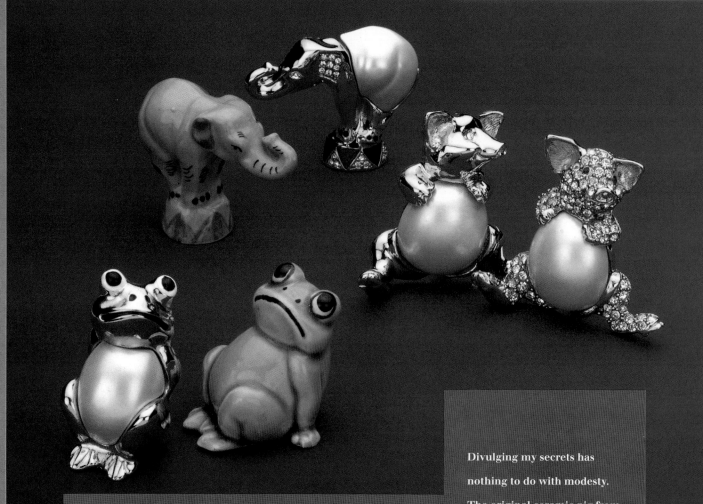

CIRCUS ELEPHANT, PIGS, AND FROG BROOCHES. 1993. Each: gold-plated metal. ELEPHANT BROOCH. Red and blue enamel, pearlized cast plastic, diamonds. Stamped Kenneth Lane; PIG BROOCHES. Pearlized cast plastic, one with pavé diamonds. Stamped Kenneth Lane; FROG BROOCH. Black and white enamel, pearlized cast plastic. Stamped Kenneth Lane

Divulging my secrets has nothing to do with modesty. The original ceramic pig from Venice was cruelly destroyed in the mold-making, but the elephant from some tacky souvenir shop and the fatally adorable frog ($1.50 from a charity resale shop in West Chester, Penn.) found during a lunch break from QVC, survived. This is what I call having the "eye."

HUMPTY DUMPTY BROOCH. 1970.
Emerald cabochons, plastic
pearl, diamonds. Stamped K.J.L.

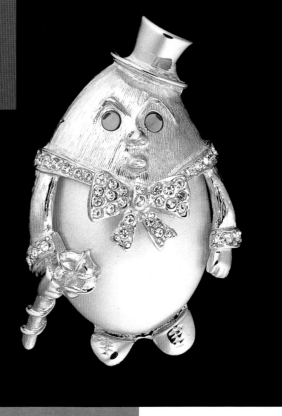

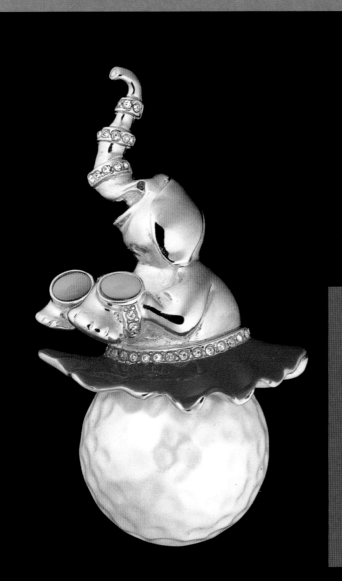

ELEPHANT BROOCH. 1991. Red enamel,
plastic pearl, turquoise, emeralds,
diamonds, gold-plated cast metal.
Stamped Kenneth Lane

The original elephant from the 1960s
ended with the tutu. I purchased it
from a vintage shop in the 1980s and
she absolutely cried for a huge pearl
to rest upon.

wonderful octopus brooch in my collection now. I had it made from a little glass object I picked up in a tourist shop in Venice. I go to Venice every year and always look in the souvenir-touristy shops, rather than the jewelers on the Piazza San Marco, because often they have either interesting, unusual, or funny things to buy. The octopus I found had been sitting on a shelf with others like it. It had a lot of personality and was rather charming.

I've found inspiration at the Bronx zoo, flea markets around the world, and in literature. In Joris Huysmans' symbolist book, *A Rebours* ("Against the Grain"), the self-indulgent hero of the novel had a tortoise studded with gems which crawled freely around the house. What an image! Of course, jeweled turtles are a favorite theme of mine.

In the early part of the century, Jeanne Toussaint, the great designer for Cartier, took animal motifs, which were really *chimères*, and had them carved in coral, studded with emeralds, diamonds, and rubies, and fashioned them into the most wonderful bracelets that bring astounding prices today at auction.

A friend, Countess Antoinette Guerrini-Miraldi, wears an absolutely marvelous family jewel which is a rather pale emerald in the shape of an apple. It's one of the jewels I've always loved and thought about. I couldn't resist, so I had an apple made in imitation purpurine. This rich red compound was developed by Fabergé when he was unable to find a natural stone in the shade of red he wanted—a red for use specifically in certain of his figurines and boxes. Purpurine was created exactly as Fabergé envisioned *his* red.

My apple has since fallen off the tree in jade, jet, clear crystal, tortoiseshell, amber, and wonderful pearl.

If you read the Bible, you know that God invented serpents and thank God he did because we'd still be in the Garden of Eden and there would be no jewelry. Snake bracelets were very popular in the nineteenth century and before that in ancient Greek, Roman, Scythian, and Egyptian jewelry. It's hard to imagine Cleopatra without a gold snake coiled up her arm.

But it was really Marella Agnelli, one of the *most* attractive women in the world, who inspired my making serpent bracelets—and it was long before I ever thought about designing jewelry. I was at a dinner in the south of France, at a restaurant with a terrace called Le Pirate. There were perhaps forty of us sitting at long tables. Fires were burning in open pits.

Marella was sitting across from me, wearing turquoise Pucci pants and a navy blue sweatshirt, with the sleeves pushed up. I guessed the shirt was from Standa, Italy's version of the five-and-ten-cent store. She was tanned and had wonderful short hair. One long arm was covered with Victorian turquoise snake bracelets. It was smashing! I'd never seen *anything* so chic.

Years later when I began making jewelry, I found a Victorian snake bracelet in an antique store that was a marvel. It was made in small sections of bone, strung on spring wire. By then I knew a little about casting, so I had the head and tail of the snake made in metal and plated gold. Remembering Marella's snakes, I did my first snake bracelets with turquoise beads wrapped around cotton cording, with a spring wire inside. It was

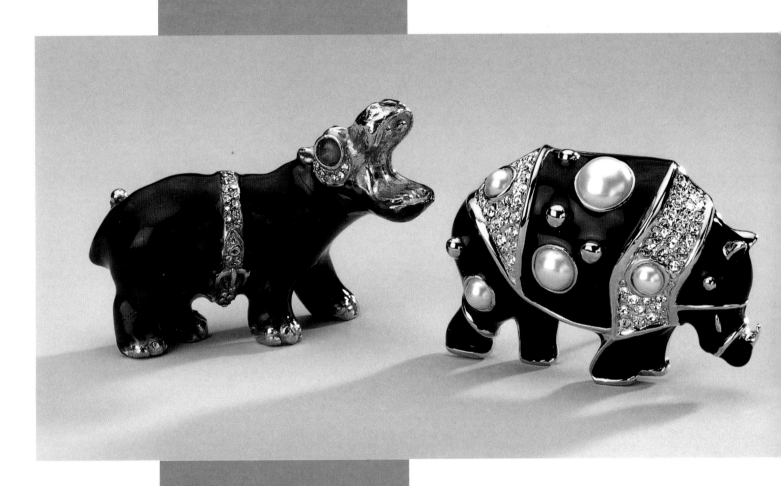

Hippo and rhino brooches. Each: gold-plated. Hippopotamus brooch, 1967. Aubergine enamel, emerald cabochons, diamond. Stamped K.J.L. Collection Virginia M. Fuentes; Rhinoceros brooch. 1989. Black enamel, plastic pearls, diamonds. Stamped Kenneth Lane

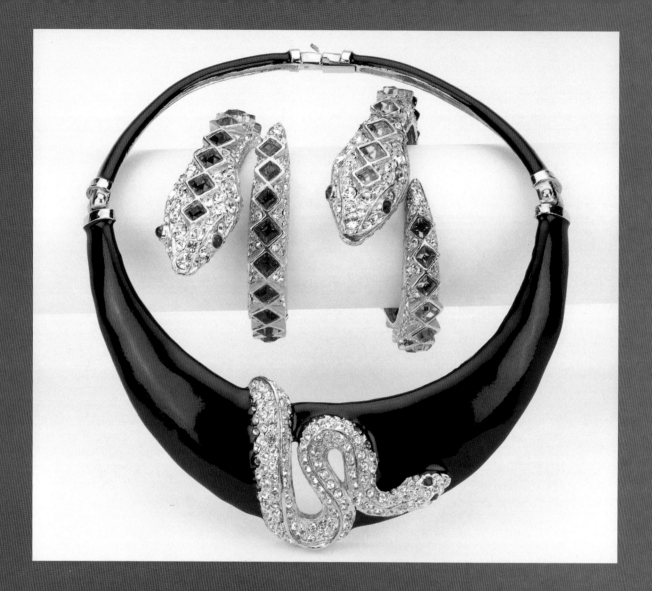

SNAKE COLLAR AND HINGED BRACELETS. Each: rhodium and gold-plated two-toned metal. COLLAR. 1970. Black enamel, pavé diamonds, rubies. Stamped Kenneth Lane; BRACELETS. 1968. (Left) Rubies, pavé diamonds, square emeralds. Stamped K.J.L. The Grace Collection; (right) Rubies, pavé diamonds, square topaz

The snake on this collar was inspired by the Fabergé blue enameled cigarette case adorned by a diamond snake given to King Edward VII by his mistress Alice Keppel. After the King died, Queen Alexandra gave the box back to Mrs. Keppel and years later she presented it to Queen Mary for her Fabergé collection.

 This very opulent snake bracelet with emerald bezel-set squares running down its back was bought by the Duchess of Windsor and one was given to Princess Margaret by her then-husband Lord Snowden. If the Duchess and her step-niece Princess Margaret had ever met and shaken hands, wouldn't it have been amusing if they were both wearing their K.J.L. serpents.

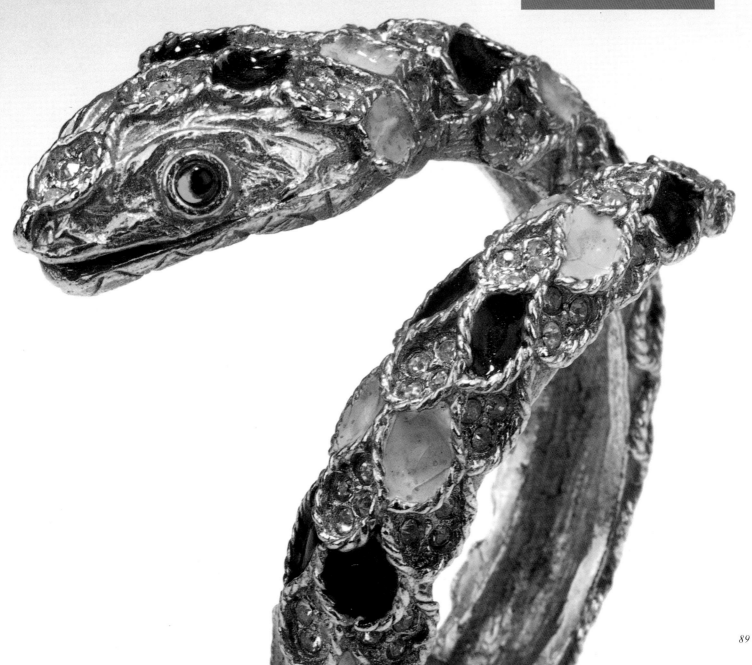

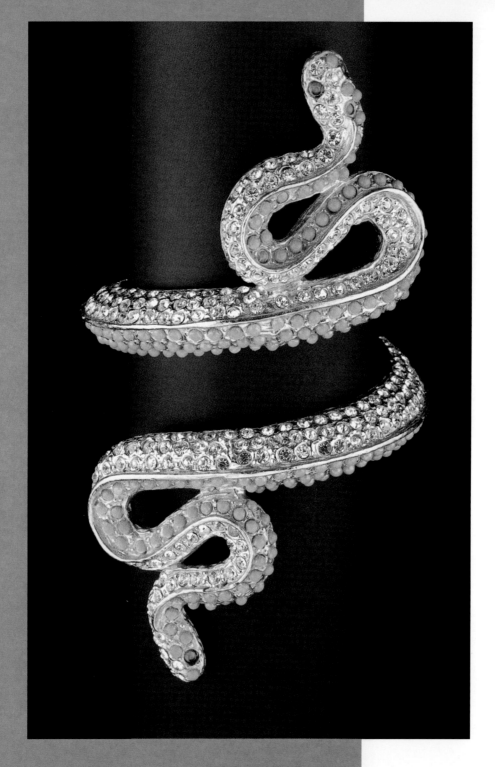

GRECO-ROMAN-INSPIRED
DOUBLE HINGED SNAKE
CROSSOVER BRACELET. 1970.
Glass emeralds and
turquoise, pavé diamonds,
rhodium and gold-plated
two-toned metal.
Stamped K.J.L.

Imagine a 19th-century
romantic Academy
portrait of Cleopatra
without a bracelet
like this.

a great success! After that, I did all sorts of other animal bracelets—panthers and tigers, lions and monkeys, with all varieties of colored beads in stripes and polka dots. Lord & Taylor did a whole window of these around 1964.

For "models" I'd buy small Viennese animal bronzes, cut their heads off and cast them. I once did that to a monkey figurine, then had the head soldered back onto the body and had the whole thing plated in gold. It was sitting in my showroom on my desk and Princess Daisy Windisch Graetz saw it and fell in love. She absolutely had to have it for her monkey collection. I had paid about $20 for it originally and sold it to her for $250!

Sometimes I invented my own animals. I've also taken them from the fantastical images in Indian miniature paintings where the great gods in their animal forms were represented whimsically by local artists.

Animal bracelets were one of my great early successes. Fortunately for me, at about the same time, David Webb had revived the fashion of animal bracelets from the 1920s and 30s and made his wonderful versions of them. Cartier has always continued to do them.

Remembering my years designing shoes, I soon started working with my favorite theme, which was animal-skin patterns—of course I had the pattern jeweled. I did pavé leopard, tiger, and zebra patterns in earrings and bracelets. I even brought the look to my flat in the 1950s and had an eighteenth-century French chair covered in leopard-stenciled calf, long before anyone else did that sort of thing.

Butterflies, bugs, and other motifs from nature came into fashion in the eighteenth or nineteenth century, and I still find inspiration in these creatures. Flowers became prevalent designs in the eighteenth century—diamond flowers, *tremblant*, wonderful things like these, that I love, as well.

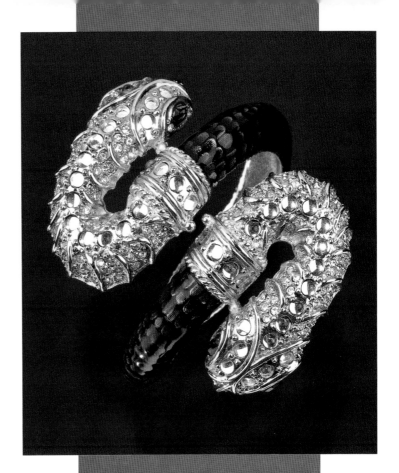

DOUBLE-HEADED SNAKE HINGED CROSSOVER BRACELET. 1970. Transparent brown enamel, glass emeralds and clear cabochons, diamonds, gold-plated metal. Stamped Kenneth Lane

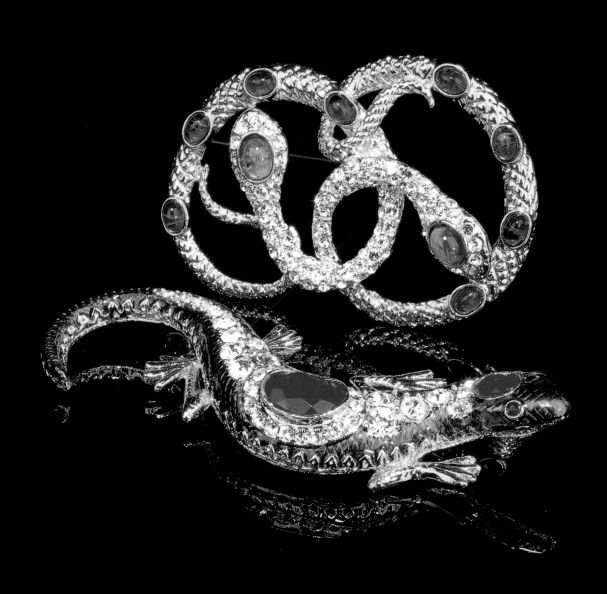

Opposite: DOUBLE SNAKE AND SALAMANDER BROOCHES. Each: gold-plated metal. Stamped Kenneth Lane. SNAKE BROOCH. 1990. Glass emerald and sapphire cabochons, pavé diamonds; SALAMANDER BROOCH. 1988. Transparent green enamel, faceted rubies, diamonds

The salamander brooch was inspired by the extraordinary St. George and Dragon statuette in the Schatzkammer in Munich, arguably one of the most extravagant and beautiful jeweled objects in the world. The dragon being slain by St. George is enameled green on one side, studded with rubies, and white on the other, studded with emeralds.

DOUBLE-HEADED SEA SERPENT HINGED CROSSOVER BRACELET. 1967. Pistachio enamel, plastic coral cabochons, glass emerald cabochons, rhodium and gold-plated two-toned metal. Stamped K.J.L. Collection Rhoda Rubovitz

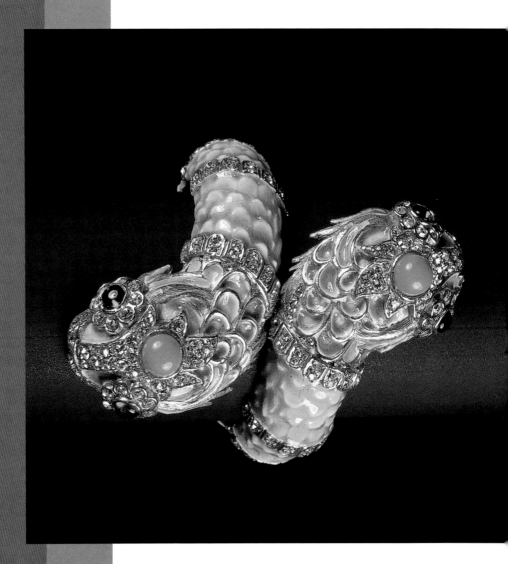

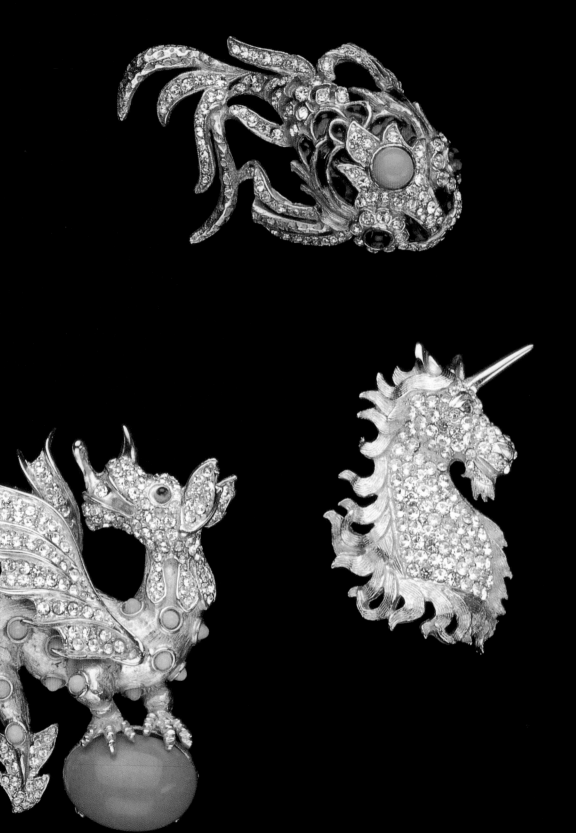

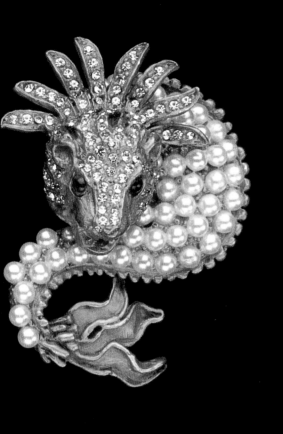

FANTASY ANIMALS. (Left to right) FISH BROOCH. 1967–68. Aubergine enamel, glass emerald and turquoise cabochons, pavé diamonds, antique gold-plated metal. Stamped K.J.L. The Grace Collection; FANTASTICAL SEA MONSTER BROOCH. Late 1960s. Glass emerald cabochons, pearls, pavé diamonds, antique gold-plated metal. Stamped K.J.L. Laguna. Collection Prudence Huang; WINGED DRAGON BROOCH. 1968. Glass emerald and turquoise cabochons, plastic coral cabochon, pavé diamonds, rhodium and gold-plated two-toned metal. Stamped K.J.L. Collection Prudence Huang; UNICORN BROOCH. 1970. Faceted glass emerald, pavé diamonds, rhodium and gold-plated two-toned metal. Stamped K.J.L. Collection Prudence Huang

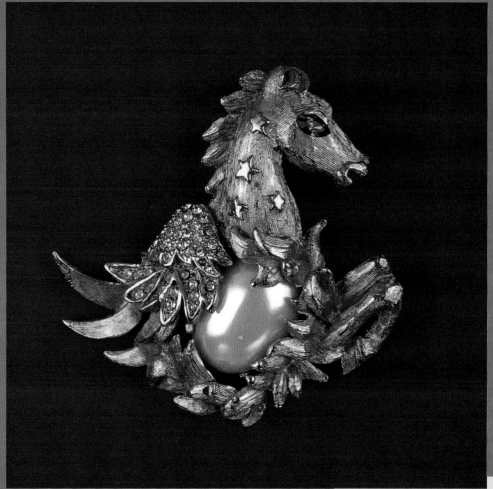

MONKEY AND FROG BROOCHES. 1967. Each: rhodium and gold-plated two-toned metal. MONKEY BROOCH. Aqua enamel, glass coral cabochons, rubies, diamonds, emeralds, pearl. Collection Prudence Huang; FROG BROOCH. Glass turquoise and aqua-marine, ruby, coral, topaz, emerald, and fire opal cabochons, baroque pearl. Stamped K.J.L. The Grace Collection

Considering that marijuana and hashish, the hallucinatory drugs of the 1960s, didn't agree with me, I can't imagine what made my imagination run so wild.

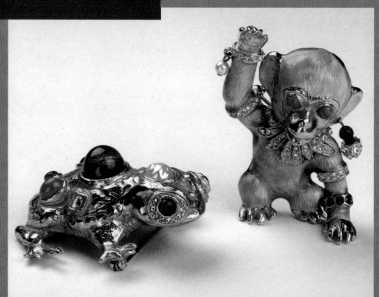

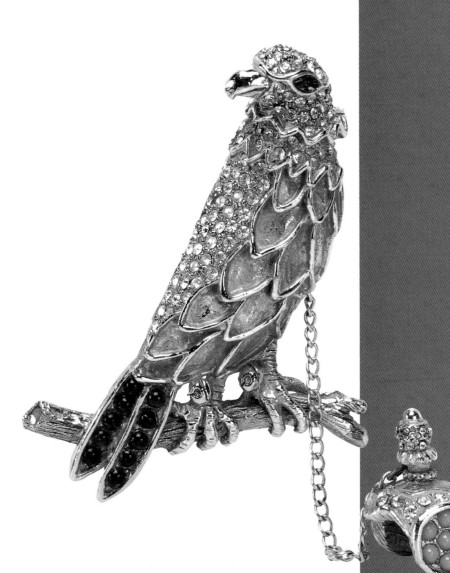

HOODED FALCON BROOCH. 1968. Glass emerald and turquoise cabochons, pavé diamonds, rhodium and gold-plated two-toned metal. Stamped K.J.L.

The hooded falcon was inspired by a watercolor painted by Van Day Truex, who for years was the head of Parsons School of Design in Paris. Under the leadership of Walter Hoving, he came back to New York to be design director at Tiffany, and changed totally the image of that institution, developing secret treasures, wonderful Mexican silver, little-known Italian ceramics, and Jean Schlumberger.

Falcons have always been the hunting birds of princes. A back stairway at the Schloss at Fulda is hung entirely with the most wonderful portraits of Hesse falcons. I think this is a truly princely brooch.

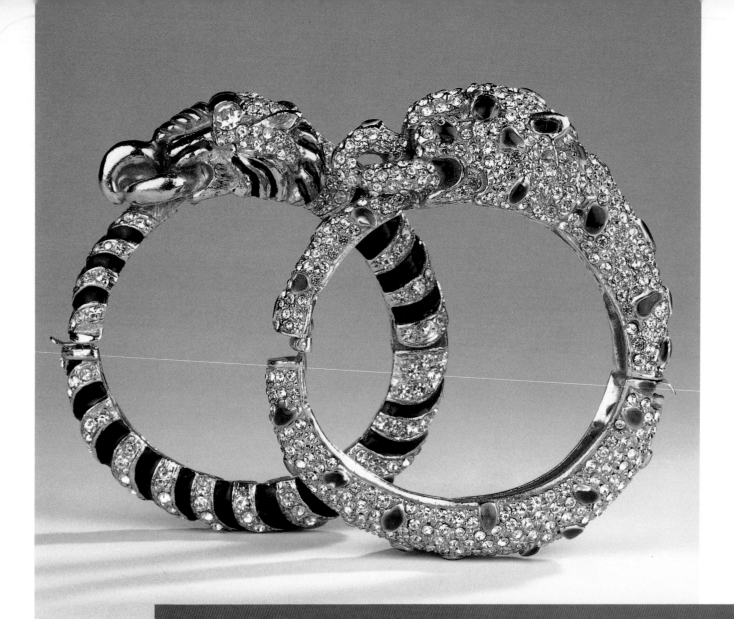

TIGER AND PANTHER HINGED BRACELETS.
Rhodium and gold-plated two-toned
metal. Stamped K.J.L. TIGER BRACELET.
Late 1960s. Black enamel, diamonds.
PANTHER BRACELET. Late 1960s. Green
enamel, emeralds, pavé diamonds.
Collection Rhoda Rubovitz

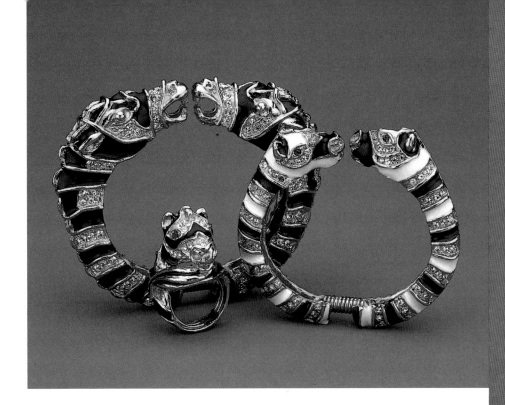

ZEBRA SPRING-HINGED BRACELETS AND RING. 1969. Stamped K.J.L. Black and white enamel, sapphires, rubies, diamonds, rhodium and gold-plated two-toned metal

Zebra bracelets were introduced by David Webb, and Diana Vreeland wore his together with two spotted and enameled panthers of mine. I invented the spring bracelet using an industrial steel spring. This works wonderfully because they are very easy to take on and off, cling to the wrist, and fit almost anyone.

LEOPARD-PATTERNED HINGED CUFFS. 1990. Stamped Kenneth Lane. Light topaz, topaz and jet flat-back stones, gold-plated metal; jet, smoke and clear flat-back stones, silver-plated metal

Jeanne Toussaint, the great designer for Cartier, created marvelous spotted cat jewels for the Duchess of Windsor. Winston Churchill said something like this about *that* lady, "All English schoolchildren should thank God every day for the birth of Mrs. Simpson." I thank God for Mme. Toussaint. Leopard skin has been fashionable since earliest times—on the saddles of Arab horses painted by Delacroix, under the voluptuous figures of odalisques, thrown over chairs, on the floor, woven in silk, and simulated in fake fur. I returned to my earliest techniques to make these mosaic cuffs.

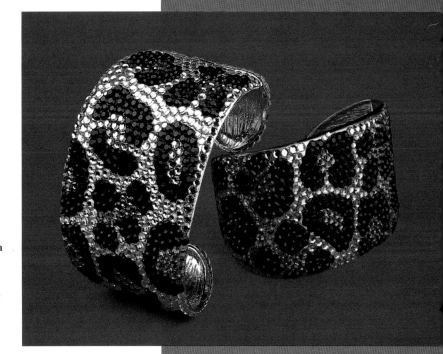

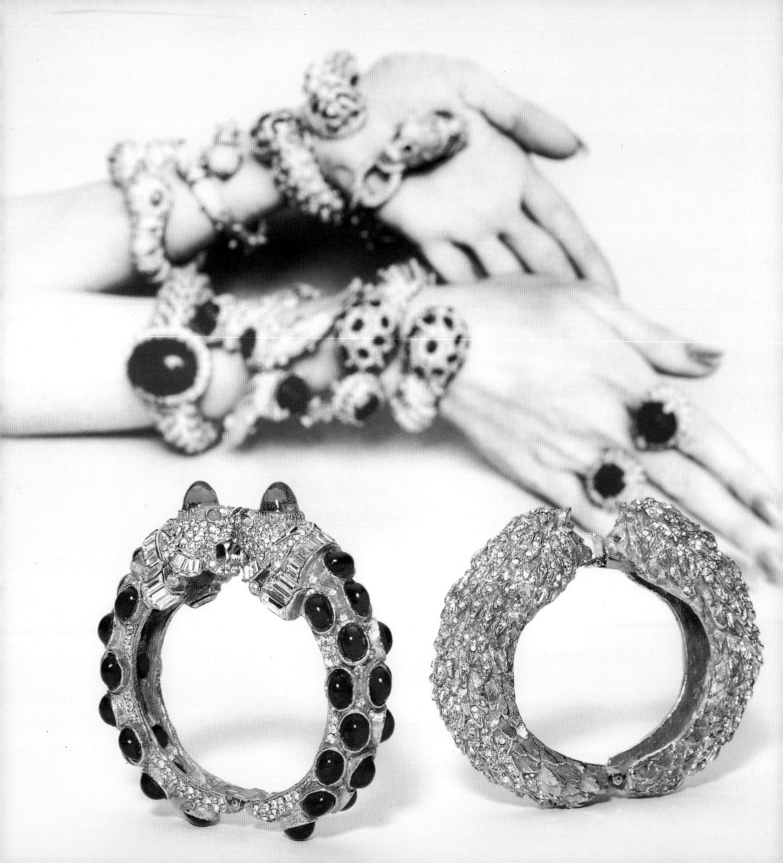

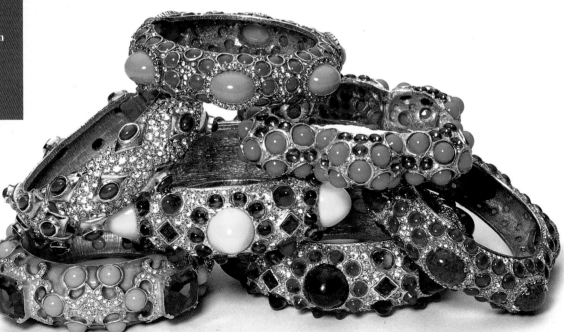

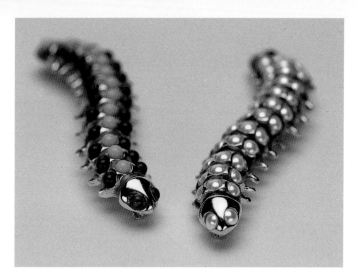

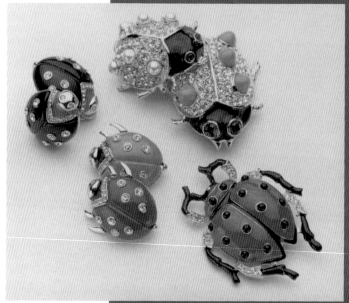

CATERPILLAR BROOCHES. 1995. Gold-plated metal. Stamped
Kenneth Lane. (Left) Green enamel, glass ruby cabochons,
plastic lapis lazuli and turquoise cabochons; (right) Brown
enamel, pearls, 3½" long

The Age of Romanticism, which lasted from the late 18th
century through most of the 19th, brought the world out of
the salon and into nature. All forms of God's creatures
appeared in jewelry—bees (Napoleon's motif), bugs of all
kinds, frogs, turtles, and even caterpillars.

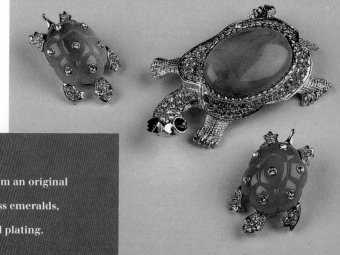

TURTLE BROOCH AND EARRINGS. 1985, copied from an original
K.J.L. turtle, late 1960s. Cast plastic jade, glass emeralds,
pavé diamonds, rhodium and gold two-toned plating.
Stamped Kenneth Lane

Opposite: LADYBUG BROOCHES AND EARRINGS. 1985. Each: rhodium and gold-plated two-toned metal. Stamped Kenneth Lane. (Clockwise, from the top) BROOCHES. Black enamel, emeralds, pavé diamonds, one set with pearls, one plastic coral cabochons; BROOCH. Red and black enamel, jet cabochons, diamonds; EARRINGS. Red enamel, black cast plastic, diamonds; BROOCHES. Black enamel, red and coral cast plastic, diamonds

DRAGONFLY BROOCHES. 1993. Each: rhodium and gold-plated two-toned metal. Stamped Kenneth Lane. Black cast plastic, faceted rubies, sapphires, emeralds, diamonds; Clear cast plastic, diamonds, 3½" across

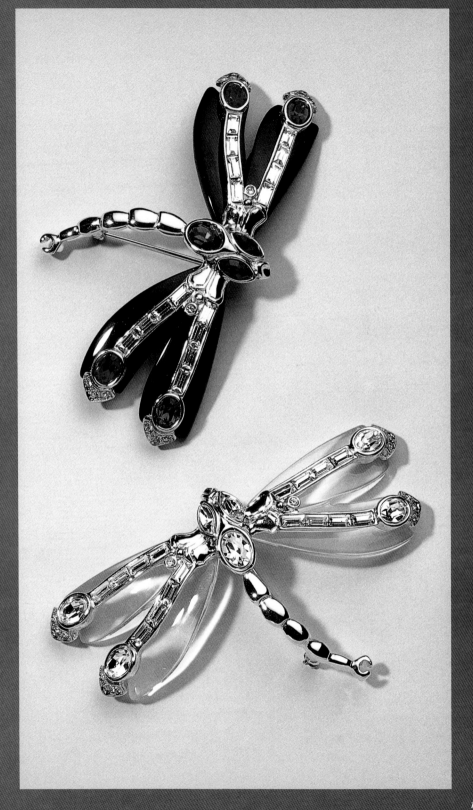

The high point of my year would be the great Lena's annual visit to my showroom. She wore earrings that I made in the 1960s on stage at Carnegie Hall for her last concert.

Art Nouveau style was original, but somehow never became particularly fashionable during its time—although there was huge interest, and endless imitators of it, in the 1960s and 70s. But Art Nouveau to wear was too intellectual for the turn-of-the-century *femme du monde*. The wonderful jewelry made by René Lalique was worn by Austrian doctors' wives and stage actresses such as Sarah Bernhardt, rather than by society women or courtesans, "les grandes horizontales." The style just wasn't flattering enough.

Art Deco has always been one of my favorite periods in jewelry design. I think it's probably the first really important design innovation in jewelry in two hundred years. Up to then, there had been many revivals. In the nineteenth century, there was a great revival of eighteenth century and even Renaissance jewelry. There was a revival of Empire jewelry, which was a revival of

Roman jewelry using micro-mosaic, done by such jewelers as Castellani. But all of those had a foot in the past.

Art Deco is the familiar and abbreviated name given to a form of design launched at the Paris Exposition des Artes Décoratifs et Industriels Modernes in 1925—a movement that influenced design until the late 1930s. It had panache and pizazz, and it was wonderful.

Art Deco was modern, clean-lined, glamorous, sexy, and completely original. The genius of Art Deco was used in architecture, interior decoration, clothing, and textile design and it had a particular longevity in jewelry design. Art Deco jewelry made by such houses as Cartier and Lacloche now bring enormously high prices at auctions and is bought to wear or held in permanent collections in museums. The workmanship of the time was extraordinary.

Art Deco jewelry had a subtlety about it—the palette was limited to green jade, black onyx, coral, and turquoise. The design was the thing, but jewelers added

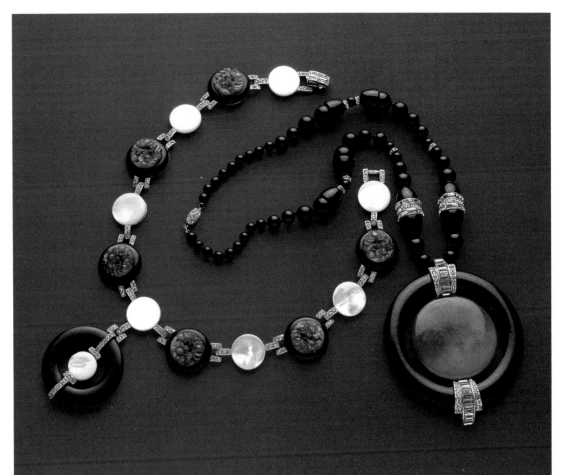

ART DECO-STYLE NECKLACES. 1972. Each: rhodium-plated metal. Stamped Kenneth Lane. NECKLACE. Mother-of-pearl, glass jade, black plastic, diamonds; PENDANT NECKLACE. Black and jade plastic, round and baguette diamonds, 23½" long

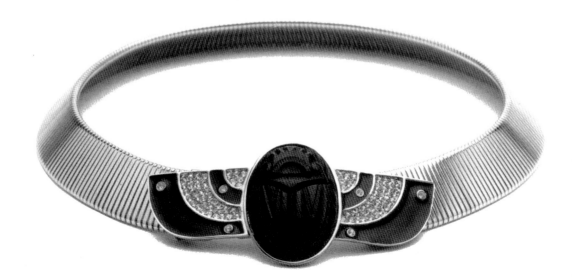

EXPANDABLE ART DECO-STYLE BELT. 1972. Black enamel, black plastic scarab, pavé diamonds, rhodium and gold-plated two-toned metal buckle, gold-plated cobra chain. Stamped Kenneth Lane

ART DECO-STYLE JEWELRY. (Left to right) DOUBLE-PRONGED DRESS CLIP. 1970. Vintage black glass, plastic coral and chrysoprase, baguette diamonds, rhodium-plated metal. Stamped K.J.L.; BROOCH. 1970. Black and coral plastic, glass jade, square diamonds, rhodium-plated metal. Stamped Kenneth Lane; BROOCH. Black and coral plastic, vintage glass jade, baguette diamonds, rhodium-plated metal. Stamped Kenneth Lane. Collection Chessy Rayner; BRACELET. 1980. Clear and coral plastic, diamonds, rhodium-plated metal; HINGED BRACELET. 1967. Black plastic and chrysoprase, pavé diamonds, rhodium-plated metal; BRACELET. 1980. Black plastic, diamonds, rhodium-plated metal; EARRINGS. 1980. One with coral and black plastic, one black and frosted clear plastic, diamonds, rhodium-plated metal. Stamped Kenneth Lane

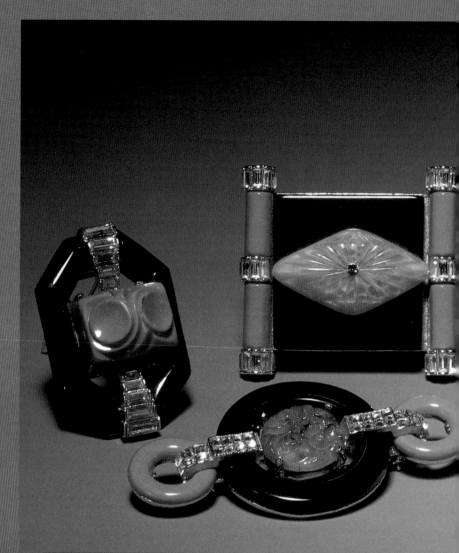

Jewelry of the Art Deco period was sexy, and so were the clothes and the rooms they were worn in. Luxurious and moderne, they were never imagined worn or lived in by other than rich, rather naughty people, drinking cocktails and smoking through long cigarette holders often made of the same coral, jade, and onyx as the jewels.

Gloria Swanson's rock crystal and diamond bracelets epitomized this era as did the rows of narrow diamond bracelets worn by Constance Bennett in films, the Dolly Sisters, and others of that ilk provided by wealthy stage-door Johnnies. These bracelets were sometimes called "service stripes."

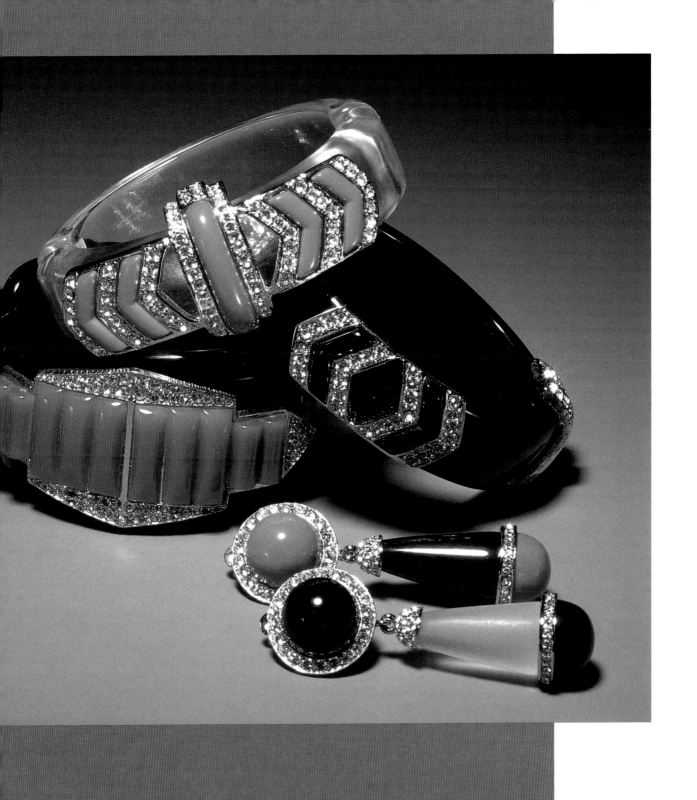

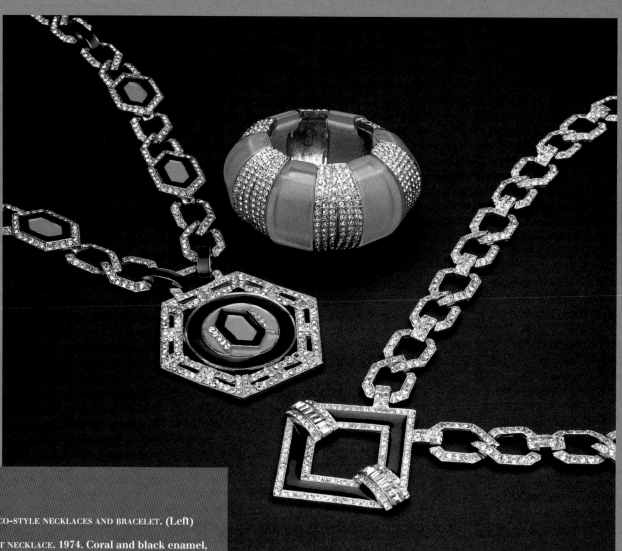

ART DECO-STYLE NECKLACES AND BRACELET. (Left) PENDANT NECKLACE. 1974. Coral and black enamel, pavé diamonds, rhodium and gold-plated two-toned metal, 26" long. Stamped Kenneth Lane; (right) PENDANT NECKLACE. Black enamel, round and baguette diamonds, rhodium-plated metal. Stamped Kenneth Lane; BRACELET. Frosted clear plastic, pavé diamonds, elastic, rhodium-plated metal. Stamped K.J.L.

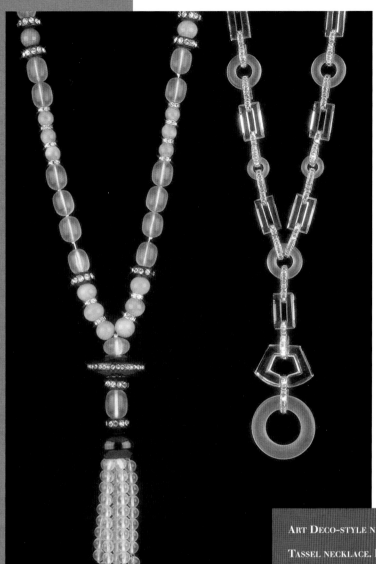

ART DECO-STYLE NECKLACES. 1970. Each: rhodium-plated metal. TASSEL NECKLACE. Black and frosted clear plastic, glass jade beads, diamonds, 42½" long; NECKLACE. Vintage glass, frosted clear plastic, baguette diamonds

The necklace of frosted clear crystal and glass was purchased from me by Lord Rupert Nevill, who was equerry to the Duke of Edinburgh, as a gift to H.M. the Queen. I would buy old glass elements from the 1920s and 30s, which were in very limited quantities, and eventually have them copied in plastic. This really worked only if the parts had rounded as opposed to sharp edges.

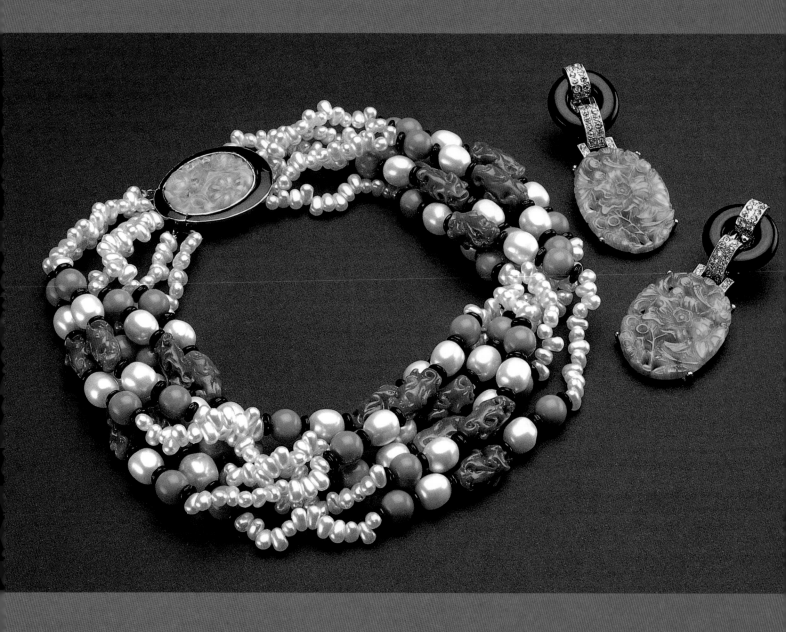

ART DECO-STYLE TORSADE NECKLACE AND
EARRINGS. Stamped Kenneth Lane.
NECKLACE. 1980. Plastic biwa and
baroque pearls, black plastic rondelles,
coral and elongated jade beads, black
enamel clasp with glass jade, gold-plated
metal; PENDANT EARRINGS. 1970. Glass
jade, black plastic, diamonds, rhodium-
plated metal

dazzle to the drama with emeralds, diamonds, clear glass, rock crystal, and even plastic, a new and versatile product at the time.

Eventually my Art Deco jewelry was being worn by such fashionable women as Aline, Countess de Romanones; Liz Fondaras; and my friend, Camilla McGrath, who has the real McCoy. When I started doing the Art Deco style in the 1970s, I was inspired by a brooch that Camilla inherited from her mother, Countess Pecci-Blunt, which was a jade plaque in a circle of black onyx embellished with a few diamonds. I couldn't stop creating Art Deco pieces, even though there was no market for the look. It was even too advanced for most of my friends, but I continued to make it because I loved it.

Finally, the Horchow catalogue did a page called, "From the Estate of Kenneth Jay Lane." It featured my Art Deco jewelry—the first really commercial promotion of this collection.

It sold out!

Baron Nicky de Gunzberg, who
was a legendary fashion editor at *Vogue*, once gave me a photograph of a pre-Columbian necklace he had seen at an exhibition in California. It was made of rock crystal prisms. I tried to copy it in plastic, but it didn't work. David Webb used rock crystal cut to look like enormous early Renaissance stones that he combined with gold, black enamel, and diamonds.

Rock crystal was very often used in Art Deco jewelry, especially in a famous pair of bracelets made for Gloria Swanson by Cartier. They were made of crystal set with diamonds and strung with insouciance on elastic. Every few years Swanson would bring them back to Cartier to be restrung!

Fulco di Verdura, who began designing
costume jewelry for Chanel, accessorized the most fash-

Bill Blass dress with Kenneth Jay Lane 18th-century-style jewelry. Photo, David Seidner, 1992

I called the 18th-century style of rococo bows, arabesques, and pendants "Let Them Eat Cake" after you know who.

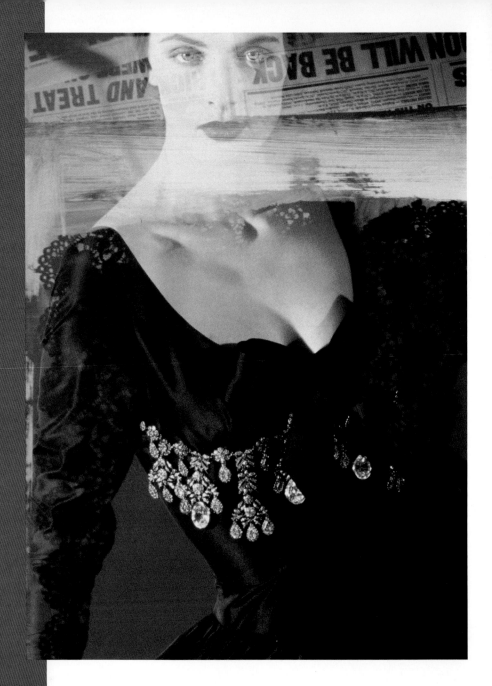

ionable women of his time. Verdura, along with Jean Schlumberger, Jeanne Toussaint of Cartier, Suzanne Belperron, and David Webb, were the great designers of the first half of the twentieth century and they have all inspired me.

Verdura's *haute bijoux* even got noticed by Cole Porter, who immortalized his name in a song called "Farming,"

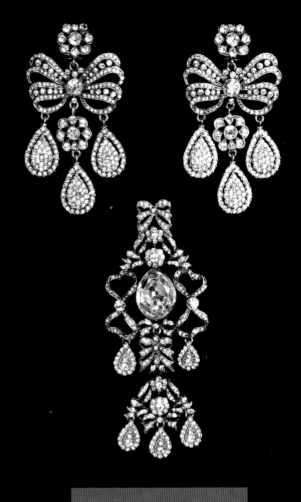

Bill Blass dress with Kenneth Jay Lane brooch. Photo, Gideon Lewin, 1988. Bill Blass Ltd. Archives

18TH-CENTURY-STYLE EARRINGS AND BROOCH. Antique silver-plated metal. EARRINGS. 1965. Diamonds. Stamped K.J.L. Ex-Collection Susan Stein Shiva Archives; BROOCH. 1980. Diamonds. Stamped Kenneth Lane

Bill Blass dress with white Kenneth Jay Lane pearls. Photo, Gideon Lewin. Bill Blass Ltd. Archives

It was always great fun and inspirational to work with dress designers. Sometimes I would create something unique for their fashion shows, other times we would adapt an already-existing design.

which he wrote in 1941. Perhaps Linda Porter, Cole's wife, may have owned some of Verdura's jewelry.

A few lines of the song go something like this:

"Liz Whitney has, on her bin of manure, a
Clip designed by the Duke of Verdura,
Farming is so charming, they all say."

Verdura was also a good friend, so before I started making jewelry, I was already familiar with many of his designs. His very talented niece, Mimi di Niscemi, was making costume jewelry for Scaasi in the late 1950s—a history she and I share—before starting her own company, Mimi di N.

The first designer to use my jewelry with his collection was Donald Brooks. I have done original jewels for years for Bill Blass, some of which were designed to be an integral part of the dress. He used my enameled frog brooches as buttons, which I made especially for him.

One of the most sumptuous assemblages of jewelry was one I made for an Oscar de la Renta collection, in the 1970s. We used the central motif of the Chanel bracelet I had made for the Diana Vreeland show, as buttons, earrings, and a belt buckle—all worn together. It was quite something.

I've known Valentino since he started. When we were both owned by the Kenton conglomerate from 1969 to 1972, he occasionally used my jewelry with his clothes. One collection I did for him entirely by telephone (prefax), and gave up that week's planned holiday to make sure he received it in time.

In the 1960s, Hubert de Givenchy showed my jeweled bracelets with his Paris collections, and later sold them at his boutique. Probably the best photographs of my jewelry can be seen in the videos of Fernando Sanchez's wonderful fashion shows.

Les Girls

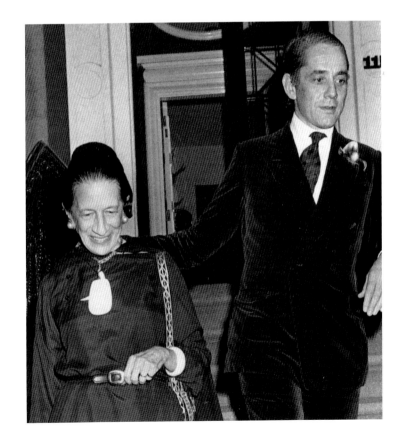

Having paid my dues at the drawing board at *Vogue* and walking enough shoe samples through the factory to compete in a marathon, it was time to become really productive. I'd been living in New York only about ten years when suddenly it was the right moment for me and for costume jewelry—women in those years *dressed to kill.* Kenneth Battelle, the socialites' hairdresser, was booked from morning to night.

I remember the night of the first blackout in New York. I was invited to a dinner at Le Pavillon on Fifty-seventh Street for Yves Saint Laurent. The lights had gone out hours before, and the party continued merrily through the blackout by candlelight. How the chef managed in the kitchen I don't know. And how "les girls" managed to arrive at the restaurant looking so staggeringly glamorous, I can't even guess. They all wore those wonderful coiffures practically out of the court of Marie Antoinette, interwoven with pearls and flowers. Many of them wore my enormous, 1960s-over-the-top earrings, which were almost de rigueur in those days. When these beautiful women wore a pair of my earrings, or an armload of my bracelets, and were photographed for *Women's Wear Daily* or *Town and Country* or *Vogue*, they made the jewelry look great.

Diana Vreeland and Kenneth Jay Lane leaving K.J.L.'s townhouse, *Women's Wear Daily*

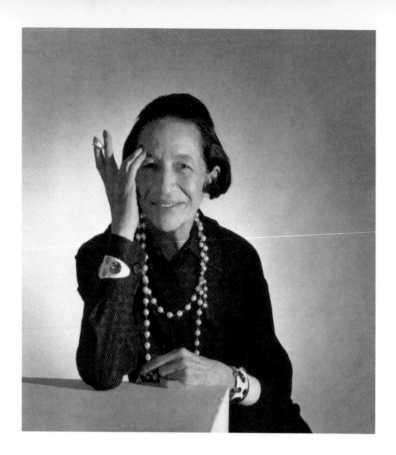

Diane Vreeland, wearing Kenneth Jay Lane
cuffs, 1979. Photo, Horst

These cuffs were favorites of Diana's and she
often wore them combined with my Chanel-
inspired Maltese cross-embellished ones,
which were originally designed by Verdura
for Chanel before he went "precious."

Even Ward Landrigan, who faithfully and
wonderfully reproduces Fulco's original
designs, thought they were by the master
when he saw this photograph.

Of course, of all the **fashionable ladies** I've ever
known, the one who had the greatest design influence on
me was Diana Vreeland.

I always derived the greatest pleasure from working
with her. Deservedly known as the high priestess of fash-
ion, she was the fashion editor at *Harper's Bazaar* from
1937 to 1962 and then editor-in-chief of *Vogue* until 1971.
She liked my jewelry from the start and featured my first
attempts in page after page of the magazine.

Diana was at *Bazaar* when we met, and soon after she
"adopted" me. It was about 1956 and I remember our
first conversation: it was about "boning" shoes.

I had received a pair of shoes from Lobb of London.
They were made from "waxed calf," the kind of calf one
couldn't polish with leather creams. Instead, they had to
be boned, or burnished with horn of some kind. I knew
Mrs. Vreeland would know all about that sort of thing, so
I said to her one day, "I'm afraid I've got a pair of waxed
calf shoes from Lobb that have to be boned, but where do
I get the right kind of bone for it?"

"Oh, my God, Ken," she said, while punching me in the
shoulder, which she was apt to do. "You know in the
whole city of New York you can't find a rhinoceros horn!"

I think she was intrigued by this rather foppish young
man in a Savile Row suit with waxed calf shoes. "Who the
hell is this kid?," she probably wondered to herself.

D.V. was incredibly demanding—the best education for
a designer. She was very precise about everything, but she
could go wild about getting a color just right. Once she
called me from *Vogue* and said, "Ken, nobody here knows
what turquoise looks like! My God! Send me some
turquoise!" A messenger arrived and I sent him back with
probably twelve variations of turquoise beads and stones.

D.V. called again.

"No, no, Ken!" she said, terribly urgently. "None of
these are right. I mean *turquoise!*"

I dug up another twelve shades and sent them to her. We
went back and forth all day. That night Diana called me at
home, as yet unsatisfied about getting what she wanted. I
improvised a bit for her. I suggested that perhaps she was

thinking of that wonderful color of turquoise you see when you're looking down into the Mediterranean from the Amalfi Drive on the coast of Italy.

"No, not at all, not at all," she insisted, impatiently.

She rejected every vivid image I presented to her. Suddenly I thought I knew just what she wanted. In Turkey there are beads that are a marvelous color of turquoise, called "donkey beads." I said the magic words to Diana.

Then she repeated the word that expressed what she wanted, as only she could: "Yes! *Daunkey.*"

That was the end of that conversation.

But this insistence on precision was typical of Diana. The girls from her office used to call me all the time in a panic. Once they called and said she was talking about the color of dried blood and they had no idea what she meant.

"Where was she last night?" one assistant asked.

"Let's see . . . ," I said. "Oh, I know. Last night we went to the Russian Tea Room and had beet borscht."

Diana used to wear my beaded bracelets with panther heads that I made two ways—enameled black with a white spotted head and the other, with reverse coloring—with her David Webb black-and-white enameled zebra bracelet. I remember having tea with her and her grandchildren, who were very young then, and one of them asking, "Which one is Mr. Webb's and which one is Mr. Lane's?"

Diana was always fantastically fastidious, whether conjuring up the right jewels for a trip to Sidi Bou Said or the perfect complement to a costume in one of her shows at the Metropolitan Museum.

She once said to me, "You must always give ideas away. Under every idea is a new one waiting to be born."

D.V. was a unique embodiment of high style and a beguiling, perceptive, and wise friend. When she was consultant to the Costume Institute at the Metropolitan Museum of Art, I created the jewelry for all the shows. One necklace I particularly adored was on a Chinese costume. Those absolutely gorgeous embroidered silk robes were miracles of handwork.

For this show, I had Chinese carved beads copied in plastic coral and jade. I wired them right on top of the

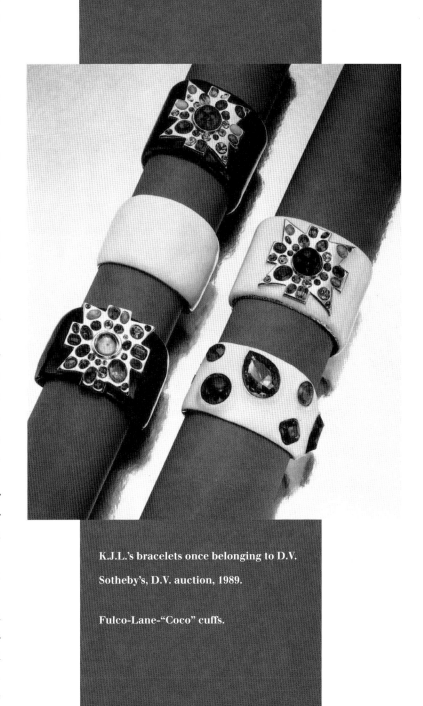

K.J.L.'s bracelets once belonging to D.V. Sotheby's, D.V. auction, 1989.

Fulco-Lane-"Coco" cuffs.

HEADLIGHT ADJUSTABLE NECKLACE, CUFF BRACELETS. NECKLACE. 1968–69. Molded German glass, black-plated metal mountings. Stamped K.J.L.; HINGED BRACELETS. 1969. Black-and-white enamel, foiled and unfoiled glass multicolored faceted stones, gold-plated metal. Stamped K.J.L.

The over-the-top version of one of my most successful necklaces. The black plating gave an old paste look to these old mine-cut glass stones. D.V. often wore two of these "Headlight" collars sans drops, together, one longer than the other.

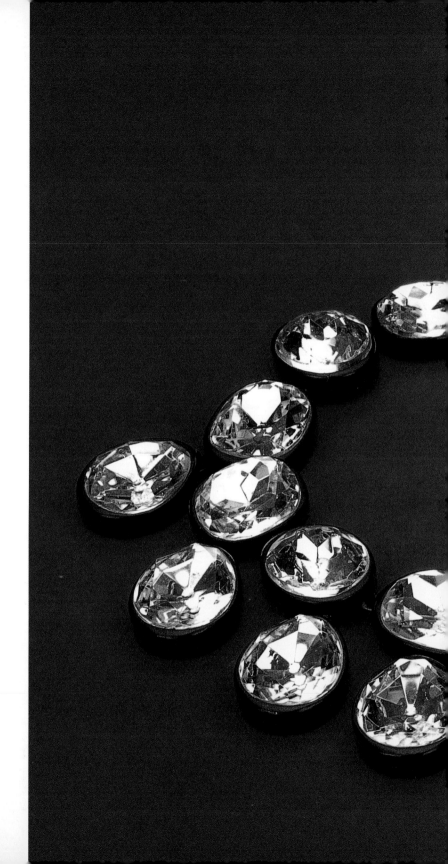

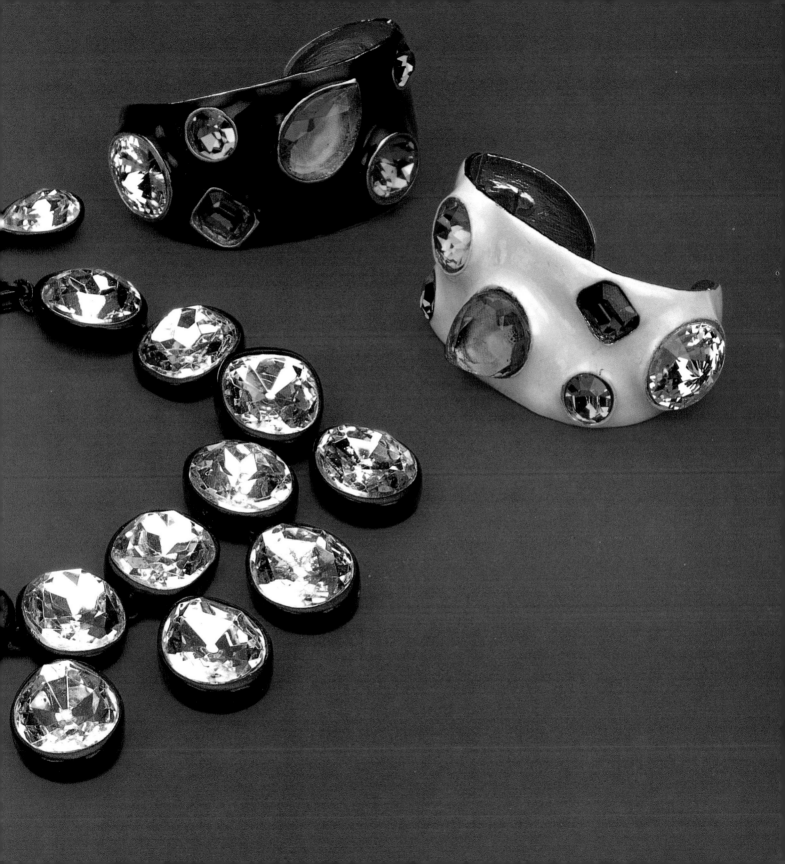

mandarin's robes, crisscrossed them, and did all sorts of crazy things with them. Every once in a while, I was called by D.V. to come to do a little repair work on the Dowager Empress, whom I think came alive in spirit at night and united the knots.

Once we were doing the exhibit "The Tens, the Twenties, and the Thirties" that featured Poiret, Vionnet, and other designers. This was before the *new* Chanel. Women were wearing her suits rather simply, not with tons of beads or accessories. At that time in the early 1970s, fashionable French women wore their Chanel suits to lunch in the country. In the exhibition, there was a 1930s Chanel evening dress with big puffed sleeves. The only woman I knew of who wore that kind of evening dress was an American, Princess Dumpy Liechtenstein. She wore it with tiny diamond stud earrings, low-heeled men's opera pumps, and beige cashmere socks, turned down into cuffs.

I didn't have a clue what to do with this particular dress, except put a short strand of pearls around the bare neck. Diana came through with the late Nina Hyde, the fashion editor of the *Washington Post*, and a very green young editor who was interviewing Diana.

Diana took one look at the pearls and said, "Ken, are you crazy? Do you think that dress belonged to a debutante?" Then she demanded that I put "some stuff" on her. Diana said that I obviously didn't understand that this dress had belonged to a very rich woman, whose lovers were maharajahs and kings and millionaires. By the time we finished, she had diamond stars on one shoulder, tons of pearls and ruby and emerald beads, a pair of my version of Chanel's Verdura enameled Maltese cross bracelets, and a hat with a veil. It was quite an effect.

The young editor asked Diana quietly if the whole thing might be considered in bad taste.

Diana answered, "My dear, there are a lot worse things in this world than bad taste."

Having worked with D.V. and knowing her all those years, I made certain things for her personal collection.

She was extraordinarily inventive in how she wore my jewelry while it was in her possession. I was sometimes amazed and even slightly appalled at some of the combinations she would put together. But it worked on her.

No one else I can think of could think of could combine dissimilar designs with such panache. She would combine my Maltese cross enamel cuffs, which I made especially for her Chanel exhibition, with other enameled cuffs randomly studded with large stones. I never thought of them being worn together.

When Diana was no longer appearing in public, and after the jewels belonging to her great friend the Duchess of Windsor were sold for an astronomical price, she called me one morning and asked, "What do you think my junk jewelry might be worth?"

I said, "More than it's worth."

"I mean, at auction,"

"More than it's worth," I repeated.

"Like how much?" she asked.

"Thirty or forty thousand dollars," I answered.

She sounded surprised. "That much? My God!"

Shortly after, I called Robert Woolley, the head of decorative arts at Sotheby's and we arranged for them to have a Diana Vreeland jewelry sale. The exhibition began with a benefit cocktail party for AIDS research and one could hardly move in the room because the attendance swelled with wall-to-wall Vreeland worshippers.

Diana asked if I would write the introduction to the catalogue, which I thought was a great honor. However, after rejecting my efforts three times, she finally decided to bring in John Richardson, the renowned Picasso expert, to help me with the text. I didn't think there was anything wrong with mine, but Diana had respect for John's writing and *my* jewelry designing.

The sale of Diana's "junk" brought $167,000. When I told D.V. over the phone what the results were, she said, *"Is that all?"*

Diana was unique. I can't imagine anyone ever replacing her!

Kenneth Jay Lane, Diana Vreeland, and Robin Hambro, *Women's Wear Daily*, early 1970s. Photo, Bill Cunningham

Leaving lunch at Le Cirque with D.V. and Robin Hambro in the early 1970s. Robin, one of the all-time great beauties, had been the U.K. editor of American *Vogue* before she married Rupert Hambro. The mother of two grown children, she recently very successfully began designing precious jewelry in London.

Diadem and choker by K.J.L., dress of H.M.Queen Alexandra, La Belle Epoque exhibition, 1983. Courtesy, The Metropolitan Museum of Art Costume Institute

This gorgeous fender appeared poolside in Hallandale, Florida. Where it is now is anyone's guess.

I've probably made more tiaras in my career than any designer of costume jewelry who didn't work for the stage. They were all done for D.V.'s exhibitions at the Costume Institute. Diana was mad about "fenders," as tiaras are always called in England. One rather grand tiara with quite good cabochon emeralds was made to go with Queen Alexandra's dress in the "Belle Epoch" exhibition. After these exhibitions were finished, the jewelry would be returned to me, although I always offered it back to the Costume Institute.

One or two of the tiaras were bought by my Japanese licensee, to be used for display. My favorite, though, the Queen Alexandra one, sat on my desk for years. When my bookkeeper, who had worked for me for many years, decided to retire and move to Florida, I asked her what she'd like as a going-away present. Much to my surprise, she said she'd love to have the tiara on my desk. I couldn't imagine what she would do with it, since wearing fenders was not a part of her lifestyle. I don't think she had ever been to a dance, let alone a ball.

One day, photographs arrived. There she was with her husband, next to the pool at the cabana club of her condo in Hallandale, Florida, wearing a bathing suit and my tiara. You can't imagine the effect. She was never a beauty and her figure would not have challenged any Miss America runner-up. It was a scream. I couldn't resist showing it to D.V., who was tempted to put it up on her bulletin board.

EARRINGS. c. 1980. Faceted jonquils, pink sapphires, amethysts, and aquamarines, flexible rhodium–plated brass connectors

These very modern shoulder-dusters were an attempt to bring the glamour and fun of the 1960s to the 1980s and thus to a new audience. Ivana and I became friends after I opened by first shop in the United States in Trump Tower. She wore them for the cover photo of her first novel.

Among the young group of today's women, I have a photo of Madonna, wearing a pair of my diamond Art Deco drop earrings.

And not to be forgotten is the Princess of Wales. A recent photograph of her appeared in *People* magazine in 1995 wearing my pearls with the caption, "Real gems like PRINCESS DI aren't afraid to fake it—her $85 Kenneth Jay Lane collar outclassed the competition at London's Youth and International Day in May."

While I happen to be on the subject of tiaras, fenders and offenders, I made a rather smashing tiara to be worn with the famous Peacock gown owned by Lady Curzon, Mary Victoria Leiter. She was originally from Chicago and married the Viceroy, Lord Curzon. Her daughter, Lady Alexandra (Baba) Metcalf, came to New York for the opening of the Royal India exhibition. At the Met, I was introduced to her by D.V., who went on and on about how marvelous I was, to make the tiara and a necklace to go with the dress. Lady Baba's reaction was hardly what I expected.

She said, "Oh, no. That won't do at all. I'm sure my mother's tiara was much better than that."

I was amused and D.V. was mortified.

Many years ago, I made a **hair ornament** meant only for a photograph for *Harper's Bazaar*. Mildred Custin, who became the president of Bonwit Teller in New York, and was a great supporter of mine, was then at Bonwit's in Philadelphia. She called me one day because a customer of hers had seen the photograph and wanted to special order it. So I had to duplicate it.

The hair ornament was a rather long snakelike wire wrapped in pearls and diamonds, which was coiled around the model's beehive hairdo. The photograph was marvelous. Of course, I was very curious about the sole buyer of this object, and asked Mildred if she could set the wheels in motion to find out who it was.

I soon found out that my diamond coil was bought by an important Bonwit customer—a woman who owned a roadhouse outside of Philadelphia and, who, poised at the cashier's desk all night, loved doing glamorous things with her hair.

I gave **Ivana Trump** a pair of earrings thsat were about eight inches long, each set with a dozen or so two or three carat "diamonds." She was photographed wearing them for the cover of *New York* magazine. Shortly after that, Ivana wore them in the south of France, and a friend of

Ivana wearing the same earrings as on the book jacket of her first novel. They were copied in diamonds by Graff.

hers, Mrs. Laurence Graff from London, whose husband is a famous jeweler and deals in very, very large stones, told Ivana she had the earrings copied in real diamonds. So those earrings, which cost about *$60*,have now been duplicated in about $200,000 worth of diamonds.

This was not the first time my *faux bijoux* were used as models for the real thing. At one time, I sold jewelry to Kenneth, the hairdresser, who had a little counter of costume stuff in his town house salon on East Fifty-fourth Street. One day, the woman whose husband owned a whole chain of beauty salons, including Kenneth's, showed me her diamond cluster earrings and asked if I liked them. They were duplicates of a pair of my smaller "diamond" earrings which she had copied by David Webb. It was my first total reversal!

Comtesse Jacqueline de Ribes is the epitome of elegance, with an astonishingly beautiful and aquiline profile. She was a great Paris hostess and one of my first loyal customers. She made the transition from being a couture client to a couturier herself, producing her first collection in the late 1970s.

She used some 60s belts of mine from her private stock to accessorize some of her gowns. She sold about a dozen very expensive dresses *with* the belts. Months later, in a panic, she called and admitted she had used my old belts and now needed more of them, having tried unsuccessfully to have them made in Paris. Jacqueline begged me to help her out so she could finish the costumes for her clients. So of course I made the belts for her first couture collection.

Jeweled belts always seem to need repairs, because although a woman will take off her necklace and put it down carefully, a belt often goes on the floor, particularly if madame is getting undressed quickly!

In the late 60s, Dior had designed a dress with an elaborate belt made of multiple chains in swags, dangling what seemed like thousands of little coins. Bergdorf Goodman bought the dress, but not the belt, which would have cost about $12,000 with duty—much too steep a price. They asked me to design a belt for them with the same feeling, and this got me started "belting" some of the loveliest waists in the world.

I had once heard of an extraordinary belt owned by the Duchess of Buccleuch. Some of the diamonds were from the original collection of Charles II, from whom the Buccleuchs descended. When I stayed with Duchess Molly at Boughton House she brought out the belt to show to me. It knocked my socks off!

Naturally, it came back to mind when I started doing these very grand belts. The Duchess of Windsor was in my showroom and saw the first sample of these "diamond" belts hot off the press, inspired by the Buccleuch collection, and had to have it. I let her buy the sample and then quickly duplicated it.

That very night, I took my mother and an aunt to dinner at La Grenouille, and who was sitting in the corner banquette when we arrived but the Windsors—with Honey and Richard Berlin, he being the chairman of Hearst Publications. The Duchess got up, knelt on the banquette, did a little shimmy and said, "Look at me, I'm Mrs. Kenneth Jay Lane." My mother's mouth fell open! Before going to our table, I introduced my mother and

TASSELLED BELT/NECKLACE. 1963. Gold-plated metal beads around cotton cording, diamond chain tassels. The Grace Collection

This golden bead-wrapped cotton cord belt can also be wrapped around the neck as a dramatic necklace.

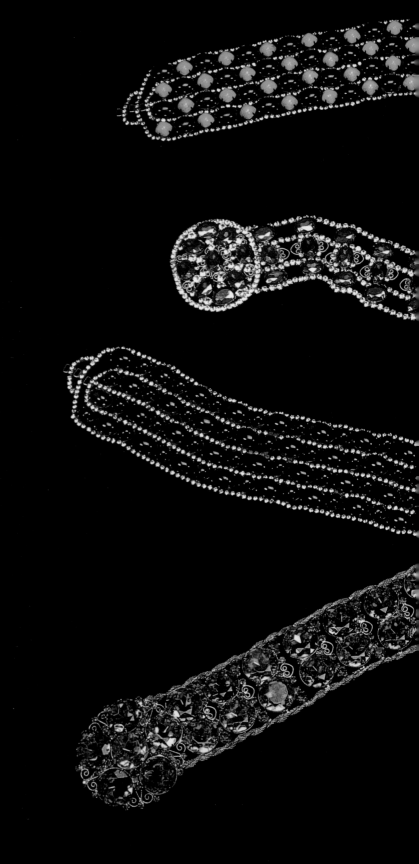

ADJUSTABLE JEWELED BELTS. **Late 1960s.**
Stamped K.J.L. The Grace Collection;
(Top to bottom) Plastic turquoise and
sapphire cabochons, round and baguette
diamonds, hand-soldered, antique gold-
plated brass mountings; Glass foiled
iridescent blue stones, diamonds, hand-
soldered, gold-plated brass mountings;
Plastic ruby, emerald and sapphire cabo-
chons, diamonds, hand-soldered antique
gold-plated brass mountings; Glass foiled
emeralds, rubies, and sapphires, hand-
soldered, antique gold-plated brass
mountings and chain

I talked Bergdorf Goodman into doing
a window of my jeweled belts in June
rather than waiting for the fall/holiday
season. I was afraid that if they waited,
all of my ladies would already have
them, they were in such demand.

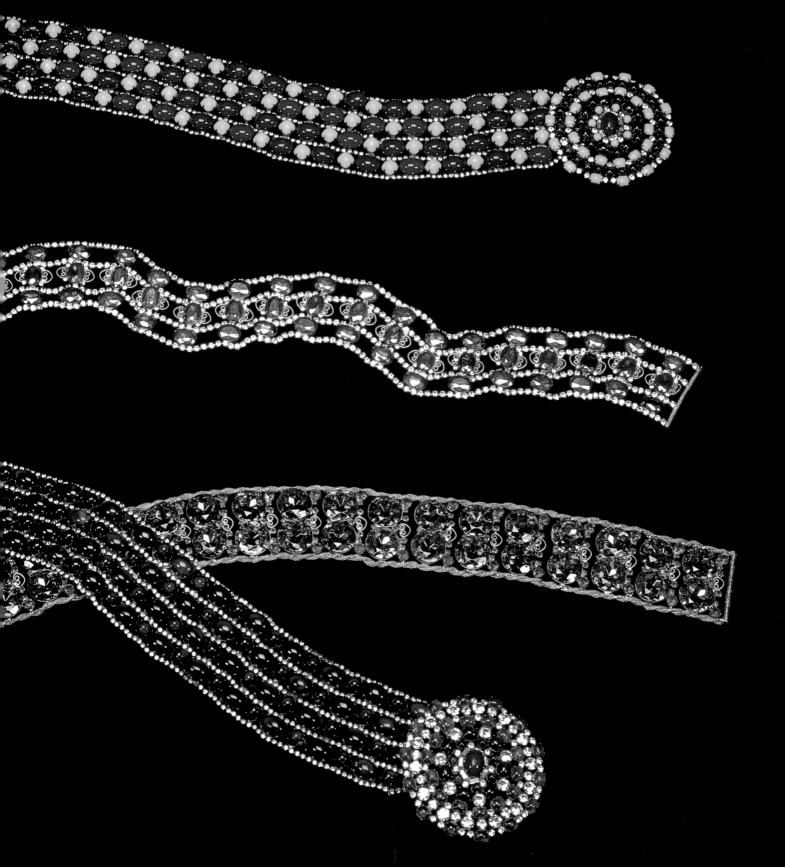

my aunt and the Duke said to my mother, "Mrs. Lane, your son is ruining me."

The last photograph of the Duke and Duchess published in *Vogue* was taken by Patrick Lichfield at their country house outside Paris. Considering the extent of her great collection of fabulous stones and one-of-a-kind original designs, she honored me by wearing only my jewelry in this picture.

The Duchess, a very good customer, also became a good friend of mine. I was at a party with them and the Duchess was wearing a magnificent emerald necklace. H.R.H. the Duke of Windsor said to me, "Ken, you see my wife's necklace? Those were better days."

I have a wonderful thank-you note from the Duchess:

New York,
June 21st, 1975

 What lovely earrings you sent to me on my birthday. Many thanks for your thought of me and the good wishes.

 I am looking forward to seeing you soon again.

 Wishing you all the best,

Wallis
Duchess of Windsor

ADJUSTABLE BELT. Late 1960s. Diamonds, hand-soldered, rhodium-plated brass mountings and findings. Stamped Kenneth Lane

George Christy, in the *Hollywood Reporter*, wrote about the belt that the "Duchess of Windsor was buried in." He and I had noticed this belt on a lady one evening, so for all I know I might have told him that story.

Today, wonderfully tall, slim Minnie Cushing Coleman wears the "duchess" belt in Newport with blue jeans—très chic.

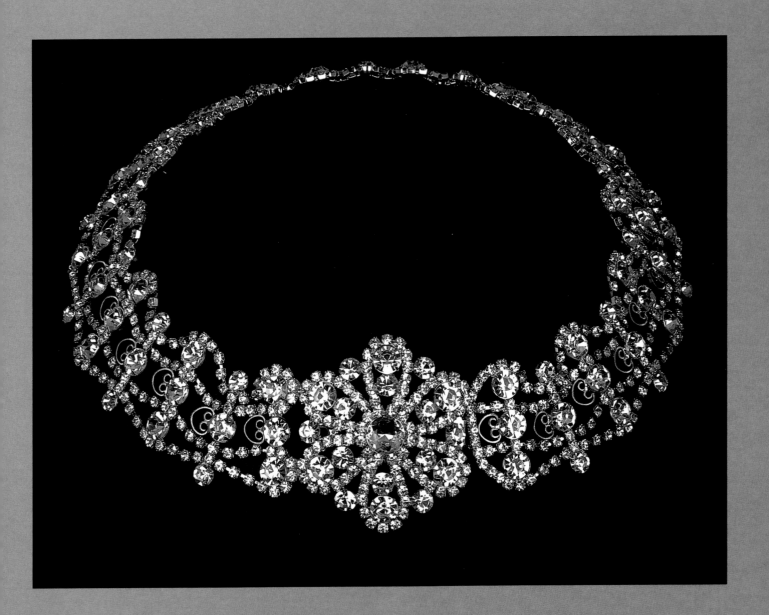

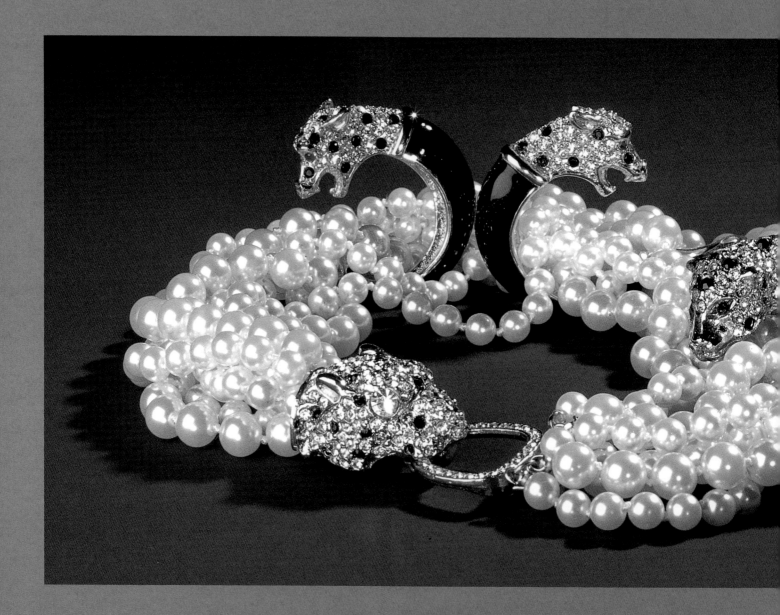

PANTHER EARRINGS, BROOCH, AND NECKLACE. Stamped Kenneth Lane; NECKLACE. 1980. Glass pearls, jet, pavé diamonds, rhodium and gold-plated two-toned metal; EARRINGS. 1980. Black enamel, jet, pavé diamonds, rubies, rhodium and gold-plated two-toned metal; BROOCH. 1969. Jet, pavé diamonds, emeralds, rhodium-plated metal

The Duchess of Windsor wore jewelry of mine that was very different from what she owned. It was never meant to look "real." The Cartier-type panther collection was inspired by the Duchess's collection—not made for her.

The Duke and Duchess of Windsor's Christmas card, 1965. Photo, Frederick Eberstadt

The necklace seen here was strung on spring wire to hold it close to the neck and was made of melon-shaped hand-turned plastic coral beads, pearls, and diamond and emerald rondelles, with pearl and glass emerald bead tassels.

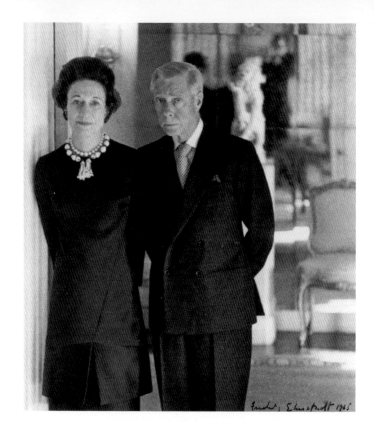

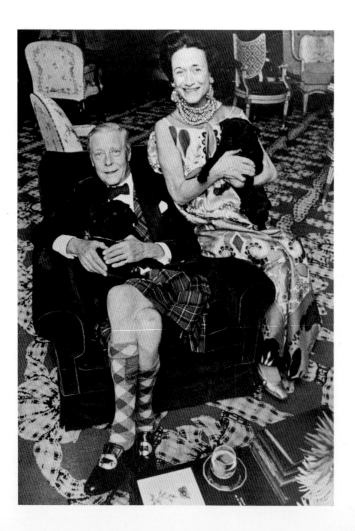

The Duke and Duchess of Windsor. Photo, Patrick Lichfield, *Vogue*, November 15, 1967

In this photo of the Windors at their country house outside of Paris, the Duchess's K.J.L. necklaces were pearls alternating with diamonds and emerald and ruby rondelles. The earrings were swinging hoops of multiple strands of thin golden wire.

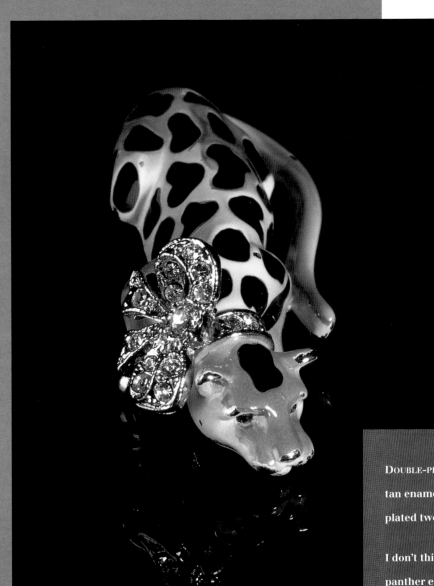

DOUBLE-PRONGED LEOPARD BROOCH. 1985. Black and tan enamel, emeralds, diamonds, rhodium and gold-plated two-toned metal

I don't think that Cartier ever made an enameled panther even for the Duchess. When I saw Cole Porter's great friend Jean Howard, the photographer and author of *Hollywood*, and the chicest of the chic, wearing a black and white one, it made quite an impression. When I returned from staying with Jean in Beverly Hills, I went straight to the drawing board and soon afterward sent her its cousin with a diamond bow around its neck, with a note saying something like, "Ain't I original!"

I do recall an amusing incident that involved the beautiful Grace Kelly. Countess Lilli Volpi was giving a pre–costume ball dinner at her palazzo on the Grand Canal in Venice on a horribly rainy night. Princess Grace arrived looking absolutely wonderful in gold lamé, dressed as Queen of the Adriatic. Prince Rainier and a few friends were her gondoliers.

I was wearing a black velvet costume with a white lace jabot, in the middle of which I had pinned a massive pigeon-blood ruby set in diamonds that I'd made in my factory in Providence. It probably cost twenty-five cents!

After dinner, Grace and I were standing and talking by an open door. Then she remarked, "Ken, that's some ruby!"

I answered, in all mock seriousness, "Of course . . . and it even has a curse."

She said, "So that's what's probably bringing the rain, your ruby!"

With that, I took the ruby off and with a sweeping gesture, flung it into the Grand Canal. Was she horrified when she screamed "Stop!" or just being a good actress? Did she actually think it was real?

Lady Diana Cooper was probably the first titled English woman to go on the stage. She was the daughter of the Duke and Duchess of Rutland. Her mother, Violet, belonged to a group called "The Souls," the philosophical thrust of which were high ideals, purity of thought, and a delicate artistic sensibility. Most of all, they were of the belief that they were above the prevailing "vulgarity" of the court and the friends of the Prince of Wales, later Edward VII.

For many years Lady Diana played the nun in *The Mir-*

acle, which toured America. I have a drawing of her napping, in full nun's habit, done by her mother, with the caption, "Diana taking a nap in Cleveland, 1925." Lady Diana later gave it to me as a wedding present. In fact, it still sits in my house next to the picture of another Diana, Diana Vreeland.

Diana Cooper was an absolutely remarkable woman and one of the great beauties of her time, with the palest of blue eyes. She lived to be ninety-two and would come to New York occasionally. Once, she came to my factory with Babe Paley and Babe and I stuffed her pockets with half my stock. She didn't realize she'd received all these presents until she got home and took off her coat.

The unicorn was her animal soul mate—she always thought *she* was part unicorn. When I had her to lunch with Diana Vreeland, the conversation didn't go very well until the subject of unicorns came up. Lady Diana won the day by saying, "The last time I saw a unicorn . . ." and the great D.V. was nonplussed.

Lady Diana was left a unicorn brooch by Violet Trefussis. (She was the daughter of Alice Keppel, Edward VII's mistress, who was even in those more civilized days invited by Queen Alexandra to his bedside when he was dying.) Anyway, when Lady Diana heard of the bequest, she immediately called the executor of the Trefussis estate, Lord Ashcombe. He explained to her that the estate had to be probated and would take a certain amount of time to be resolved. She was not happy. I'm not sure exactly what age she was at the time, but she may have been afraid that she wasn't going to live long enough to receive this wonderful bequest.

Having seen a photograph of Violet Trefussis' gold and diamond unicorn brooch, I made the version she wore until she received the real thing. She often wore them both, with one on her hat.

Years ago, there was a dinner at Blenheim Palace, including my friend, the beautiful Jean Hannon Douglas, the Duke of Marlborough's daughter, Sarah Churchill, and her Chilean husband, Guy Burgos. Lady Sarah was wearing huge aquamarine and diamond drop earrings. Her father—who was not crazy about Guy because he had little money at the time—asked where she'd gotten those incredible earrings. Sara said Guy had given them to her. Her father wondered aloud how on earth her husband could pay for them.

Guy piped up and said, "In Chile, we find aquamarines like those in our gardens."

Jean, who knew these earrings very well, asked to see them. As they went around the table, everyone remarked how beautiful the stones were. When they got to my friend, she turned them over and read the signature out loud, "*Oh*! It's *K. J. L.*"

The legendary Barbara Paley, perhaps the queen of style, was a great friend of mine. When Babe would come to my factory, I knew she was there without being told—a silence descended simply from the force of her presence.

Babe had a way of wearing jewelry that was arresting, whether it was precious or fake. She had that kind of style. Once I went to dinner at her house and one arm was covered with skinny rhinestone bangles that she had bought for a dollar each at Alexander's. The look was smashing.

One day, Babe called and asked what I had done with the little masks she'd left at my office to be strung up. I asked, surprised, "What masks?" She said, "Oh, I left them with your assistant a few weeks ago."

When I went to my office the next day, my assistant produced a box, inside of which were three of the most magnificent Pre-Columbian gold pectorals I'd ever seen. I sent them back and asked her please never to do that again.

Various other ladies have left some rather precious beads without any warning. Aimee de Heeren, who has an extraordinary collection of jewels and is still a great beauty, left some gem amethyst beads. My secretary neglected to tell me they were there, and I didn't know about them until several months passed. Luckily, they hadn't disappeared!

Ladies like these inspire me to do special things for them. Gloria Guinness had a wonderful way of taking necklaces that I meant to be worn in twos, and wearing them instead in multiples. Gloria would make four or six necklaces worn together the focal point of her costume.

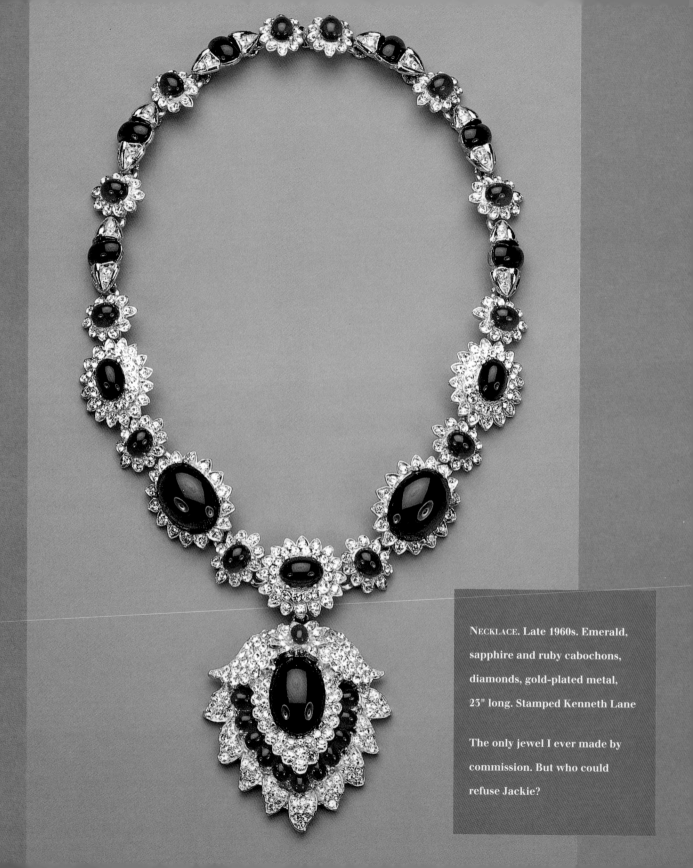

NECKLACE. Late 1960s. Emerald, sapphire and ruby cabochons, diamonds, gold-plated metal, 25" long. Stamped Kenneth Lane

The only jewel I ever made by commission. But who could refuse Jackie?

Linda Evans of *Dynasty*
wearing the same necklace.

I've been very lucky to have known several **First Ladies** and I feel honored that they've chosen to wear my jewelry.

Jacqueline Kennedy Onassis was the epitome of style. She once asked me to copy a necklace that Onassis had given her. She had gotten it out of her vault, and I went to her apartment to look at it. "There's only one thing I can't copy exactly," I told her. "The cabochons—they simply don't make fake stones of such poor quality." Jackie laughed.

We made a bargain that I wouldn't charge her to make the mold, which is very costly, if she would let me put the necklace into my collection. She gave me her blessings and I copied it in every color, including turquoise and coral. Years later, Bill Blass asked me to make the pendant drop into a brooch for one of his collections.

Every once in a while, Jackie would whisper to me, "I saw our necklace on *Dynasty* the other day."

STARFISH BROOCHES. 1985. Satin gold-plated metal. One with variously cut diamonds, one multicolored pastel stones. Stamped Kenneth Lane

Jackie Onassis wearing K.J.L. starfish pin.
Photo, Eric Weiss, *Women's Wear Daily*,
September 24, 1991

This candid photo was taken of Jackie at
a book party in Manhattan.

She wrote me a lovely note, which I cherish:

Dear Kenny

　　　　　You were absolutely right
in thinking your earrings might
bring cheer. They have done just
that! I do love them and you for
thinking of me.

　　　　Thank you and much love

　　　　　Jackie

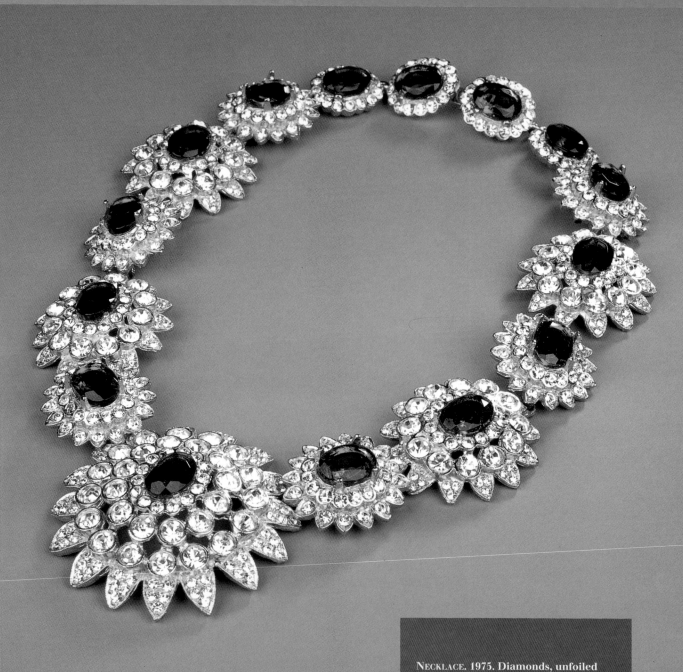

NECKLACE. 1975. Diamonds, unfoiled German glass emeralds and sapphires, gold-plated metal, 16½" long. Stamped Kenneth Lane

These necklaces created something of a stir in Paris when the press pondered which famous jeweler made them. Not a famous jeweler at all, only moi.

I knew Nancy Reagan when her husband was governor of California. Whenever I'd make a personal appearance at Saks or I. Magnin, she'd always stop by and purchase some little thing. That was part of her generosity. I'd also see her occasionally in New York. She was always charming, attractive, and beautifully dressed.

When she became First Lady, she bought many things from me—sometimes it was the jewelry shown with a dress by Bill Blass, or sometimes we'd discuss on the telephone what she wanted, or Jerry Zipkin would simply tell her. She certainly did American fashion proud by being such a wonderfully dressed First Lady.

One time Nancy Reagan appeared at the American Embassy in Paris at an official dinner, wearing black satin Galanos knickers, which caused some comment, and a pair of my jet and ruby necklaces. The American newspapers were full of photos of the First Lady and the big question was whose necklaces they were—Van Cleef, Bulgari, Cartier?

Since I never leak such details to the press about First Ladies without checking first, I called Mrs. Reagan and asked if she minded if I said they were mine. She said she'd be delighted to have everyone know they were "K. J. L.," American made and *not* precious jewelry.

Oscar de la Renta, Nancy Reagan, and Barbara Walters, CFDA awards, Metropolitan Museum. Photo, *W*, February, 1989

Nancy's necklace incorporates some of the motifs from the Van Cleef necklace I made for Jackie.

When George Bush was vice president, his wife, Barbara, started wearing my jewelry because of our very good mutual friend, Princess Catherine Aga Khan. She is the wife of Sadruddin Aga Khan, who for many years was the High Commissioner of Refugees at the United Nations. Caty would give Mrs. Bush little presents of my things, so she was familiar with what I do. One day, Mrs. Bush called and asked if she could come to the showroom.

Conservative at first, she bought five strands of small pearls. Eventually, the size grew into the larger pearls that became her signature. Those three strands of pearls are almost like wearing shoes—some women couldn't go out without them. I don't think C. Z. Guest would pull a weed out of her garden not wearing pearls.

Mrs. Bush's style wasn't really chronicled until she became First Lady and wore my pearls with her Scaasi gown to the Inaugural Ball. Always unassuming, Barbara Bush would giggle a bit when her costume was written about. She'd say, "Can you imagine that *I've* become a fashion leader?"

Now those pearls are in the Smithsonian with my name on them.

Mrs. Bush is very special, with a genuinely gracious spirit. The day she gave the Inaugural gown and jewelry to the Smithsonian, she had a little lunch at the White House for me, Scaasi, and Judith Leiber, whose bag she had carried.

Later, I made some black pearls for her to wear to Emperor Hirohito's funeral. Protocol demanded that the pearls be black for the occasion, but we forgot about the matching earrings. At more or less the last moment, we produced those as well. Then at the *very* last minute, Mrs. Bush called and said she'd been told they were leav-

ing at 5:30 the next morning. Even a Federal Express package could not arrive at the White House on time. We managed to get around the problem by using the air shuttle, and the day was saved. I watched the funeral on television. Mrs. Bush looked very attractive and distinguished, but I must say, I couldn't quite see the pearls. The day after we sent them, a thank-you note arrived—with a check.

In 1994, I sent her a pair of earrings for her birthday and she wrote me:

Barbara Bush April 18th 1994

Dear Kenneth—

I love the shell earrings. Thanks so much for remembering me. In a way you have changed my life—if I go anywhere without pearls, people act disappointed. It is really very nice and touching, but you can hardly wear two or three strands playing golf!! Speaking of

playing golf—George and I just played in Seoul, Korea. Who ever thought I'd do that!!

Please give Blanche my love. She and you have always been so kind to me. I'll call her soon.

With every good wish and so many thanks, Kenny—

Barbara

Barbara Bush and K.J.L. at The White House,
January 9, 1990. Courtesy, The White House

In the Lincoln Bedroom at the White House after
a lunch given for those designers who worked on
Mrs. Bush's inaugural costume.

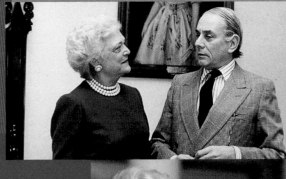

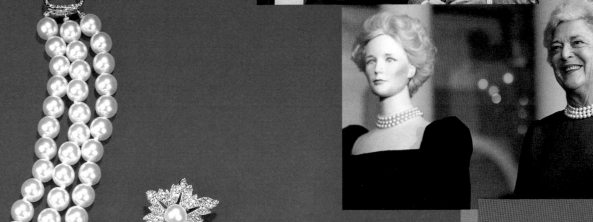

Barbara Bush wearing
K.J.L. 3-strand pearl
choker, 1990. Courtesy,
The White House

Mrs. Bush at the Smith-
sonian Institution next to
her inaugural costume.

NECKLACE AND FLOWER EARRINGS. Rhodium-plated
metal. NECKLACE. 1985. Hand-knotted glass pearls,
diamonds; EARRINGS. Mid-1970s. Glass pearl center,
pavé diamonds. Stamped Kenneth Lane

143

President-elect Bill Clinton waves to onlookers after arriving at the Washington home of Pamela Harriman, November 19, 1992. Harriman, in the doorway, hosted a private dinner for the Clintons and is seen wearing a saxophone pin, designed by Kenneth Jay Lane. Hillary Clinton has her back to the camera. AP/Wide World Photos

I've included Pamela Harriman **with** First Ladies for several reasons. She's one of the first ladies of the world today—for an English woman to become the U.S. ambassador to France is certainly a feat. She was very responsible for raising the funds to put the Clintons in the White House. When Bill Clinton was elected president, and much to-do was made of his playing the saxophone, I remembered I had made a saxophone pin many years ago as part of a group of musical instruments brooches. I took the one sample I had left and sent it to Pamela with a note saying, "I think you really deserve to blow your own horn."

She called immediately to thank me, and, to my great surprise, asked if I could send her several dozen more to give away. I had them made and sent them to her. One of the recipients was Mrs. Vernon Jordan, who was often photographed wearing it. Shortly afterward, Pamela told me she had been besieged by Democratic women who wanted the golden sax. She asked me to sell them to a store in Washington, so they'd be available. I then called Gahl Burt, who was fashion consultant to Saks Jandel, a fine specialty shop in Chevy Chase, Maryland, and whose husband had been our ambassador to Germany. Ultimately, the store sold hundreds of these pins—an unexpected windfall. We also sold the saxophone on QVC and it "blew out the door."

Another **Washington** client who I'm very proud to have is Supreme Court Justice Sandra Day O'Connor, who is a handsome woman and has come to my factory/showroom to make selections. She is much more attractive in the flesh than she is in photos, and I told her so!

SAXOPHONE BROOCH. 1992. Satin gold-plated metal.
Stamped Kenneth Lane

I never really meant to capitalize on this saxophone
brooch that I made for Pam, but the demand was so
great that I couldn't refuse.

President Clinton and First Lady Hillary
Rodham Clinton at an imperial banquet at
the Imperial Palace in Tokyo, July 8, 1993.
AP by Martin Cleaver/Wide World Photos

I made these two Art Deco dress clips long
before Bill Blass used them as ornaments on
this dress worn by Mrs. Clinton.

Opposite: NECKLACE AND EARRINGS. 1965. Unfoiled glass rubies and emeralds, diamonds, hand-soldered, antique-silver plated brass mountings. Stamped K.J.L.; necklace: Collection Joia; earrings: Collection Prudence Huang

Eleanor Lambert. Photo, Nina Meledandri

The great doyenne of the fashion world. Eleanor has no equal anywhere. As the Empress of Fashion, a title she inherited and once shared with Diana Vreeland, this very royal necklace suits her very well. I am so honored that she has worn it for almost 30 years.

I'm very proud that Eleanor Lambert, who invented fashion publicity in the U.S., uses a favorite photograph of herself wearing one of my courtly necklaces from the 60s, which she *still* wears from time to time for grand occasions.

I met her when she was doing public relations for Delman shoes in the 50s, as I was then working for Genesco. Eleanor created the Best Dressed List, the Coty Award, and really put American designers on the map, particularly during World War II, when French fashion didn't exist in the United States. She has championed more of today's famous designers than I can name.

When I began my jewelry-making, I showed her my baubles. She thought it would be amusing to trim her Christmas tree with my earrings, until she found out the

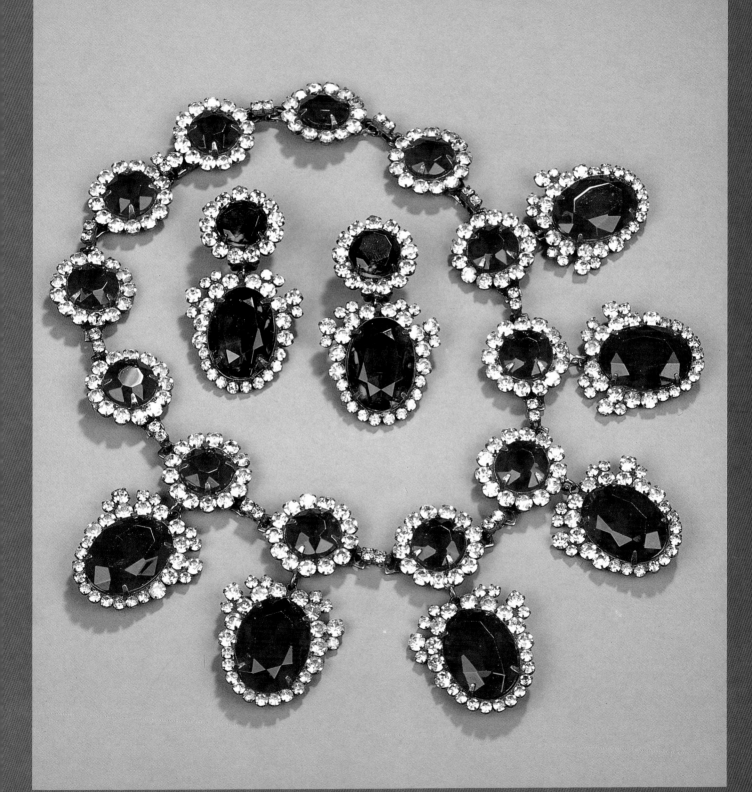

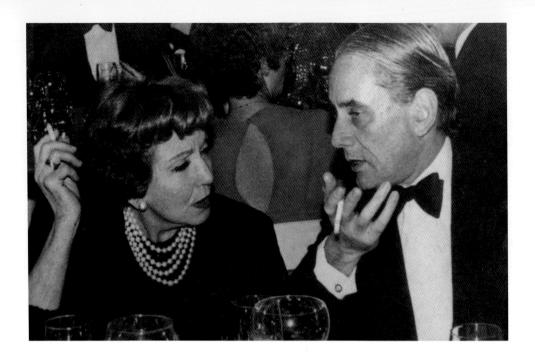

Claudette Colbert and K.J.L.,
c. early 1980s.

I loved to tease Claudette about her milk bath as the Empress Poppaea, Nero's wife, in De Mille's *Sign of the Cross.* When this picture was taken at a gala dinner at Saks Fifth Avenue, she was in the shadow of eighty-five years, but looked not much older than I did and had the mind and memory of a very bright young thing.

price of these "ornaments." I was very fortunate to see her a great deal in my youth because her son, Billy Berkson, whose father, Seymour, was the publisher of *The Journal American*, became and is one of my best friends.

Some **women bridged the worlds** of society *and* the arts. Millicent Rogers was one such woman. She died much too young in 1954, the year I moved to New York City, and I never met her.

Making jewelry for the Metropolitan Museum Costume Institute shows sometimes inspired me to go off in new directions. Millicent Rogers was featured in Diana Vreeland's Metropolitan Museum show called, "American Women of Style." Like Chanel, she was a unique talent with a very particular style. She combined American Indian silver jewelry with an eighteenth-century Russian diamond order and wonderful cuffs, rings, and necklaces that she made herself out of the very purest gold at her ranch in Taos, New Mexico. I was able to develop a satin-finish 22 karat gold-looking plating, so that my versions of her jewelry looked very much like the real thing.

When she died, she bequeathed her collection of Indian artifacts and some of her jewelry to the Millicent Rogers Museum in Taos. Her son, who was a friend of mine, gave me a very special and original cross that she had made herself to copy for the gift shop at the Museum. I made a wax mold of the original, so it wouldn't be harmed, and the museum bought my replicas at a very reduced price.

Visiting friends in Santa Fe, we went to Taos and to her museum. I had been there once before, but when I went again with friends, we looked more closely at her own jewelry displayed in the glass cases. I asked the curator, who was showing us around, if he could open the case so we could feel the wonderful weight of the gold in our hands. When I held the cross, I realized something was wrong. I turned it over and my God, it had "K. J. L." stamped on the back. They had taken the original out of the case and replaced it with my copy—which the public would never know was made yesterday!

But I must say a good design never dies. I used Millicent's cross motif and stuck a ruby in it for a charity bash at St. John the Divine—and it was a smash.

An amazing **array of great movie stars** came to my factory/office in the early days—stars such as Cyd Charrise, Gloria Swanson, Irene Dunne, and Loretta Young. Claudette Colbert once tried on a huge ruby necklace that I had made for a Bill Blass collection and despaired, "Oh, no, Ken! I can't wear this! I'm the original no-neck monster."

I said to her, "Yes, darling, that's why you're a vamp." "Vamps can't have a long neck, otherwise they couldn't get their eyes and their boobs in the same frame! So be happy you have no neck. It's what made you a great Cleopatra."

One day, Baroness Cecile de Rothschild called and said she was in from Paris and wanted to stop by with a friend. I never thought about who that friend might be.

When I saw Cecile arriving with a lady in a tall beaver hat pulled down almost over her eyes, I realized it was Greta Garbo. I was thrilled. She tried on every pair of long earrings I had and assumed a different role with each one. Garbo had actually *become* Queen Christina, or Marguerite Gautier, the title character in *Camille.*

It was one of the great moments of my career.

I didn't make jewelry for Marilyn Monroe, but, recalling my previous career, I did make shoes for her. However, Elizabeth Taylor, known for her precious jewelry collection, owns a number of my pieces, which people mistake for the real thing.

I always went to L.A. to Swifty Lazar's annual Academy Awards dinner party at Spago. One year, Liz and Audrey Hepburn were both presenters of Oscars and came later to Swifty's. Audrey was wearing a Givenchy dress and my earrings, and looked wonderful. She and I were sitting and chatting when Elizabeth stopped by to say hello.

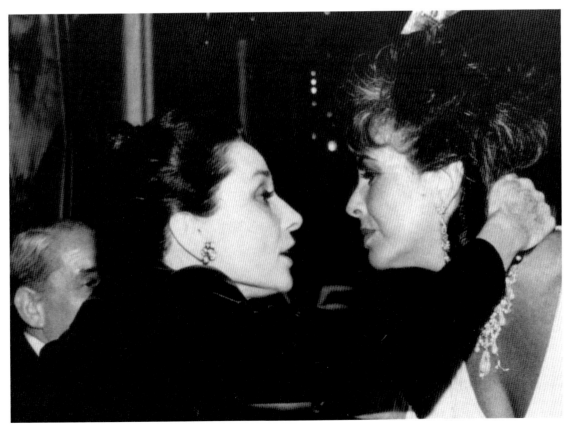

Audrey Hepburn and Elizabeth Taylor at the Academy Awards dinner, *US* magazine, May 5, 1986. Photo, Michael Jacobs/MJP

That's me on the left at Swifty Lazar's yearly Academy Awards dinner at Spago, with Audrey and Liz.

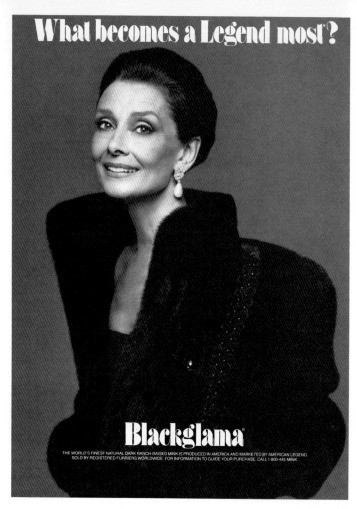

What becomes a Legend most?

Blackglama

THE WORLD'S FINEST NATURAL DARK RANCH-RAISED MINK IS PRODUCED IN AMERICA AND MARKETED BY AMERICAN LEGEND.
SOLD BY REGISTERED FURRIERS WORLDWIDE. FOR INFORMATION TO GUIDE YOUR PURCHASE, CALL 1-800-445-MINK.

Audrey Hepburn for Blackgama, 1960s.

**Audrey was against wearing fur and refused the mink coat
in lieu of a check that went immediately to UNICEF.**

Audrey said, "Liz, are your earrings 'K. J. L.?'"
Liz replied, "Sorry Kenny, they're 'Richard Burton.'"
Then Audrey asked if the necklace was Kenny Lane. Liz
laughed and answered, "Sorry, no. It's a 'Mike Todd.'"
When the wonderful Audrey posed for the witty "What
Becomes a Legend Most?" Blackgama mink ad, she was
given a choice of earrings to wear—Van Cleef, Cartier,
Tiffany and other jewelers, but adorably, she insisted on
wearing mine.

Many years ago when Liz was married to Richard Burton, she bought a mess of my "stuff," and laid it all out on the bed of their Plaza suite. When Burton walked in and saw all the jewelry, he went into a slightly tipsy rage, ranting that Liz had gone stark raving mad. Then she told him it was all mine, and they had a good laugh.

Joan Bennett, one of the great stars of the 40s and 50s, came to my office not long before she died, with her daughter, Shelley Wanger Mortimer. I remembered a film Miss Bennett starred in that impressed me enormously as a youngster, called *Man Hunt*—a wartime thriller directed by Fritz Lang that was set in Germany. In the last scene, Miss Bennett, who is wearing a diamond arrow in her beret, attempts to cross the border into Switzerland, but she's spotted by a German sniper, and shot.

I was very moved by this scene in the film and, recalling it, designed a similar diamond arrow pin. The one I made was a jabot pin—the head of the arrow on one end of the cross brace and the tail of the arrow on the other.

Fortunately, I had kept a copy of this brooch and took it out of a drawer and gave it to her. She was, I believe, more pleased that I remembered the film than by the gift of the diamond arrow.

There was a shop on **Madison Avenue** that sold Art Deco objects, jewelry, and all sorts of collectibles, which included a few very attractive, quite valuable old Chanel pieces in the window, with a note that said the jewelry was from the collection of the late Rosalind Russell, "The great star of stage and screen."

I smiled because when I had been in Los Angeles just after she died, her husband, Freddy Brisson, kept phoning me. He had to talk to me, he said, and wanted me to stop by their house and see Roz's costume jewelry. I did, finally, on my way to the airport.

A weeping maid took me to Roz's room where Freddy had spread out all the jewelry on the bed. I thought it must have come from the studio costume department and been worn in every film she'd ever been in. She'd probably worn half of it into her swimming pool for many years. Obviously, Freddy had left the good things out. He wanted to know if I thought he should give the "collection" to the Costume Institute as a tax deduction. I told him he should donate it all to the Salvation Army!

Later, I was told that some of my jewelry was in a Sotheby's Collector's Carousel Auction, captioned "from the collection of the late Rosalind Russell." In the catalogue were some photographs of rather simple earrings of mine, described as stamped "K. J. L." or marked "Kenneth Lane," distinctions given to such humble stuff as if they were from Fabergé. I went to look them over. You've never seen such tarnished, moldy old things!

I never did dare to find out what they sold for.

At an **extraordinary concert** at New York's Minskoff Theater, Bette Midler opened her show posing on a pink, satin-lined oyster shell, which was ceremoniously dragged on stage by a number of elderly African-Americans singing "Ole Man River." For a follow-up, she opened her second act appearing in the giant paw of King Kong.

Later, I was taken back stage by Ahmet Ertegun, my host for the evening and president of Atlantic Records. The Divine Miss M. received me very warmly. The next day, thinking of her in the oyster shell, I sent Bette a goodly amount of my pearl "strandage."

She sent me a wonderful note in thanks:

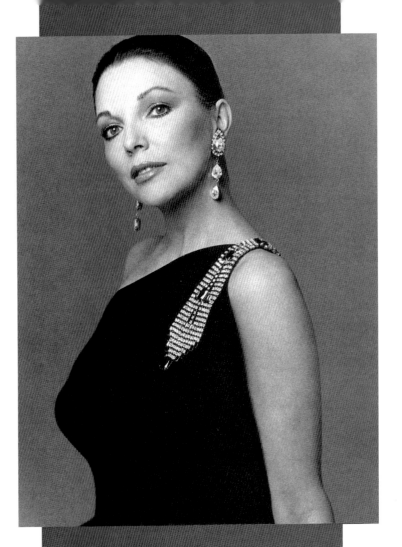

Joan Collins, *Harper's Bazaar*, September 1989.
Photo, Scavullo

Joan Collins, a great friend in a dress by Bill Blass, which incorporated a very snazzy shoulder treatment adapted from a sort of Lorelei Lee, Art Deco necklace I had made previously for Joan. She also wore many jewels of mine as Alexis in *Dynasty*.

Joanie, who is more genuine than 24k or D flawless, is the perfect foil for the *fake*. She fakes reality and makes fantasy real.

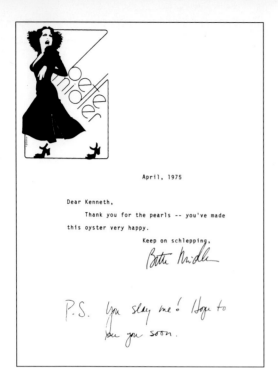

April, 1975

Dear Kenneth,

Thank you for the pearls -- you've made this oyster very happy.

Keep on schlepping,

Bette Midler

P.S. You slay me! Hope to see you soon.

Backstage after a performance of the **Bolshoi ballet** I was introduced to the great Russian ballerina, Maya Plisetskaya. Years before she had been photographed, wrapped in a great lynx coat, by Richard Avedon, and was still very attractive. Being terribly clever and knowing what everyone in New York made and did, she gave me an enormous dying-swan bow and said, "Oooh, Myeester Lane, you make such byeeootiful tings." And I answered, "Oooh you dance such byeeootiful dances."

A few days later, at my invitation, she came to my showroom, looked around and said, "Oooh, sooo byeeootiful. Sooo expyensive, and I am so poor." I knew that was true and how little even prima ballerinas earn in Russia, so I told her, "You can have as much as you can wear out of here."

She managed to get on twelve necklaces, several rings on every finger and bracelets all the way up to here on each arm. She was just loaded with stuff. Then she said to me, "And what can I do for you?"

I replied, "How about a dying swan?"

So right there, in front of a tiny mirror, and all my people in my stock room, weighed down with all the jewelry,

Maya undulated her arms and did a brilliant dying swan. If only I had had a camera.

Maya got away with a lot of loot, but I didn't mind. She deserved it.

I first saw the incandescent **Carol Channing** on stage when I was fifteen and she was starring in a revue called *Lend An Ear*. Of course, I've seen her legendary performance in *Gentlemen Prefer Blondes* and several times in *Hello, Dolly*. Her brilliance has not tarnished over the years—and she's just as delightful off the stage as on.

For years now, I've been making diamond rings for Carol that she gives away when she's on tour with a show. I make the rings adjustable since she likes wearing them before giving them away.

When people admire her 15-carat cushion-shaped diamond and say it looks like a million dollars, she gets a kick out of taking it off her finger and saying, "It's yours!"

She recently sent me a lovely note:

A few ♪♪'s from

Carol Channing

August 26, 1995

Kenneth, you dear,

We all know that "DIAMONDS ARE A GIRL'S BEST FRIEND," but you are my best friend!

This is by way of confirming our current order of 100 diamond rings. As you know, wherever I am playing, I bestow upon the mayor and local celebrities my "DIAMOND AWARD" which is, of course, a "Kenneth Jay Lane diamond."

We are looking forward to having you as our guest at the "Hello, Dolly!" opening in New York (see enclosed schedule).

All I can say is "thank you," but it does mean so much more.

Grateful xxx,

Carol

Lana Turner visited my factory many times and collected many of my pieces, which were sold after her death, at a Christie's East auction of costume jewelry. Lana, in her inimitable way, charmed the cool and daunting Bette Davis in a way I must mention here.

Sometime in the 70s, Bette Davis was mistress of ceremonies at a charity event at Roseland. Miss Davis announced the many stars who were there that night— such as Myrna Loy and Joan Fontaine, all of whom made their appearance on the stage. Then she introduced Lana Turner.

Lana, who was not of the same ilk as Bette Davis, came out looking absolutely wonderful in a very glamorous spangled gown and earrings of mine. I don't know if these ladies knew each other or not, but Lana, with a great smile on her beautiful lips, greeted Bette Davis affectionately. When Lana made a gesture to embrace Davis, Davis would have none of this. Instead, she extended a very stiff hand to be shaken.

Unflappable, Lana took the microphone and praised Bette Davis in a long, glowing testimony to her talent as the greatest actress who ever lived and the most extraordinary woman who ever graced the American stage and screen, and on and on.

Everyone in that ballroom was holding their breath until Bette Davis reacted. Lana finished her speech, went to embrace Bette Davis and she got her kiss. The audience went wild!

Raquel Welch, 1985. Photo, John
Paschal/DMI, David McGough, Inc.

I made this necklace to fit Raquel's neck
exactly and she wore it with a strapless
gown as a presenter at the Academy
Awards in Los Angeles.

Raquel Welch would come to my showroom and do a
semi-strip tease to see how a necklace would look
against her wonderful bare shoulders. She would come
by many times and try everything on. Then she'd take
what she liked home to be photographed to see if it
suited her, especially if she was planning a special
appearance, such as at the Academy Awards.

I've made unique necklaces for her, taking pieces we
have and adapting them to suit her. Raquel's great
beauty certainly does no harm to my jewelry.

To quote the now-famous transvestite, Chablis,
who was immortalized in John Berendt's fascinating
book, *Midnight in the Garden of Good and Evil*, and who
created a new verb, "to clientele with," I suppose I *do*
clientele with my clientele.

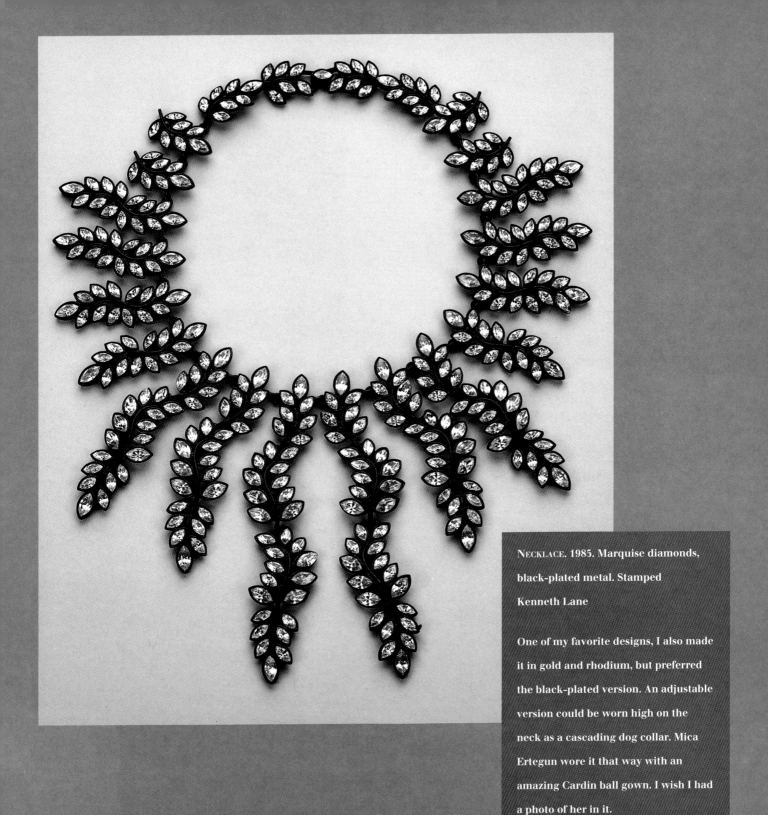

NECKLACE. 1985. Marquise diamonds, black-plated metal. Stamped Kenneth Lane

One of my favorite designs, I also made it in gold and rhodium, but preferred the black-plated version. An adjustable version could be worn high on the neck as a cascading dog collar. Mica Ertegun wore it that way with an amazing Cardin ball gown. I wish I had a photo of her in it.

1st row, left to right:

In my office, November 1966; with Doris Duke at the Cloisters in New York to celebrate Jane Engelhard's 60th birthday, mid-1970s. Photo, Bill Cunningham; Mary Lazar and George Christy, 1986. Photo © Marissa Roth; with Estée Lauder at the opera, 1990. Photo © Mary Hilliard; David and Serena Linley, 1994. Photo © Mary Hilliard; with Oscar and Annette de la Renta, 1990. Photo © 1990 Mary Hilliard

2nd row:

In my gangster pinstripe suit, late 1960s. Photo, Ellen Graham; Mercedes Bass and Grace Dudley, 1993. Photo © Mary Hilliard; Bianca Jagger, 1988. Photo © Mary Hilliard; Lee Radziwill, 1993. Photo © Mary Hilliard; Jessye Norman, 1993. Photo © Mary Hilliard; Swifty Lazar, Shakira Caine, and Princess Esra Jah, 1986. Photo, Marissa Roth; Rajmata Jaipur, 1989. Photo © Mary Hilliard

3rd row:

Julie Christie at my showroom on East 38th Street, 1966. Photo, Jack Robinson; Mary Lou Whitney at the opera, 1991. Photo © Mary Hilliard; Barbara and Henry de Kwiatkowski, 1993. Photo © Mary Hilliard; with Carolina Herrera, 1990. Photo © Mary Hilliard; with Paloma Picasso, 1990. Photo © Mary Hilliard

4th row:

With Betty Comden at the "Party of the Year" for the Costume Institute at The Metropolitan Museum of Art, c. 1950s; with Elsa Peretti at the Rhode Island School of Design President's Athena Award dinner, 1981. Photo, Ahrleen Rubin; Jerry Hall, 1988. Photo © Mary Hilliard; on QVC with Jane Rudolph Treacy, c. 1992

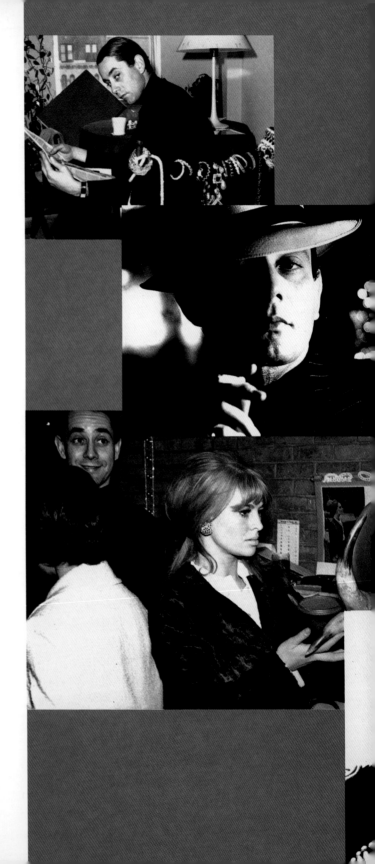

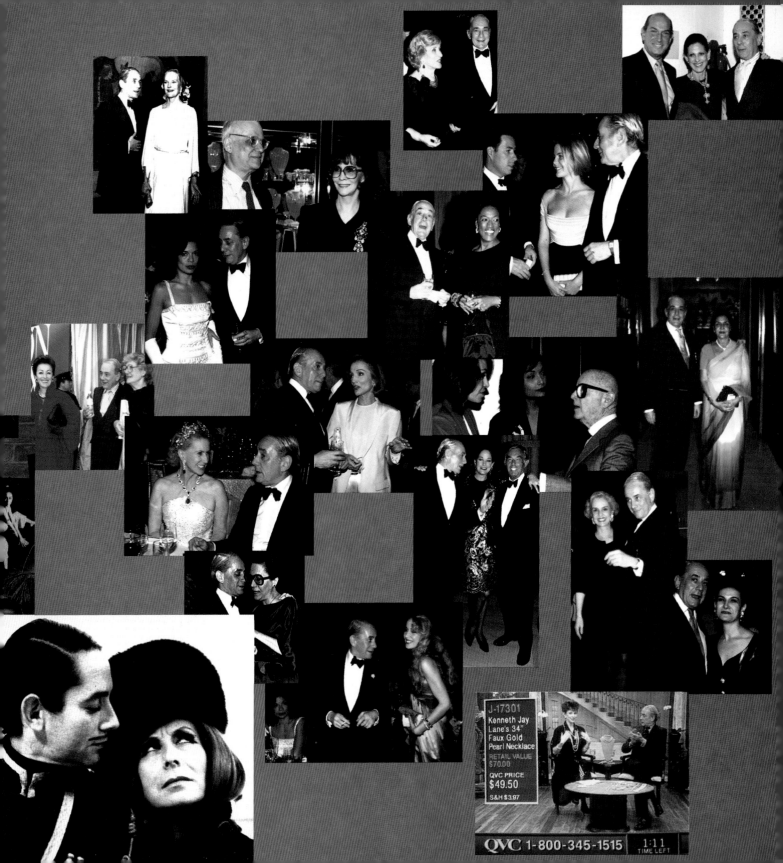

Acknowledgments

Writing a book that spans over thirty years of a designer's career can be achieved only with the generous assistance of friends, collectors, librarians, photographers, archivists, and all the others to whom we are deeply grateful.

How can I thank my darling friend Aileen Mehle, who as Suzy wrote the wonderful introduction for my book, and who wears my creations with such style. Not only does she inform the world where I dine and dance almost every day, but she is my best advertisement.

Heartfelt thanks to our friends who so readily retrieved their private caches of Kenneth Jay Lane baubles and photographs: Carol Caver of Joia, Constance Emmerich, Mica Ertegun, Robin Feldman, Virginia Fuentes, Prudence Huang, Ivana, Eleanor Lambert, Chessy Rayner, Terry Rodgers, Rhoda Rubovitz, and particular thanks to The Grace Collection.

There are many photographers who kindly gave us permission to use their work. Special thanks go to Mary Hilliard. Warmest appreciation goes to AP/World Wide Photo, Richard Avedon, Fred Coston, Bill Cunningham, DMI, Frederick Eberstadt, Ellen Graham, Horst, Michael Jacobs, Gideon Lewin, Patrick Lichfield, Phil Marco, Nina Meledandri, Duane Michals, Tony Palmieri, Irving Penn, Francesco Scavullo, Tobi Seftel, David Seidner, Anita and Steve Shevett, Anthony Snowdon, Pierre Venant, and Eric Weiss.

We are deeply grateful to all of the people whose valuable assistance and research was much needed and appreciated: Cynthia Carhart and Donald Osterweil of the Condé Nast Library; Cheryl Crane of the Lana Turner Estate, Christie's, New York; Blanche Davinger and Sigfredo Gonsales of Kenneth Jay Lane, Inc.; Deirdre Donahue of the Costume Institute Library at The Metropolitan Museum of Art, New York; Linda Edgerly and Deborah Shea of the Bill Blass Archives; Diana Edkins of *Vogue;* Ahmet Ertegun; Sean Ferrer and Connie Wald; Dennis Golonka of *Harper's Bazaar;* Richard J. Horst, Susanne Kirtland, Tish Loughlin, and James Reginato of Fairchild Publications; Oscar de la Renta Archives; Peter Rogers of Blackgama; Warner Chapelle; The White House; and Robert Woolley and Julie Leopold of Sotheby's, New York.

Photographer John Taylor's distinctive work deserves very special recognition and thanks.

To the staff at Abrams, whose expertise and creativity produced this beautiful book, we salute you! Thanks are extended to Abrams assistant Margaret Braver; director, rights and reproductions John K. Crowley; photography researcher Catherine Ruello; and to designer Carol Robson, whose enthusiasm and appreciation for the subject gave an extra sparkle to the pages!

To the editor of this book, Ruth Peltason, we not only thank for her genius, patience, and endless hard work, but for her willingness to go beyond what was required. And to Paul Gottlieb, the publisher of Abrams, we thank for his vision, sleight of hand, and magic tricks.

Photograph Credits

The publisher and authors wish to thank those individuals and institutions for permitting the reproduction of their photographs or jewelry. Principal photography of Kenneth Jay Lane's jewelry was taken by John Bigelow Taylor. Those credits not listed in the captions appear courtesy Kenneth Jay Lane, except for those provided below. All references are to page numbers.

Courtesy Christie's, New York: 153
Courtesy Favara, Skahan, Raffle Advertising, Inc.,
 photograph by Bill King: 150
Courtesy *Harper's Bazaar:* 17
Courtesy Ivana: 123
Courtesy Aileen Mehle: 6
© 1987 Sotheby's, Inc.: 117
Courtesy *Vogue.* Copyright © 1965 (renewed 1993)
 by the Condé Nast Publications, Inc.: 32, 36

Editor: Ruth A. Peltason
Designers: Carol A. Robson with Gilda Hannah
Rights and Permissions: Catherine Ruello

Page 1: Pear brooch. c. 1966
Pages 2–3: Montage of Indian jewelry and photograph of Kenneth Jay Lane as a young rajah
Page 5: Fountain-style Art Deco–inspired earring. Mid-1960s

Editorial note: For the purposes of labeling the costume jewelry in this book,
the words *diamond, ruby, sapphire, emerald, pearl,* and *turquoise* have been used
to describe their synthetic counterparts.

Library of Congress Cataloging-in-Publication Data

Lane, Kenneth Jay, 1932–
Kenneth Jay Lane : faking it / by Kenneth Jay Lane and Harrice
Simons Miller ; with a foreword by Suzy.
p. cm.
ISBN 0–8109–3579–1 (cloth)
1. Lane, Kenneth Jay, 1932– . 2. Jewelers—United States—
Biography. 3. Costume jewelry—United States. I. Miller, Harrice
Simons. II. Title.
NK4798.L36A2 1996
688′ .2′ 092—dc20
[B] 96–13671

Published in 1996 by Harry N. Abrams, Incorporated, New York
A Times Mirror Company
Printed and bound in Japan